DATE D D0016935

DEC 0 7 1987 NOV 10 '93 DEC 1 9 REC'D
 OCT 2 1993

NOV 3 0 1987 NOV 1 0 1993
FEB 1 6 1988 APR 20 '94
FEB 2 2 1988 DEC 8 '94
APR 1 4 1988 NOV 17
APR 2 3 1988 JUL 18
AUG 1 6 1989 FEB 28 '96
AUG 1 0 1989 APR 1 9 MAR 0 4 20
OCT 1 7 1990
 JUN 17 '96
OCT 1 7 1990
FEB 0 1 1991 MAY 3 1
FEB 0 2 1991 21
JUN 1 2 1991 OCT REC'D
JUN 2 1 1991 MAR 0 6 1997
FEB - 4 1992 AUG 2 3 1997
MAR 0 2 1992 AUG 2 3 REC'D
MAY 1 8 NOV 17
 NOV 29 '93 DEC 1 7 1997
GAYLORD PRINTED IN U.S.A.

ART CENTER COLLEGE OF DESIGN LIBRARY
1700 LIDA STREET
PASADENA, CALIFORNIA 91103

ART CENTER COLLEGE OF DESIGN
3 3220 00077 2645

731.4
Y75
1980

Methods for MODERN SCULPTORS

by
Ronald D. Young
Robert A. Fennell

ART CENTER COLLEGE OF DESIGN LIBRARY
1700 LIDA STREET
PASADENA, CALIFORNIA 91103

Sculpt-Nouveau
21 Redwood Drive
San Rafael, CA 94901

© Copyright, Ronald D. Young and Robert A. Fennell, January 1980

Second Printing, January 1981
Third Printing, December 1981
Fourth Printing, July 1983
Fifth Printing, October 1984
Sixth Printing, January 1986
Seventh Printing, December 1986

Library of Congress Catalog Card Number 79–92170
ISBN 0–9603744–0–X

All rights reserved. This book or parts thereof may not be reproduced in any form without written permission from one of the authors.

Drawings by Ronald D. Young
Design and graphics coordination by Judith Whipple

Printed in the United States of America

Acknowledgments

We want to express our gratitude first of all to our wives, Karen Young and Joanne Fennell, who spent untold hours working with, listening to, and encouraging us throughout the preparation of this book.

Our special thanks to our editor and coordinator, Shirley Manning, whose expertise kept us on the right track from start to finish; she became a good friend in the process.

Our sincere appreciation to Rick Hall, head of the Sculpture Department, College of Marin, Kentfield, California; to Herk Van Tongeren, editor of *Sculpture News Exchange* and co-director of Johnson Atelier, Technical Institute of Sculpture, Princeton, New Jersey; and to John Camera, Joe Carolfi, Henry Coryat, and Dana Stewart of Johnson Atelier. And our thanks to Yunga Kim of Princeton University, Tom Walsh of the University of Illinois, and the many other friends, artists, and craftsmen who individually contributed to this book.

Contents

I **INTRODUCTION** 1

II **WAXES AND SPRUES** 6

The Choice of Waxes 7

Wax-Working Methods 9

The Sprue System 16

Spruing Smaller Sculptures 28

Spruing Larger Sculptures 31

III **MOLD MAKING** 40

Piece Molds 41

Flexible Molds 44

IV **CERAMIC SHELL CASTING** 60

The Virtues of Ceramic Shell 61

Ceramic Shelling Procedures 65

Reinforcing the Shell 75

Drying the Shell 77

Materials and Mixes 78

Equipment Needed for Ceramic Shell
Casting 89

Problems in Ceramic Shell 100

V **DEWAXING** 102

Problems in Dewaxing 102

Dewaxing Without a Kiln 103

Dewaxing With a Kiln and Holding
Tank 106

Characteristics of Kilns for Ceramic
Shell Dewaxing 109

Building a Small Kiln 110

Designing and Building a
Larger Kiln 114

Safety and Kilns 127

Preparing the Shell for the Pour 129

VI **THE MELT AND THE POUR** 130

Equipment Needed 130

The Furnace and Crucibles 133

Building Your Own Furnace 133

Firing the Furnace 138

VI **THE MELT AND THE POUR (con't)**

 Placing the Shells 139

 Judging Metals 139

 The Pour 143

 Cooling 143

 Shell Removal 145

 Diagnosing Problems in Shell Casts 145

VII **WELDING, CHASING, CLEANING** 155

 Removing Sprues and Vents 156

 Welding 156

 Chasing 161

 Final Sandblasting 170

VIII **POLISHING AND PATINATION** 174

 Polishing and Buffing 175

 Patina Effects 179

 Preparing for Patination 180

 Patination Methods 189

 Variables and Problems in
 Chemical Patinas 202

 Protecting the Patina 204

IX **PATINAS FOR METALS** 209

 Bronze 209

 Copper 231

 Brass 238

 Silver 245

IX **PATINAS FOR METALS (con't)**

 Aluminum 246

 Zinc 249

 Tin 249

 Lead 250

 Stainless Steel 250

 Other Steels and Iron 252

 Old Dry Paste Formulas 257

X **CONSERVING AND PRESERVING
 BRONZE PATINAS** 259

 Cleaning a Patina 260

 Stabilizing Bronze Disease 261

 Removing a Patina 263

 Preservation 267

APPENDIXES

A. Slurries and Stuccos for Ceramic
 Shell Casting 269

B. Further Reading 274

C. Suppliers 277

D. Glossary of Terms 283

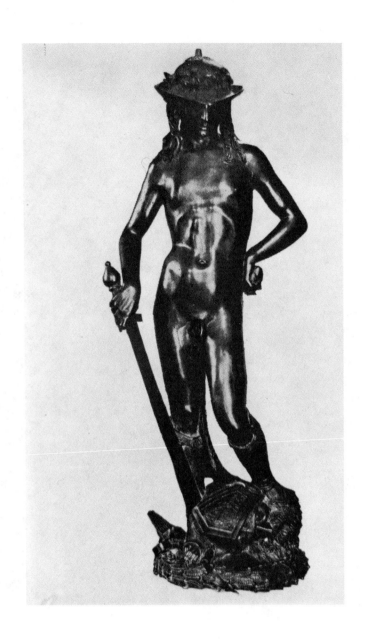

FIGURE 1. DONATELLO'S <u>DAVID</u>, 1435

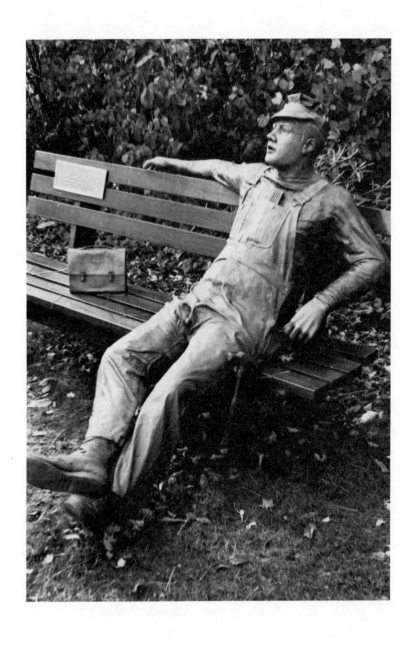

FIGURE 2. SEWARD JOHNSON'S LUNCH BREAK, CAST IN CERAMIC SHELL
AT JOHNSON ATELIER

1

Introduction

This book is full of practical advice for the student and working sculptor alike. We have gathered information from many sources--from other books, of course, but also from foundries and industries and artists in other lands--and we have tested out for ourselves all the guidelines we offer here to others. One of the authors, Ronald Young, has owned and operated a commercial foundry specializing in ceramic shell bronze casting. For some years he taught ceramic shell casting at the College of Marin in California, and is now co-director of the Johnson Atelier, Technical Institute of Sculpture in Princeton, New Jersey. Coauthor Robert Fennell has used readily available materials to build his own complete home foundry for casting in ceramic shell. He holds college art degrees in jewelry design and metal crafts.

We are particularly pleased to bring together in one place full information about metal casting with the ceramic shell process, a technology that has been known for many years by engineering firms but is only now

beginning to be practiced by sculptors. Near the end of the book is another unusual offering of information: many formulas and methods by which chemicals can be used to bring about beautiful patinas, for bronze and other metals, that formerly could be produced only by exposure to natural elements for years or centuries. Other chapters deal with other crafts of the sculptor-- mold making, working in wax, kilns for dewaxing, the melting and pouring of metal, and chasing and finishing the piece. Our emphasis throughout is on materials and equipment that will give best results, yet often can be made by the artist at little expense.

As we prepared our descriptions of modern methods for the sculptor, we came to appreciate, more than we really ever had before, the long history of art and craft in bronze, the classical metal of the sculptor.

Recent scholarship has traced bronze work back at least to 5000 B.C. and to cultures from the Mediterranean to China. However, the purposeful fusing of metals into alloys goes back to about 1800 B. C. Bronze is basically an alloy of copper (75 to 90 percent) and tin (preferably at least 10 percent) but almost all bronze is improved in fusibility with the addition of zinc and lead, and many other elements may be added or be present naturally in small amounts.

The Egyptians were the earliest known miners of copper. Their main source was the island of Cyprus, from which the word copper is derived. The Phoenicians were great seafarers with access to the copper of Cyprus, Arabia and other lands, to the tin of Britain, and to both these metals and zinc and lead from Spain. They became skilled workers in bronze and carried their craft to many other countries. They also unfortunately contributed to the destruction of some early and great bronze art, for bronze was always in demand for the manufacture of weapons.

To produce a bronze casting, metal has to be brought to about 1700°F. or more and poured into some

kind of mold which provides the negative image of the work. The early molds were **intaglio,** that is, cut into stone or other hard material. Another early method used sand and clay, bonded together by oil, into which the original piece was pressed, then the cavity filled with molten metal.

The most accurate and still the most popular method for casting bronze is the **cire perdu** or lost wax technique. It was known in Egypt by about 1570 B.C., may also have developed in China a few decades later, and by the 7th century B.C., had been brought to a high level by the Greeks. In essence, the original model is sculpted in wax, then covered by some sort of heat resistant material, then heated to the point where the wax melts out, leaving the negative impression inside the mold to be filled with molten metal. We can hardly claim originality in our discussion of working with wax (Chapter II) but we can offer special advice that will make the subsequent ceramic shelling and casting of the piece more successful.

The earliest bronze castings were solid and their weight, as well as the size of the heat resistant crucibles that could be handled, limited the size of the casting. Larger statues and vessels were cast in sections and then joined with rivets or soldering, both crafts that the Greeks perfected some 3000 years ago. By the 6th century B.C., Greek artists and foundrymen had developed assembly line methods to satisfy the demand for their products in many lands. By the 4th century B.C., the Romans had similar methods for producing armor and weapons for their legions.

The Greeks also developed the basic method for making many copies of a work. The original was sculpted in a hard material such as stone or wood and then a mold was formed in sections over it. The "piece mold" was then removed from the original, a layer of wax was poured into the reassembled mold, and the core was filled with refractory material, after which the wax was melted out.

A great breakthrough came with hollow core casting, requiring far less metal than a solid casting. Here, instead of the original being made in solid wax, the wax was modeled over a core of refractory material and the mold was formed over the wax. With the core material held in position by bronze pins, the wax was melted out and the bronze poured into the space between the core and the mold, both of which could then be chiselled away once the bronze had cooled.

In the many centuries from the birth of Christ to the Renaissance, art in bronze flourished mainly in China and especially in India, where dancers and other human figures were skillfully depicted in motion and the sculptures elaborately decorated with engraving and inlays of precious metals and stones.

With the Renaissance, Florence and then Venice attracted the greatest sculptors. Donatello of the famous David bronze and Ghiberti, both trained in the Guild of Goldsmiths, were followed in Florence by Giovanni, Michelangelo, Riccio, Bologna, and Cellini. The **Memoirs** of Cellini give fascinating accounts of the art and craft of bronze casting.

In Germany, foundries developed techniques for casting huge bells and cannons weighing thousands of pounds in a single pour. The ability spread to France where, during the 17th century, cannon foundries cast large statues, especially equestrian figures, in just one or a few pours. Although the 18th century saw much bronze work of household size, in the form of clock cases, candelabras, and the like, Falconet's colossal bronze of Peter the Great was cast in one pour--all 16 tons of it.

In the 18th century, Barye was one of the first great artists to break away from traditional styles, with beautifully finished bronze sculptures of animals. Then came Rodin (1840-1917), one of the greatest sculptors of all time, who used living models for his masterly

anatomical re-creations: when his male nude, The Age of Bronze, was shown, he was accused of casting from life, that is, actually molding a living person. This would have been easy if he had had some of the modern mold materials that we describe in Chapter III.

We have been understandably diverted away from the craft and into the art of bronze, which is not really the subject of this book. Our aim here is to give helpful advice and guidelines on modern techniques in sculpturing, including the building of equipment. We assume throughout most of the book that bronze is the metal of choice and that ceramic shell will be the casting mold. However, because so little information has been published to date on patination, we include in Chapter IX many formulas for the patination of copper, steel, and other metals.

More than in other fields, art in sculpturing rests on knowledge of materials and methods. By adding to that knowledge, we hope to contribute to the art.

II

Waxes and Sprues

Along with clay, wax is a material universally used by sculptors. Wax can easily be worked with the hands once it is warmed by an infrared lamp, a light bulb in a closed container, direct sunshine, or any other artificial or natural source of heat. A distinct advantage of wax over clay is that it can be melted and poured without drying or cracking.

Wax may be worked and formed with the fingers or with simple tools made by the artist out of wood, metal, or other materials. Wax may be carved from a solid form or the model may be built up section-by-section just as clay sculpture can be. Since wax will not chip, flake, or peel, the sculpture may be worked on over a long period of time. It need not be covered except to protect it from dust or excessive heat. There are many wax sculptures that are centuries old, yet appear to be recently made.

By using a simple wooden or styrofoam armature

that may be burned out of the mold with the wax, the artist can model a sculpture of any large or unusual dimension. Large sculptures, such as busts, should be done in hollow core with an even wax shell 3/16 to 1/4 inch thick. Small sculptures may be done in solid or hollow wax.

THE CHOICE OF WAXES

Early sculptors such as Michelangelo, Giovanni, Bologna, and Cellini made their own wax for modeling, using various formulas--most based on beeswax--to make waxes of different hardness or pliability. One problem with beeswax is that its properties vary according to the flowers that the bees have visited!

Although some modern artists also formulate their own waxes--we give some formulas later--this practice has become less popular as more prepared waxes, such as microcrystalline wax, have become available. This synthetic wax is a by-product of petroleum refining. The crystals in its structure are smaller than in natural waxes or paraffin; thus it is described as "microcrystalline." This wax is one of the most commonly used in bronze casting today.

Most of the major oil companies produce and sell microcrystalline wax, and it can usually be bought directly from them or through their distributors in quantities of 50 or 100 pounds. However, it is often easier to buy the wax through an art store or sculpture supply house. In the larger art supply houses, there is often a wide choice among the prepared microcrystalline waxes in hardness and melting temperatures. In all, there are over 40 types of microcrystalline wax from which the artist can choose.

Although microcrystalline wax comes in various colors, many sculptors prefer brown, especially if they are working in bronze. A brown wax such as Victory Brown is popular. Its workability, pliability and melting point of approximately 175^{o}F. make this a desirable wax

to work with. A brown color helps the artist in bronze to visualize the finished sculpture.

A yellow or other light colored wax can easily be changed to a darker tone by slowly melting the wax in a double boiler, deep fryer, or other suitable container and then adding lamp black or a commercial coloring agent until the desired color is obtained. However, care must be taken not to overheat the wax, which causes it to smoke and gather carbon. Overheating not only makes the wax less workable but, because of the carbon gathered in the wax, can also change the surface of the final bronze casting. A simply candy or wax thermometer, both inexpensive items, is the best safeguard against overheating. If it is not possible to obtain either of these items, two easy and fairly accurate methods of determining wax temperature may be used. One is to touch the melted wax for a moment with a finger; if the wax sets up instantly, it is approximately the right temperature. The second method is to remove the wax container from the heat as soon as the wax is melted, allow the wax to cool until a thin layer sets on the surface and sides, and then pour it into a container such as a wax sheet maker, to cool before it is used.

An artist will often want to use both a soft and a harder wax on a single sculpture. Normally, a soft modeling wax would be used initially over some type of armature--such as styrofoam, wood, cardboard, or any combustible material--that would burn out of the ceramic shell mold (described in Chapter IV) with the wax. A harder wax is then often used for the surface or finish coat where fine detail is desired. The harder wax makes the sculpture less susceptible to distortion and is also better for carving textured effects, since positive and negative lines are more clearly distinguishable.

The labels on most prepared waxes show the melting temperature. With most waxes there is a direct

correlation between the melting temperature and the hardness or pliability. A wax with a melting temperature of $225°$F. would be much harder and less pliable to work with than a wax with a melting temperature of $150°$F. (possible exceptions are a few jewelry waxes).

WAX-WORKING METHODS

There are three basic methods of working with wax. They may be used separately or in any combination.

The first method resembles that used in clay sculpture. Here the artist takes small lumps of wax, heats them, shapes them, and places them piece-by-piece on the sculpture. The warmed, pliable wax easily adheres to itself with the minimum amount of pressure.

The second method is to take wax sheets, cut to appropriate shape and size, and bend and shape the sheets section-by-section into each other. Figure 3 and 4 illustrate two ways of making wax sheets. The edges of the sheets are fused together by melting them with a heated instrument such as a soldering iron or a metal scrapper, spoon or other preheated tool. Larger wax forms made out of sheets, especially those formed in sections, may have to be supported by internal cross-sections of wax strips or bars to prevent them from warping or sagging.

The third way of working with wax is to make a solid block of wax, usually a harder variety, and carve it into the desired sculptural shape.

Often the artist uses all three methods in one sculpture. You may first weld sheets of wax together, then press small lumps onto this shape, and then carve the detail out of the wax lumps to achieve the final surface.

Plaster bat
(mold) regressed
1/4"

Pouring wax

Plaster bat must
be thoroughly wet
before wax is
poured into it
so that wax will
not stick

FIGURE 3. MAKING WAX SHEETS WITH A PLASTER MOLD

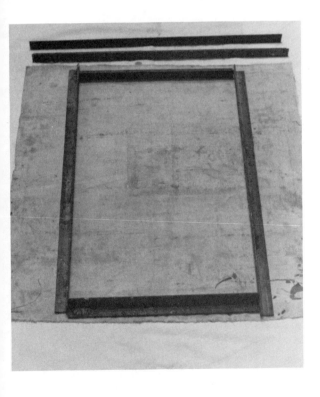

Angle iron can be
adjusted for size

Wet canvas tarp

Wax poured into
center

FIGURE 4. MAKING WAX SHEETS WITH A CANVAS AND ANGLE IRON MOLD

Wax is also used for dipping, a process which results in enlarging or building onto a previously made sculpture form or armature.

If you have only one type of wax, you can make it softer by simply melting it, as previously mentioned, and adding various amounts of petroleum jelly, lanolin, mineral oil, or a regular 30-weight motor oil. If you want to make the wax harder, you can add paraffin or a polyethylene powder with or without resin. Keep in mind that the wax's melting temperature and its natural hardness affect its shrinkage rate.

Table 1 gives some basic formulas for making your own waxes. Be sure to filter any wax thoroughly, through three or four layers of cheesecloth when the wax is hot, to remove the residues of foreign substances.

The properties of the basic types of wax, without additives, are summarized below:

	Source	Melting Temperature Range (oF.)
Beeswax	natural	140-200
Microcrystalline	petroleum	180-250
Paraffin	petroleum	120-180

The final surface on the wax--even a fingerprint--will be duplicated exactly in a good metal casting, a point the artist must keep in mind during the final stages of the wax working. There are many techniques for obtaining a smooth surface. Various grades of sandpaper ranging from 200 to 600 can be used, or you can polish the wax gently with a nylon stocking or a soft cloth treated with a small amount of oil of eucalyptus. Other chemicals used for surface polishing are lighter fluid, methyl ethyl keytone, Kralon acrylic spray, microfilm, and trichloroethene (that is, chlorethene) which can be obtained in jewelry or chemical stores. Heat treating

TABLE 1. WAX FORMULAS

	Ingredients by Weight (Percent)	
Modeling Wax 1	Beeswax	56%
	Paraffin	34
	Petroleum jelly	3
	Lanolin	3
	Lamp black	4
Modeling Wax 2	Beeswax	10%
	Microcrystalline	50
	Paraffin	30
	Rosin	6
	Lamp black	4
Dipping Wax	Plastic wax	20%
	Paraffin	45
	Microcrystalline	30
	Rosin	5
Spruing Wax	Paraffin	50%
	Microcrystalline	50

is another method of attaining a smooth surface. This is done by going carefully over the surface of the wax with a small propane torch using a soft flame, or moving an infrared or heat lamp across the surface.

The tools used for surface effects are limited only by the artist's own imagination. Ready-made metal modeling tools, pieces of metal flattened to various shapes, carved hardwood, toothbrushes, and clay working tools are a few popular items used in texturing the surface of the wax sculpture.

Small dental tools of various angles--see Figure 5--are commonly used for fine detail work. These tools may be slightly heated over a Bunsen burner, alcohol lamp, or some type of torch. They are then applied to a separate piece of wax, usually a hard wax, to deposit it on the sculpture in liquid form.

Commercially-made electric wax pens that automatically extrude wax on demand, or spatula-type pens that melt and pick up wax, may be obtained at most jewelry and sculpture supply houses. They are, however, rather expensive. The sculptor may make his or her own electric wax-working tool for a fraction of the cost of the commercial ones. This electric spatula, illustrated in Figure 6, consists of an inexpensive 25-watt soldering iron (including extra tips which you can form into various shapes), a common 600-watt light rheostat to control the heat temperature of the iron, and an extension cord. This is a valuable tool for modeling or carving, and it is excellent for joining wax sections together and for attaching the sprues in preparation for the cast.

Once the actual wax sculpture has been finished, the artist has to become an artisan in building a sprue system that will behave properly during both the ceramic shelling and metal pouring stages. However, you may first want to duplicate an original work by making a mold of it. The different techniques of mold making are described in the next chapter. Here we are concerned with preparing the wax sculpture directly for subsequent stages.

14

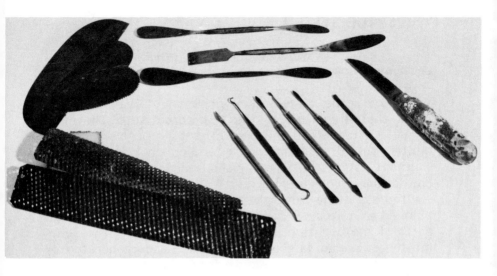

FIGURE 5. HAND WAX-WORKING TOOLS

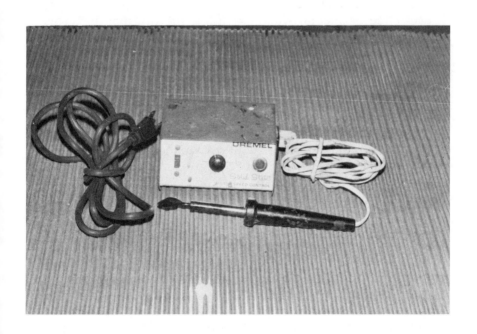

FIGURE 6. HOME-ASSEMBLED ELECTRIC WAX-WORKING TOOL

THE SPRUE SYSTEM

The way in which the wax sculpture is sprued will determine how well the piece casts.

The sprue system is a network of wax bars and vents that are fused to the sculpture itself. The main sprue is attached to the pouring cup through which the molten metal will be poured after the dewaxing or "burnout" stage. The main and secondary sprues, (also called runners or gates), which will be cast in the ceramic shell mold along with the sculpture itself, have to be planned in terms of carrying the molten metal into all parts of the negative image inside the mold. The vents must be planned so that air and the gases generated by the molten metal can escape from the mold.

Although it is relatively easy to make the wax sprue bars, commercially-available ones offer several advantages: they come in a variety of sizes and shapes, their strength and flexibility are standardized, and most are made of special waxes with low melting points. This last characteristic is important to assure that the heat required for dewaxing is not so intense as to crack the mold itself.

Sprue bars may be solid or have a hollow core. The core hole is an advantage because a metal rod can be inserted into it to hold the wax sculpture during shell mold making; the subsequent dewaxing is also speeded up because the hollow bar collapses rapidly. At least for the main sprue, square or triangular shaped bars are preferable to a round bar because they experience minimum shrinkage and, during the pouring stage, the angular channels they leave behind tend to stop turbulence in the molten metal and to speed its flow.

The main sprue bar should be tapered at the end that attaches to the sculpture, so that this end of the sprue channel will act as a "choke control," building up the pressure of the molten metal behind it and thus

helping the metal to flow with good force into all the niches in the mold.

At the other end of the main sprue is the pouring cup. One of the easiest ways to make it is simply to dip an ordinary styrofoam cup into melted wax. Even for a small sculpture, the cup has to be big enough (e.g., eight-ounce capacity) to hold a good head of molten metal (e.g., at least 5 to 6 inches of bronze) to help force the metal that is making its way through the sprue channels into all the crevices of the mold--and also to act as a reserve for the metal.

Figure 7A is a simple sketch of hollow core sprue bars. Figure 7B shows a pouring cup and main sprue bar.

Principles of Spruing and Venting

Before we get into the "how-to" of spruing for ceramic shell molds, it is worth considering the fundamental requirements of a gating and venting system:

1. The metal should flow through the system with as little turbulence as possible, so that gas and air will not be trapped in the mold. Turbulence is one of the main problems in casting bronze and other metals.

2. The metal should enter the mold cavity in a manner that will produce temperature difference between points in the casting, thus promoting directional solidification or proper "freezing" (cooling) of the molten metal.

3. The sprue system must deliver metal at a rate and velocity sufficient to completely fill the mold cavity before freezing.

4. The vents must be placed at points where they will readily let the trapped gases and air escape, so that the piece will fill properly.

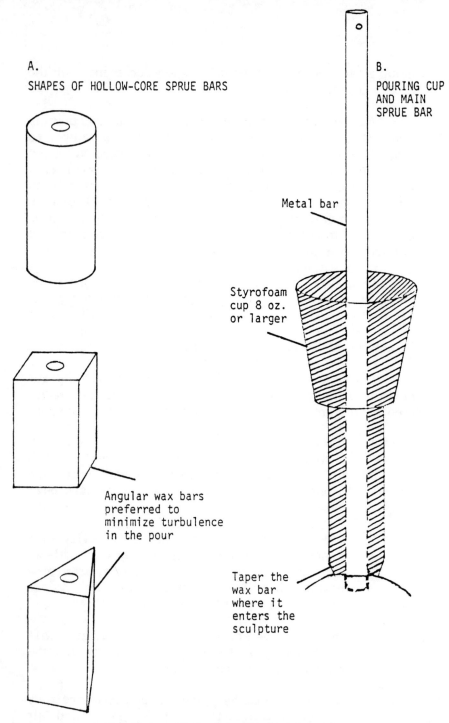

A.

SHAPES OF HOLLOW-CORE SPRUE BARS

B.

POURING CUP
AND MAIN
SPRUE BAR

Metal bar

Styrofoam
cup 8 oz.
or larger

Angular wax bars
preferred to
minimize turbulence
in the pour

Taper the
wax bar
where it
enters the
sculpture

FIGURE 7. SPRUE BARS AND POURING CUP

18

Several scientific principles underlie these requirements. First, the law of continuity states that the velocity of a stream is increased as it enters a smaller channel. Thus, the size of a sprue will determine the speed at which the metal flows through it. Newton's first law of motion states another characteristic of fluid flow: an object or fluid in motion remains in motion in a straight line and at the same speed until some other force is exerted on it to change its speed or direction. Thus, the angles of the turns in a sprue system are important, as is the shape of the piece. Any sudden of sharp change in the direction or speed of the metal flow will create turbulence.

To begin with, the pouring cup or button is very important. Figure 8A shows the most common shape for a cup. But it has some disadvantages: the velocity of the metal flow may be so great that it puts too much pressure on the shell; and the funnel shape of the cup may create a vortex and thus turbulence. On the other hand, with a cup shaped as in Figure 8B, you can reduce the chance of a vortex in the rapid filling of the main sprue.

Next, the shape of the main sprue bar itself is important. A circular shape tends to encourage vortex formation while a square or triangular shape will help prevent turbulence--see Figures 9A and 9B.

Next, the distance of the pouring cup and main sprue from the piece will affect velocity, turbulence, head pressure, and shear plane. The sprue works best if it is tapered at the base because, if the fluid metal remains in close contact with the sprue walls instead of pulling away from them, the chance of air being sucked into the mold cavity with the stream of metal will be reduced. Also, a tapered sprue will significantly increase the flow rate of the molten metal--see Figure 9C and 9D.

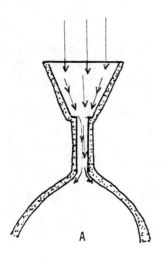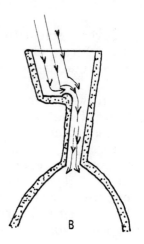

FIGURE 8. COMMON AND ALTERNATIVE CUP SHAPES

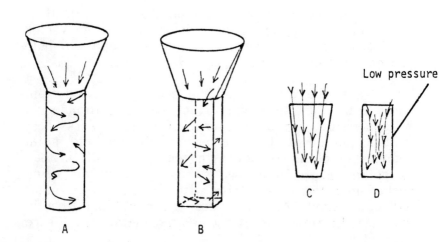

FIGURE 9. MAIN SPRUE SHAPES

Just as water flows more smoothly over sand than rocks, the surface of the wax sprue walls should be as smooth as possible so that the surface of the ceramic shell will be smooth and thus prevent turbulence and the breaking away of bits of the shell in the molten metal.

Any sudden or sharp change in the direction or speed of flow can create turbulence (as illustrated in Figure 10A) or breakaway of the ceramic shell (Figure 10B). Streamlining or rounding the corners of the sprues will help (Figure 10C).

Types of Sprue Systems

Consider the flow of metal through three types of sprue system: step spruing, bottom spruing, and direct spruing. Step spruing and bottom spruing are both considered indirect spruing.

Metal in a step spruing system will continue to flow through the bottom gates even after it has filled the ceramic shell mold cavity right up to the top gate. The reason for this is that, as the stream of molten metal falls, it continues to create a low pressure area at the entrance to each of the upper gates--the step sprues.

The vertical step spruing system has the advantage of letting the metal come into the mold relatively gently. By setting the step or secondary sprues at an upward angle from the main sprue, you can avoid premature entry of metal into the upper gates. You can get the metal to flow in from the bottom, as in Figure 11A, instead of flowing at lower pressures and possibly splashing into other sprues--as in Figure 11B.

Figure 12 illustrates the importance of the size of the step sprues. Sometimes you may need to increase their size and sometimes decrease it, depending on the piece. For instance, if your sculpture is tall, you may want to make the sprues larger in order to decrease the

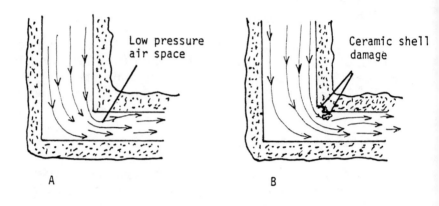

A B

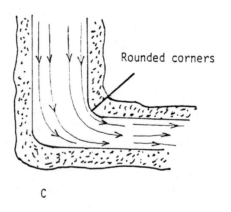

C

FIGURE 10. EFFECTS OF CORNERING OF MOLTEN METAL

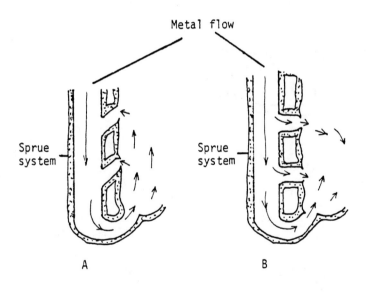

FIGURE 11. ANGLING OF SECONDARY SPRUES

23

Direction
of flow

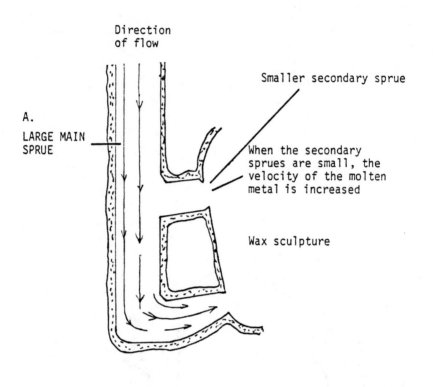

Smaller secondary sprue

A.
LARGE MAIN
SPRUE

When the secondary
sprues are small, the
velocity of the molten
metal is increased

Wax sculpture

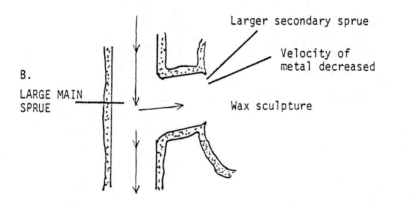

Larger secondary sprue

Velocity of
metal decreased

B.
LARGE MAIN
SPRUE

Wax sculpture

FIGURE 12. SIZE OF SECONDARY SPRUES

24

velocity of molten metal and thus decrease the pressure on the ceramic shell mold.

The other indirect spruing system is bottom spruing. It is called so because the molten metal is fed up into the sculpture from the bottom--see Figure 13A. The reason for the bottom sprue (or runner) is to lower the velocity of the entering metal. Although this may mean more weight of metal and thus more physical pressure on the mold, bottom spruing is a good way to hold a difficult piece on the sprue system. You can also increase the size of the bottom sprue (Figure 13B) so as to decrease the velocity and turbulence of the molten metal. And by rounding off the corners of the sprues (Figure 13C), you can reduce the risks of turbulence and shell breakaway.

Remember that, as the bottom sprue is increased in size, the weight of the bronze on the ceramic shell mold will increase, and so the shell mold should be reinforced as described later in Chapter IV.

Direct spruing is the most commonly used system for pieces to be cast in ceramic shell, because fewer sprues are needed than with traditional mold materials. Direct spruing puts less pressure on the shell mold but its main advantage is directional soldification: for shell casting, it is always better to solidify the metal from one direction, because the thin ceramic shell will cause the metal to chill (solidify) rapidly.

As Figure 14 illustrates, in the direct sprue system the sprue is brought into the wax sculpture at the top of the piece (as in part A of the figure) instead of at the bottom (B) or at the side (C).

Direct spruing is often the best system for a solid wax sculpture but it is also good for use with hollow waxes. This is because of the direct way the metal solidifies. In step or bottom spruing, the metal flows relatively slowly and may solidify at many points of the

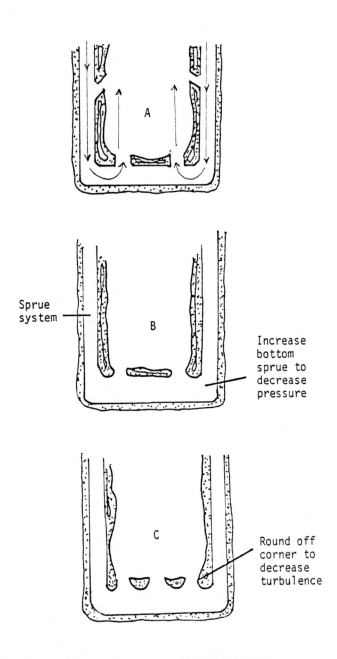

Sprue system

Increase bottom sprue to decrease pressure

Round off corner to decrease turbulence

FIGURE 13. BOTTOM SPRUING

A.
DIRECT

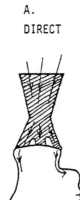

B.
BOTTOM INDIRECT

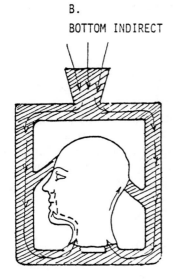

C.
STEP INDIRECT

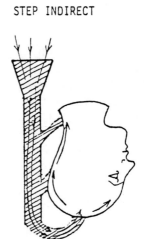

FIGURE 14. DIFFERENT SPRUING SYSTEMS

piece. In direct spruing, the metal flows rapidly because it is flowing directly.

If the wax sculpture is hollow and you want to use a direct sprue system, it may be done in either of the ways illustrated in Figure 15. Part B illustrates what may be the better way to sprue, if possible, because it may prevent the metal from splashing as it goes into the shell cavity, causing "cold skinning" or "cold shot" that may later peel or flake off the surface of the bronze. Remember, if you use method B, the vents must help support the sprue system, so they must be larger.

Venting

Because ceramic shell is very permeable, molds made of it need very few vents. But sometimes vents are helpful for releasing gases that would otherwise get trapped in some parts of the mold. The best rule of thumb is to put vents on the top surface of a piece and where it has long appendages. Figure 16 illustrates good venting.

Each wax sculpture needs a slightly different sprue and vent arrangement, depending on its size and the complexity of its shape. We give basic guidelines below: all are based on the subsequent use of ceramic shell casting, described in Chapter IV. As already noted, ceramic shell is light in weight and porous, and far fewer sprues and vents are needed than when the mold is to be made of more traditional materials.

SPRUING SMALLER SCULPTURES

If you are working with a small wax sculpture--say, no more than 12 inches high and 3 inches in diameter--the main sprue bar need be no more than 1 to 1-3/4 inches thick for a solid wax piece and certainly no more than an inch thick if the sculpture is made mostly of hollow-core. Special care, of course, has to be taken when spruing a hollow-core sculpture. If it is made of relatively thin wax, one or more bronze core pins should be used to hold any core material in place. When a solid

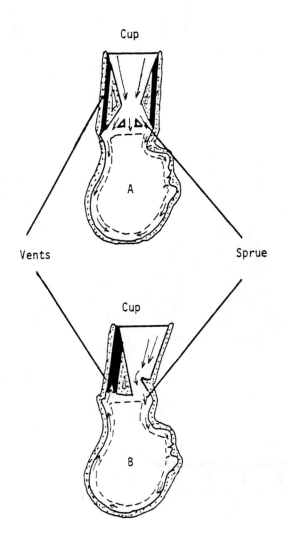

FIGURE 15. ALTERNATE SPRUING METHODS FOR HOLLOW CORE CASTING

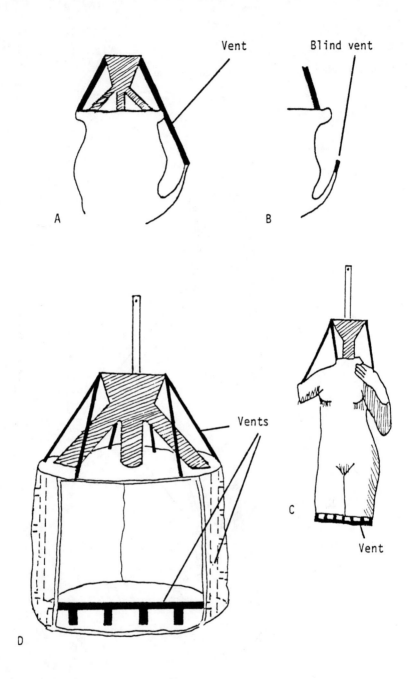

FIGURE 16. VENTING SYSTEMS FOR CERAMIC SHELL MOLDS

core is used, the pins are placed through the wax (usually four or six are enough) before the core material is poured. When a metal bar in inserted into the sculpture itself, it must be well-waxed to prevent sticking to the shell when the bar is being removed during burnout.

Figures 17 and 18 summarize our advice on the spruing of small sculptures. Although we have included vents in some drawings, ceramic shell material is porous enough that no vents at all may be needed for small sculptures of simple shape. When a vent is used, note that it should come to the top of the pouring cup to allow gases to escape.

Figure 19 shows the difference in spruing a hollow core and a solid piece, including the use of bronze pins.

SPRUING LARGER SCULPTURES

Figures 20 through 23 illustrate the spruing of different shapes of larger pieces. In Figure 20, note the need for more sprues and vents if a large sculpture is to be cast in one piece rather than two pieces; also, in large and complicated sculptures, each appendage must be sprued individually to avoid flexing and breaking. In large flat pieces--see Figure 21-- the main concern is to brace the piece so that it will not warp. In large round pieces--Figure 22--the trick is to avoid too much head pressure from the molten metal.

When a piece is very large, as in Figure 23, special sprue arrangements have to be made just to handle it.

Figure 24 shows suggested cut lines for a life-size wax model to be cast in several pieces.

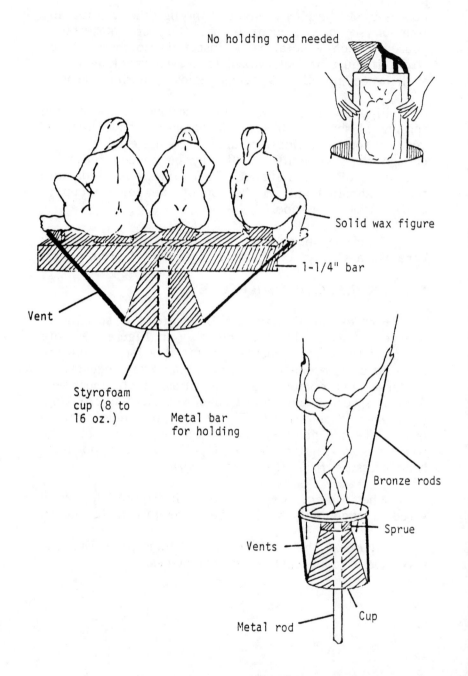

No holding rod needed

Solid wax figure

1-1/4" bar

Vent

Styrofoam
cup (8 to
16 oz.)

Metal bar
for holding

Bronze rods

Sprue

Vents

Cup

Metal rod

FIGURE 17. SPRUING FOR SMALL, SIMPLE SCULPTURES

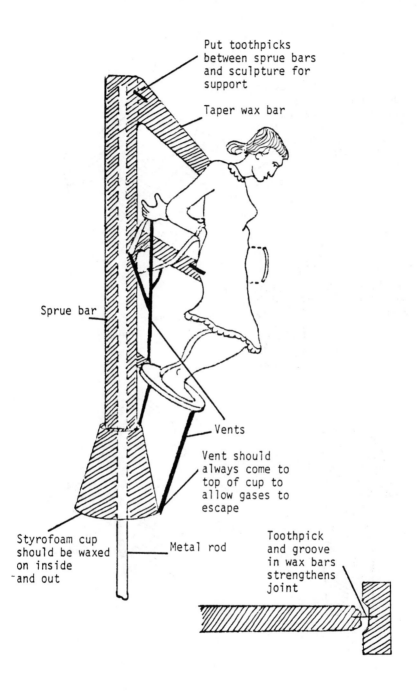

Put toothpicks between sprue bars and sculpture for support

Taper wax bar

Sprue bar

Vents

Vent should always come to top of cup to allow gases to escape

Styrofoam cup should be waxed on inside and out

Metal rod

Toothpick and groove in wax bars strengthens joint

FIGURE 18. SPRUING FOR MORE COMPLEX SCULPTURES

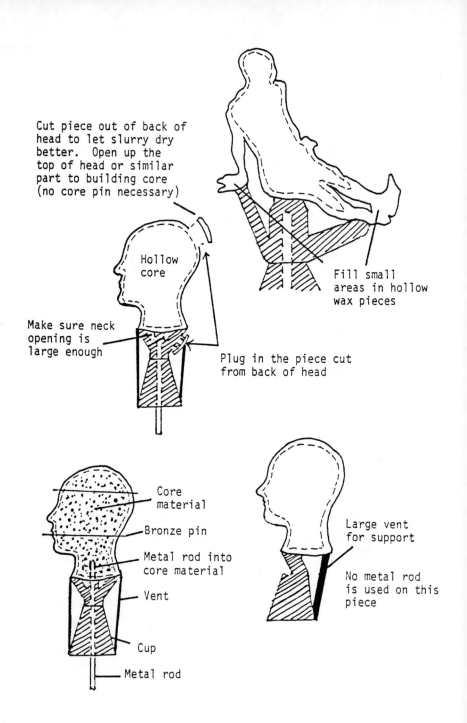

Cut piece out of back of head to let slurry dry better. Open up the top of head or similar part to building core (no core pin necessary)

Hollow core

Make sure neck opening is large enough

Fill small areas in hollow wax pieces

Plug in the piece cut from back of head

Core material

Bronze pin

Metal rod into core material

Vent

Cup

Metal rod

Large vent for support

No metal rod is used on this piece

FIGURE 19. SPRUING HOLLOW CORE AND SOLID PIECES

34

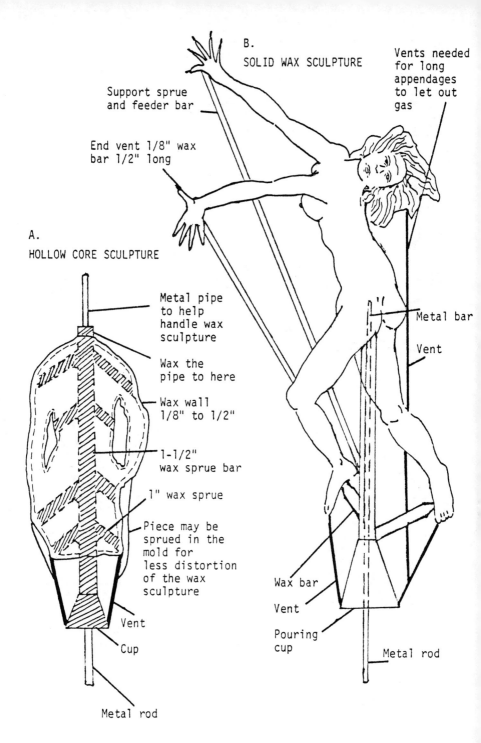

B.
SOLID WAX SCULPTURE

Vents needed for long appendages to let out gas

Support sprue and feeder bar

End vent 1/8" wax bar 1/2" long

A.
HOLLOW CORE SCULPTURE

Metal pipe to help handle wax sculpture

Wax the pipe to here

Wax wall 1/8" to 1/2"

1-1/2" wax sprue bar

1" wax sprue

Piece may be sprued in the mold for less distortion of the wax sculpture

Vent

Cup

Metal rod

Metal bar

Vent

Wax bar

Vent

Pouring cup

Metal rod

FIGURE 20. SPRUING A LARGE PIECE FOR A SINGLE CAST

ART CENTER COLLEGE OF DESIGN LIBRARY
1700 LIDA STREET
PASADENA, CALIFORNIA 91103

35

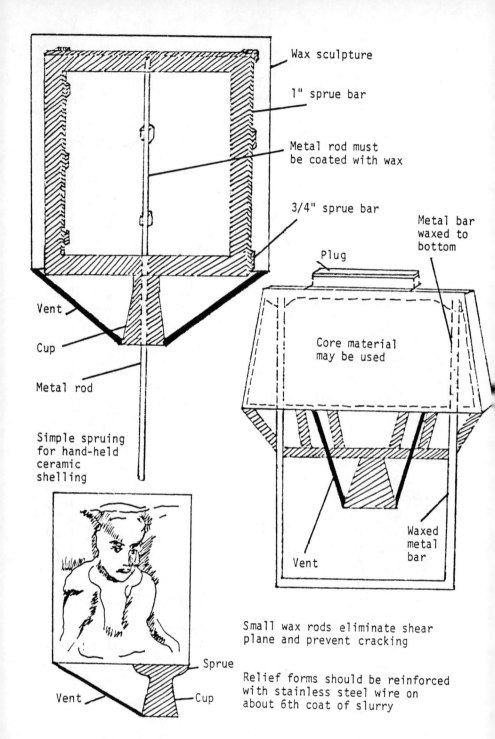

Wax sculpture

1" sprue bar

Metal rod must
be coated with wax

3/4" sprue bar

Metal bar
waxed to
bottom

Plug

Core material
may be used

Vent

Cup

Metal rod

Simple spruing
for hand-held
ceramic
shelling

Waxed
metal
bar

Vent

Small wax rods eliminate shear
plane and prevent cracking

Sprue

Relief forms should be reinforced
with stainless steel wire on
about 6th coat of slurry

Vent

Cup

FIGURE 21. SPRUING LARGE FLAT PIECES TO PREVENT FLEXING

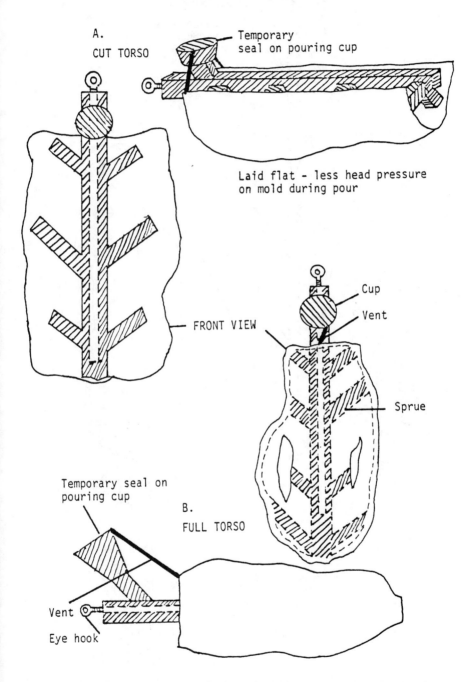

A.
CUT TORSO

Temporary
seal on pouring cup

Laid flat - less head pressure
on mold during pour

FRONT VIEW

Cup

Vent

Sprue

Temporary seal on
pouring cup

B.
FULL TORSO

Vent

Eye hook

FIGURE 22. SPRUING LARGE PIECES TO MINIMIZE HEAD PRESSURE

37

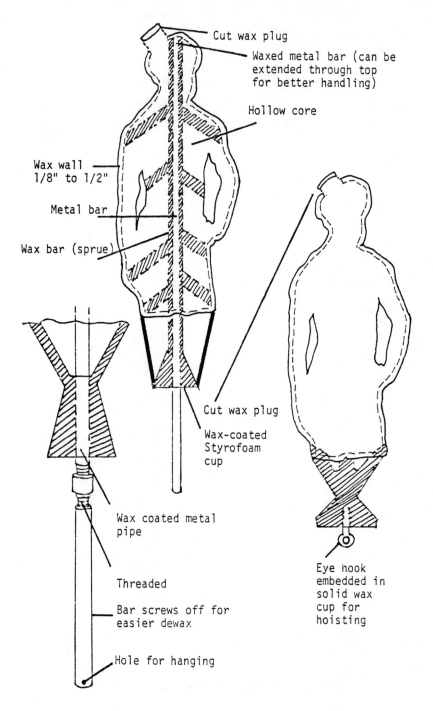

Cut wax plug

Waxed metal bar (can be extended through top for better handling)

Hollow core

Wax wall 1/8" to 1/2"

Metal bar

Wax bar (sprue)

Cut wax plug

Wax-coated Styrofoam cup

Wax coated metal pipe

Threaded

Bar screws off for easier dewax

Hole for hanging

Eye hook embedded in solid wax cup for hoisting

FIGURE 23. SPRUING LARGE PIECES FOR EASE OF HANDLING AND FINISHING

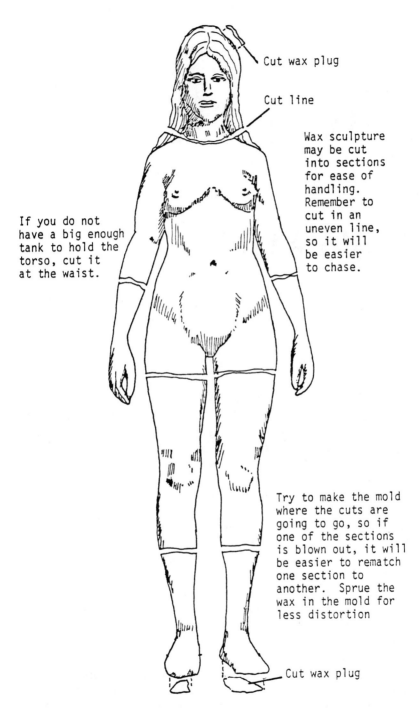

Cut wax plug

Cut line

Wax sculpture
may be cut
into sections
for ease of
handling.
Remember to
cut in an
uneven line,
so it will
be easier
to chase.

If you do not
have a big enough
tank to hold the
torso, cut it
at the waist.

Try to make the mold
where the cuts are
going to go, so if
one of the sections
is blown out, it will
be easier to rematch
one section to
another. Sprue the
wax in the mold for
less distortion

Cut wax plug

FIGURE 24. CUTTING A LIFE-SIZE WAX MODEL FOR MULTIPLE CASTS

III

Mold Making

A sculptor often wants to duplicate a wax, clay, wood or other model, or to copy a finished casting. The basic methods of mold making are summarized in this chapter. Many more details are available in books devoted entirely to the subject.

Once a mold of the model has been made, a new positive is made by filling the mold with wax. If a solid casting is desired, the wax is allowed to solidify before it is removed from the mold. If a hollow core casting is desired, the wax is poured into the mold, allowed to stand for about 15 seconds, and then it is poured back into the wax heating pot. This may have to be done two or three times to build the wax positive up to a thickness of 1/8 to 3/16 inch or more.

It has been our experience in hollow core casting that using two types of waxes results in excellent finished pieces. We use a microcrystalline wax followed by a hard backup jewelry wax such as Sierra Red or Cheva Green.

40

PIECE MOLDS

A piece mold is usually made with plaster of paris. It has both advantages and disadvantages. One advantage of this material is its nominal cost and another is its availability at most art, paint, and building supply stores. One more advantage of plaster of paris as a mold material is that it dries in just 15 or 20 minutes.

One of the disadvantages of a piece mold, whatever the material, is that it has to be made in two or sometimes four or more sections to allow for all undercuts and detail of the original model. Each section is keyed into the adjoining sections, as illustrated in Figure 25.

The surface fidelity of the piece mold will not be as accurate as that of a flexible rubber mold, described later, and the numerous seam lines caused by sectioning the piece mold together will show up on the wax model upon removal of the mold. The time often saved in making a plaster piece mold may be lost in reworking the wax after it is removed.

If the sculpture to be reproduced is very simple, with few or no undercuts, a plaster mold may be one of the easiest forms of reproduction. However, if the sculpture contains numerous undercuts, projections, recesses, or fine detail, it would be advantageous to use one of the flexible mold materials.

The division lines for a piece mold are made by either thin metal shims or clay "walls." Plaster is then applied to one section at a time. The wall of metal or clay isolates these sections until the plaster hardens. If a clay wall is used as a dividing line, it should be between 1/4 and 1/2 inch thick and about 1 inch in height. "Keys" or register points should be made in the wall so that the plaster will accurately interlock in proper sequence. The first clay wall section is removed when the plaster is dry and the plaster edges sealed

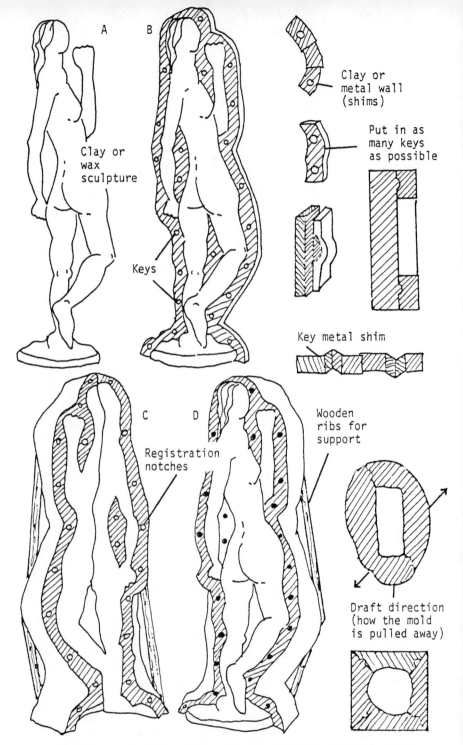

Clay or
metal wall
(shims)

Put in as
many keys
as possible

Key metal shim

Clay or
wax
sculpture

Keys

Registration
notches

Wooden
ribs for
support

Draft direction
(how the mold
is pulled away)

A B

C D

FIGURE 25. PLASTER PIECE MOLD AND INTERLOCKING MOLD KEYS

with shellac followed by petroleum jelly or hot wax. An adjoining section of plaster is then applied.

The wet plaster may be applied within the clay wall sections by pouring it in a puddle and stirring the plaster with a stick or spatula to release trapped air. To pick up greater detail, the plaster can be thrown or flicked onto the model by hand. The plaster is then built up to the desired height of approximately one inch. A wire loop should be embedded in the center of each piece to allow simple removal of the section after the plaster dries.

Sealing the edges of each plaster piece with shellac (followed by a mold release) or hot wax keeps them from adhering to each other. This enables easy removal, section by section, after the mold is completed.

If the original sculpture is made from any material other than wax, a mold release should be applied to it. This will prevent the mold from adhering. Commercial mold releases are available but common materials such as plastic spray, green soap, paste wax, motor oil, silicone mold release, petroleum jelly (Vaseline), or a cooking oil may be used as parting agents, and all work satisfactorily.

After the entire piece mold is made, it is removed section by section from the original sculpture. The sections are then reassembled into their keyed positions. The outer seam lines are sealed with wax or clay. Tape, rubber tubing, or cord is usually used to bind all sections together. The hollow mold is turned upside down, placed in a container, the inner surface is wetted with water, and melted wax is then poured up to the top (and emptied out if a hollow core casting is desired).

When the wax solidifies, the plaster pieces are removed section by section. Any parting lines or imperfections on the wax surface can then be reworked.

FLEXIBLE MOLDS

If intricate or complicated patterns are to be reproduced, flexible mold materials avoid the complications of piece molds. Industries as well as sculptors rely on flexible mold materials for accuracy of detail.

There are various types of flexible mold materials available and new types are constantly appearing on the market. The initial flexible rubber mold was an air-curing latex. It is still popular because it is inexpensive. More recently, three other popular flexible mold materials have appeared. They are either silicone or polyurethane rubber, called room temperature vulcanizing (RTV); Black Tuffy, called cold mold compound (CMC), a polysulfide rubber; and vinyl hot pour. The RTV and CMC are two-part catalyst activated compounds that set quickly at room temperature, reproducing accurate detail. The vinyl hot pour is a rubbery textured material that melts at approximately 350°F. and must be poured over the pattern. This type of material may be remelted and used repeatedly, but cannot be used on a wax or other pattern that cannot tolerate heat.

Latex

An air-curing latex rubber may be either water or ammonia based. The ammonia type is the more popular since it dries more rapidly and has good elastic properties, strength, and durability. Latex is also more versatile than other mold making compounds since various materials--including polyester resin, epoxy, wax, plaster,

and concrete--may be poured into it safely. It is less expensive than most other flexible mold materials. However, latex has several disadvantages, including the number of layers needed (between 10 and 13) and the length of curing or drying time required for each layer.

Most models should first be sprayed or painted with shellac in order to seal them and allow easy removal of the latex.

Latex is normally applied by brushing or spraying it on the sculpture, which should be placed on a flat, smooth surface such as Masonite. Brushing is the most common method of avoiding the formation of air bubbles around the pattern. The layers may be applied to the entire piece and brought down in a 2-inch lip or skirt surrounding the pattern on the Masonite platform. With a simple smooth original, the latex mold can often be removed as easily as pulling a sock over a foot. But with a detailed pattern, a two part mold is advisable (see Figure 26). This is done basically as we decribed in making a plaster piece mold. An oil clay such as plasticine (Roman Clay) is used for the divider wall, with keys or register points so that the two halves will accurately interlock upon completion.

If the latex is to be brushed on, a soft sable brush should be used. Soaking the brush in soapy water before application makes the brush easier to clean later.

The first coat is the most important, because all surface details are picked up here. When it has dried (from 2 to 4 hours later, depending on temperature) a second followed by a third coat may be applied. After the fourth coat is applied, 2-inch strips of cheesecloth should be laid into the wet coat and allowed to dry. Three more coats of the latex are then applied, each allowed to dry, followed by another coat of latex and more 2-inch cheesecloth, three more latex coats allowed to dry, one more coat of latex with cheesecloth, and the final application of latex. This brings the total

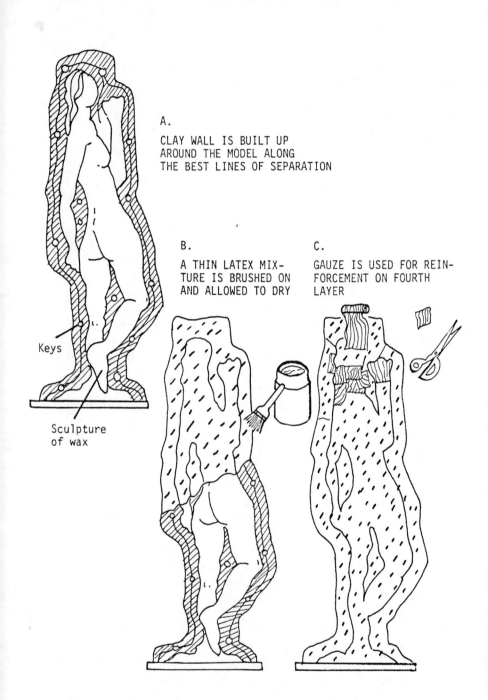

A.

CLAY WALL IS BUILT UP
AROUND THE MODEL ALONG
THE BEST LINES OF SEPARATION

B.

A THIN LATEX MIX-
TURE IS BRUSHED ON
AND ALLOWED TO DRY

C.

GAUZE IS USED FOR REIN-
FORCEMENT ON FOURTH
LAYER

Keys

Sculpture
of wax

FIGURE 26A. FLEXIBLE MOLD CONSTRUCTION
WITH MOLDING COMPOUND BRUSHED ON

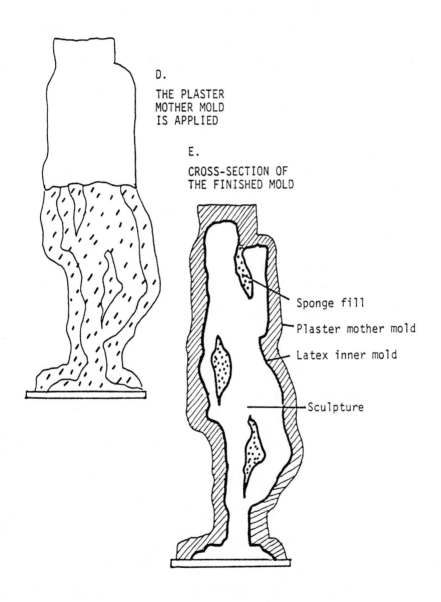

D.

THE PLASTER
MOTHER MOLD
IS APPLIED

E.

CROSS-SECTION OF
THE FINISHED MOLD

Sponge fill

Plaster mother mold

Latex inner mold

Sculpture

FIGURE 26B. FLEXIBLE MOLD CONSTRUCTION
WITH MOLDING COMPOUND BRUSHED ON

layers of latex to 13, including the three strengthening layers with cheesecloth.

Deep impressions or undercuts may be built up or reinforced with a commercially obtained filler--which must be saturated with liquid latex--or with fillers such as talc, sawdust, cheesecloth, or rubber shavings. The filler buildups should be limited to 1/2 inch in thickness, and each application must be allowed to dry thoroughly before proceeding to the next layer.

There is an optional way to apply a latex mold that appears to give as much accuracy and durability as the one previously mentioned, yet is completed in about half the time. The first three coats are applied as above, including the cheesecloth on the third coat. The fourth coat is mixed in equal proportions with rubber tire shavings. These small bits of rubber may be obtained at most tire or recap stores for a nominal charge and often free. About 3/16 to 1/4 of an inch of this pasty mixture of rubber shavings and latex should be applied to the sculpture and allowed to dry--the drying time seems to be shorter than a single layer of pure latex requires.

After drying, this fourth coat is followed by a final coat of latex, bringing the total applications to five, including the one of latex mixed with the rubber shavings.

Regardless of the method used in applying latex as a flexible mold material, thorough drying of each layer is essential. It is also necessary to allow the completed mold to cure at least 48 hours before removal.

A plaster support mold must be built around the latex covered pattern in order to prevent the mold from distorting. (The terms support mold, backup mold, and mother mold are all interchangeable; they merely refer to an outer hard shell containing the flexible mold and thus retaining the original shape of the pattern it is copying.)

It should be noted that prior to pouring wax into a finished mold, the mold should be thoroughly cleaned, dried and coated with either talc or silicone mold release. If the mold is to be stored for a long time, it is advisable to pour wax into it and allow the wax to soldify. Alternatively, the mold can be dusted with talc and sealed in a plastic bag to inhibit distortion and deterioration.

RTV and CMC

Silicone rubber (RTV) and polysulfide rubber (CMC) are excellent mold materials for complicated patterns where accuracy of detail and numerous reproductions are desired. The method used is similar in both cases, but below we assume use of CMC, that is, Black Tuffy.

CMC was developed years ago primarily for industrial uses but it is now considered essential by many sculptors for accurate reproduction of their work. Although there is no mold material available that will not distort, CMC shows minimal evidence of distortion and maximum fidelity in surface reproduction. CMC is used primarily for reproductions in wax--this is another reason for its popularity in bronze sculpture using the lost wax method. It is **not** a reproduction mold for epoxies, resins, or concrete. If the pattern is porous, it must be sealed before using CMC. Usually two- and sometimes three-part molds are made with CMC material.

Unlike latex, which is applied directly from the can, CMC requires a catalyst that must be accurately weighed in proportion to the polysulfide material. The normal ratio is 8 parts catalyst to 100 parts liquid rubber, but we have had better results with 10 parts catalyst to 100 parts liquid. The manufacturer's mixing recommendations should be strictly observed until you have had enough experience with the results to experiment with different proportions. It is important to add the catalyst to the rubber slowly in a circular motion and to mix thoroughly for three or four minutes. It is advisable to use two containers, stirring and pouring

from one container to the other to assure good blending. Coated paper cups of the type often used in mixing fiberglass resin are useful, and wooden tongue depressors are inexpensive stirring sticks for small amounts.

Room temperature is another important considera-tion when using CMC. A minimum of 75°F. is needed for accurate and strong molds. If it is impossible to obtain a termperature of 75°F. or higher, an inexpensive wooden or Masonite box, lined with aluminum foil, and containing four to ten 100-watt light bulbs makes an excellent drying container. Oven curing at 150°F. for an hour also works well.

De-bubbling the CMC mixture is important for accurate surface reproduction when the mold material is poured over a pattern. If you can use a vacuum machine, allow the CMC to rise to the top of the container, then release the vacuum. Repeat this pro-cedure three to five times, depending on the volume of CMC.

A simpler method than vacuuming, yet just as effective, is to brush three coats of CMC over the pattern, letting each coat dry, and then apply cheesecloth for strength over the fourth coat. The fifth coat can be mixed with Cab-O-Sil, a thickening material, or rubber shavings as previously described. Then apply the sixth and seventh coats, and after the eighth coat, cover again with cheesecloth strips. The ninth coat is a final sealer. After it has dried thoroughly, you apply the mother or backup mold.

In the brushing-on technique, the pattern itself should be placed on a Masonite base, as described earlier for latex molds. The sculpture may be divided in half by a plasticine clay wall which is keyed, as described for a piece mold, and after 1/2 inch has been built up, the clay border is removed and the cured rubber edge treated with a mold release or paste wax. The second half is built up exactly the same as the first. After both sides are dried and cured, the backup mold is

applied using the parting line of the CMC as the halfway mark for the plaster. Again, clay may be used as a divider. After proper curing, both outer and inner molds are removed from the pattern, cleaned, and reassembled. The negative surface of CMC should be sprayed with mold release prior to receiving wax.

An alternate method for RTV or CMC mold making is to coat the entire pattern, allow it to set, and then cut the rubber with an Exacto knife along a predetermined parting line. The backup mold is made using the cut line as the divider.

Since CMC is not an inexpensive mold material, the brushing-on method is normally the most economical. If you want to save time, there are two basic methods of pouring or dipping with CMC.

For a small uncomplicated sculpture, you can either stand or suspend the patter in a reinforced cardboard, wood, or clay container. Brush on the first coat of CMC and allow it to set while mixing an adequate amount of CMC in the box. Thoroughly submerge the pattern, then allow it to set completely (24 to 48 hours). It may be possible simply to peel back the mold from its base. If not, cut the mold away, cutting in an irregular line at the corners so that they will interlock accurately on reassembly and keep the mold's original undistorted shape. If it is possible, leave a small part of the mold attached to the other section, to act as a hinge for reassembly. If the pattern is large, a backup mold may be necessary. Once the pattern is removed, a pouring cup, gate, and (if necessary) vents can then be easily cut into the reassembled mold to allow entrance of melted wax.

In the second alternative to brushing on CMC, the entire sculpture is first covered with ordinary thin plastic wrapping material such as a Saran Wrap or Handi-Wrap, and supported on a wooden base. Then you cut strips of clay or plasticine about 1/4 inch thick and mold them

over the sculpture--see Figure 27--being sure to include a keyed wall parting line in the layer and building up a clay projection an inch or two above the highest point of the sculpture. The projection will eventually act as a pouring gate--see Figure 28. The wooden base supporting the pattern is randomly countersunk close to the model--see Figure 29--and the backup mold is placed over the clay. This may be reinforced with hemp or cheesecloth for strength. Don't forget to remove the clay parting line and seal the edge of the first backup mold before making the second backup mold.

Remove the hardened backup molds carefully to prevent damage to the keys and the countersunk points. Then remove the clay and plastic facing. The next step is to seal the pattern and the inner face of the backup mold with a release agent. Then reassemble the backup mold around the pattern, carefully lining it up to the countersunk registration points. Seal its seams carefully with wax or clay, leaving open only the hole that was made by the clay projection. Bind the two halves of the mold together.

On complex sculptures it may be necessary to build in air vents that will prevent air entrapment. This can be done by pushing small plastic tubes into the clay facing and allowing them to protrude through the backup mold. It is also possible to drill small vent holes through the top of the backup mold--but be sure not to place holes below the highest level of the actual pattern or the CMC will leak out. Also, completely seal the base and seams of the backup mold before pouring CMC. After the CMC is set and cured, remove it from the pattern either by peeling back or cutting with an Exacto knife. If it is to be cut, do so as closely as possible to the parting line of the backup mold so that they separate together. This may be accomplished by placing only one of the halves of the backup mold over the CMC before it is removed from the pattern and cutting the rubber along the parting line.

The CMC mold is then cleaned, coated with a release agent, and placed back in the backup mold, which

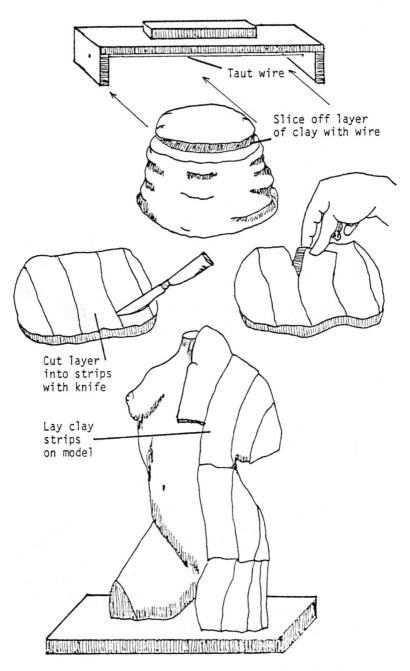

Taut wire

Slice off layer
of clay with wire

Cut layer
into strips
with knife

Lay clay
strips
on model

FIGURE 27. COVERING MODEL WITH CLAY BEFORE MOLDING

53

A.

APPLY CLAY SEPARATING
MEDIUM TO THE MODEL
WALL, THEN LAY FLAT
PIECE OVER THE MODEL
AND A WALL AROUND
THE EDGE

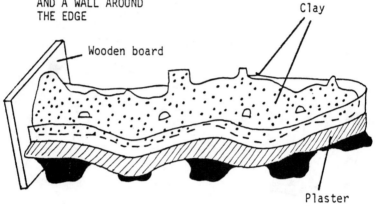

Clay

Wooden board

Plaster

B.

PLASTER MOTHER MOLD
WITH RISER HOLE AND
POURING HOLE. SHELLAC
AND VASELINE THIS MOLD
BEFORE POURING CMC
OR BLACK TUFFY

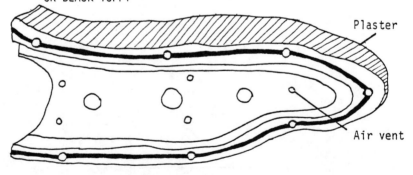

Plaster

Air vent

FIGURE 28A. TWO-PART CMC OR RTV AND BACKUP MOLDS

C.

PLASTER CLAY COATING
STRIPPED FROM TOP
HALF OF MODEL

Clay coating still
around lower half
of model

Keys

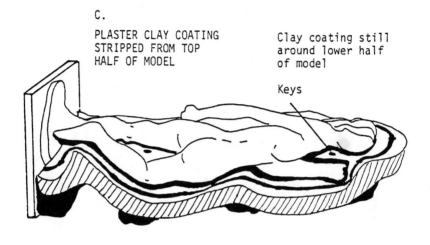

D.

POUR CMC INTO CENTRAL
FUNNEL RISER TO SEE
HOW FAR IT HAS FILLED
MOLD BY ITS HEIGHT ON
SIDE RISERS. BE
SURE TO SEAL AROUND
MOLD WITH WAX AND STRAP
MOLD

Wire banding
holds mold
together

Plaster

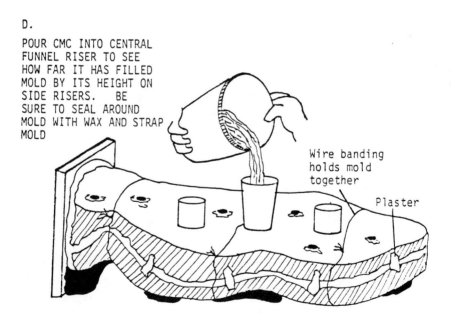

FIGURE 28B. TWO-PART CMC OR RTV AND BACKUP MOLDS

55

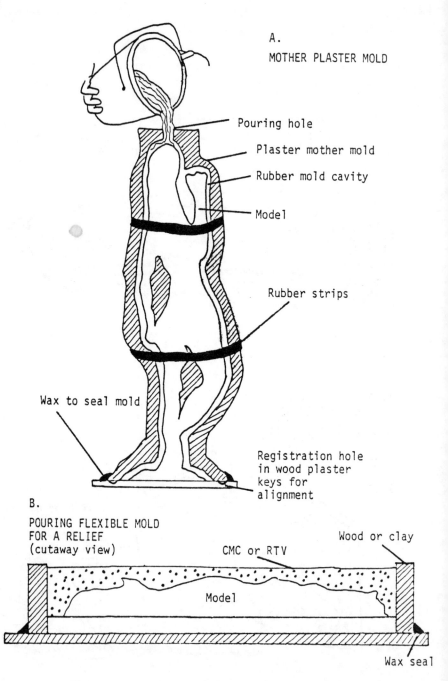

A.
MOTHER PLASTER MOLD

Pouring hole

Plaster mother mold

Rubber mold cavity

Model

Rubber strips

Wax to seal mold

Registration hole
in wood plaster
keys for
alignment

B.

POURING FLEXIBLE MOLD
FOR A RELIEF
(cutaway view)

Wood or clay

CMC or RTV

Model

Wax seal

FIGURE 29. ONE-PART (KNIFE CUT) FLEXIBLE MOLD

is again sealed with clay or wax along the parting line. Then bind the backup mold securely with rope, string, tape, or preferably strips of rubber inner tubes; invert the mold and fill it with wax. Remove the mold when the wax has hardened, and do any surface retouching work required on the wax.

Vinyl Hot Pour

Another popular medium in mold making is called hot pour. It is a vinyl base material, usually worm-like in shape with a soft spongy texture at room temperature. Hot Pour #50 is one of the popular materials but various manufacturers may label it differently, and most give complete instructions on its use. These instructions should be followed explicitly. As the name indicates, hot pour is applied in its melted state, which normally is between 340°F. and 360°F.

Like other mold materials, hot pour has both advantages and disadvantages. It is inexpensive, it can be used immediately upon cooling, and it retains accurate detail through several wax castings. It can also be remelted and used numerous times.

The disadvantages of hot pour are the numerous steps and equipment needed for completion of the mold, and the fact that it cannot be used to make a mold of patterns made or wax or oil base clay such as plasticine because of their low melting tempertures. If it is used on either plaster or stone, a vacuum machine is usually needed in order to get accurate surface reproduction.

As with the other flexible mold materials, the pattern should be sealed and coated with a mold release such as wax or silicone. If a piece mold is to be made, the model may be divided into sections and poured individually. If a two dimensional or simple relief model is used, it can be placed in a container that is then filled with the liquefied hot pour.

To prepare the hot pour material, a double boiler is almost essential if a professional melting pot is not available. The material must be heated to a pourable liquid state of approximately 350°F. To do this in an oven takes a long time, and you should not attempt to melt the hot pour material in a single container placed directly over heat such as a gas or electric burner.

Mineral, heating, or cooking oil has to be used in the bottom of the double boiler, because water at the boil temperature doesn't give off enough heat to melt the material to a pourable state. Lining the top of the boiler with aluminum foil will keep it clean for future use.

After the pattern is prepared for molding, gradually add and melt enough hot pour material in the top of the boiler to cover the pattern. Stir the melting material slowly, being careful not to entrap air bubbles. Then with a rubber spatula, tongue depressor, putty knife or other thin flat instrument, ladle the melted material over the pattern and, as excess molding material drops to the base of the pattern, ladle it back over the top of the model and all high points to assure uniform thickness.

During this period, you should also pass a heat lamp over the molded surface of the pattern several times to draw bubbles that may form on the face of the pattern--and therefore destroy some surface fidelity--to the outer surface of the mold.

The hot pour material should be built up to a thickness of 1/2 inch or more, then allowed to cool and solidify at room temperture for 20 to 30 minutes. The resulting mold is thick and rigid enough that a backup mold is often not necessary.

If it is a piece mold, merely coat the dried edges of the mold with a release agent such as silicone before the second section of the mold is poured. This allows the halves to be easily separated after cooling.

Gelatin and Moulage

These molds are relatively inexpensive, and are similar in preparation and pouring to the vinyl hot pour.

There are two types of gelatin molds. The agar type is derived from marine algae. It comes in solid form, dissolves in hot water, and may be applied in its liquid form at 110°F. to 120°F. It hardens at slightly above body temperature. Agar has been used since the turn of the century and is popular in law enforcement because it can be used as a death mask mold. Artists have developed its use in making negative molds of life sculpture. It may be applied to any area of the body without harm. After the inner surface of the mold is sprayed with silicone mold release, either plaster or wax may be poured into it as long as only a few reproductions are required. This mold normally needs a thickening or strengthening agent and some type of preservative. The manufacturer's instructions should be followed precisely.

The other type of gelatin mold is an animal extract called Collogen. It normally comes in sheets, flakes, or powder and some types have to be saturated in water overnight before heating in a double boiler. Its pouring temperature is close to the agar type. The finished mold often requires a coating of alum to strengthen the mold's texture.

Moulage is a contemporary ready-prepared gelatin mixture. It merely has to be placed in a double boiler and heated before use. This product can have an alginate, wax, or vinyl base. Again, the manufacturer's instructions should be strictly followed.

Relief molds can be easily made with gelatin, and so can piece molds using either a clay or shim divider.

It is always necessary to apply a backup mold because the gelatin materials are fragile and require maximum support.

IV

Ceramic Shell Casting

Although the principle of lost wax casting is thousands of years old, the materials and equipment used for casting have evolved from crude forms to the space age. The most revolutionary medium for casting virtually any known metal is ceramic shell. Its innate properties allow precision casting of the most intricate shapes to close tolerances and with exceptionally fine surface finishes.

Prior to the second world war, industrial scientists found that sodium could be removed from sodium silicate by ion exchange, thus producing silicic acid and then colloidal silica. This silica was originally used as a clarifier in treating water. The gels formed from the solution would trap and settle the sediment. Soon colloidal silica was found to be an excellent binder for refractory powders and materials such as alumina, silica and silicates such as clay, mullite, talc, mica, fosterite, and zircon.

This colloidal silica normally is a colorless, slightly opalescent liquid containing particles of silica held in suspension. The particles are so small that millions are contained in a single drop of the chemical. According to one manufacturer, a single gram of liquid may contain enough of these microscopic silica particles to cover a surface area of a thousand square feet or more.

The action of these microscopic silica particles upon each other and upon refractory powder it is mixed with results in a mold material that is strong and light in weight, with an extremely smooth surface and a low coefficient of thermal expansion.

Within the past 25 years numerous companies such as Nalco, Monsanto, Dupont, Stauffer, Ransom & Randolph and others have done extensive research in producing various types of colloidal silicas and refractory grains that will produce precision castings. During the last 10 years these materials have been used extensively in the production of precision parts needed for aircraft and space exploration.

THE VIRTUES OF CERAMIC SHELL

The artist and craftsman benefit greatly from modern ceramics research. With the ceramic shell method, you can cast both large and small lightweight molds in practically any metal from aluminum to stainless steel. For the artist, ceramic shell has many advantages over the old type of monolithic mold:

One advantage is weight. A wax model invested in a traditional mold weighing, say, 100 pounds, can be invested in a ceramic shell mold weighing 10 pounds or less when completed. Monsanto found that a 24-inch pattern setup that weighed 19-1/2 pounds with a ceramic shell mold would have weighed 318 pounds if an old-fashioned solid mold for the same setup were to be made.

A second advantage is that no special flask or steel ring is needed to contain the wax pattern or investment. In ceramic shell casting, the wax sculpture is alternately dipped in a slurry mixture and covered with a refractory grain powder until the shell is 1/8 to 1/2 inch thick. Except in special cases which we will discuss later, no special reinforcement of the mold is necessary.

A third advantage in shell casting is that relatively few sprues, vents, or gates are required. For most castings, a large entry cup with from one to three large sprues are usually all that is required. For small uncomplicated castings, it is often unnecessary to have any vents since the porosity of the shell material allows air and other gases to escape. In contrast, a solid investment mold would require a model to have intricate sprues, vents and gates attached to it. Figure 30 illustrates this difference.

A fourth advantage is that hollow core castings can be made simply by coating the inside of the model with slurry and refractory grain at the same time the outside surface is coated. By contrast, in the solid investment casting of a hollow core model, pins are shoved through the wax model into the hollow core, and the core material is poured into the cavity. After the casting is completed, this core is broken away and the core pins that held it in place are cut off and chased into the surface. In cases where there are blind holes inside a core of a model, a special quick-drying core material for ceramic shell that we have developed should be used, as discussed later in this chapter.

A fifth advantage of ceramic shell casting is the short burnout or dewaxing time. The dried ceramic shell may be fired and dewaxed in a pre-heated kiln and ready for metal to be poured into it within 45 minutes. The burnout for the same model invested in a traditional

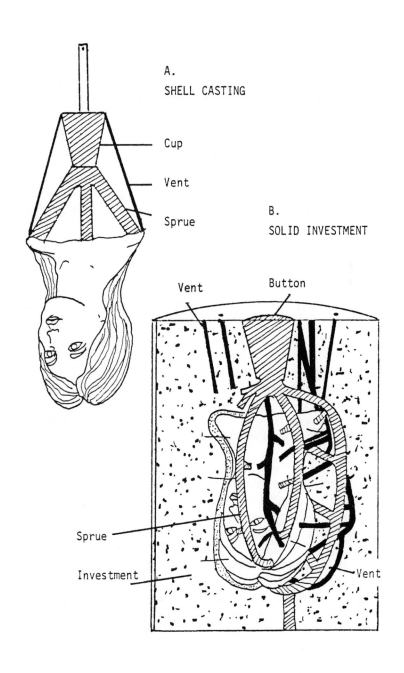

A.
SHELL CASTING

Cup

Vent

Sprue

B.
SOLID INVESTMENT

Vent

Button

Sprue

Investment

Vent

FIGURE 30. SHELL VERSUS SOLID INVESTMENT

mold would require one to three days and considerably more gas or electricity.

A sixth advantage is that a ceramic shell normally needs support only in the upright position when any metal, even stainless steel, is poured into it. On the other hand, a clay, sand, or silica mold is often packed in a sand pit before the metal is poured and requires a considerably longer time to cool.

A seventh advantage of ceramic shell casting is cleanup. Shortly after the metal has solidified, the thin ceramic shell partially cracks and falls away from the surface. The remainder is fairly easy to remove by means of sandblasting and conventional tools such as hammers and chisels. On the other hand, the solid investment requires not only a longer cooling period but possibly more time in breaking the casting from the investment and cleaning the model for final finishing.

One last major advantage to ceramic shell casting is final finishing. Since fewer sprues or vents are needed, less time is required in sawing, cutting, or grinding these unwanted appendages from the casting's surfaces.

Yet a few more virtures of ceramic shell casting should be mentioned. It allows a wide range of casting weights, from 1/4 ounce to more than 100 pounds, and up to three feet or more of length. Some foundries are obtaining excellent results in making life size pieces in a single pour, but the artist usually will prefer to make larger castings in sections, then weld the sections together. Intricate pieces are easily cast, surface reproduction and finish are excellent, and distortion is minimal even in large shapes. Ceramic shell not only meets but often surpasses the dimensional tolerances established by the Investment Casting Institute. Also, because of the rapid cooling of ceramic shell, the castings have a finer grain structure which allows for a smoother and structurally sounder casting.

Unfortunately, most of the bulletins written by producers of ceramic shell materials are so highly technical that normally only engineers, scientists, and technicians seem able to interpret them. Undoubtedly this discourages the artist or craftsman who would like to do shell casting, yet feels that extremely sophisticated foundry conditions are needed.

We hope to disprove this myth by clearly describing simple and accurate procedures for ceramic shell casting that can be done economically in a home-built foundry and certainly in a college or commercial foundry.

CERAMIC SHELLING PROCEDURES

As previously mentioned, the basic substance that makes it all work is colloidal silica, which is microscopic silica held in liquid suspension. When a fine refractory powder or "flour" (normally 300 to 400 mesh) is added to this liquid colloidal silica in the proper proportion, a rather viscous mixture or slurry is formed. The model is alternatively dipped in the slurry (see Figure 31 and 32), then sprinkled completely with a refractory stucco (see Figures 33 and 34). As the shell dries, the water in which the silica is suspended evaporates, causing the microscopic particles to merge closer together and bond with the refractory powder. The number of slurry and stucco coats needed depends ont the size of the piece-- usually six coats to build a shell of 1/8 inch or more around small pieces, eight coats for larger pieces, and twelve coats for very large pieces whose shells should be at least 1/2 inch thick all over to withstand the stress of the poured metal.

This is the basic method, but there are details you should know in order to prepare a strong, clean shell to receive the molten bronze or other metal. Therefore, we give below, step-by-step, the best practices in our experience of shell casting. Later we describe in more detail the preparation of the slurry and stuccos, and the choices you have in materials and equipment.

FIGURE 31. SLURRYING SMALL PIECES

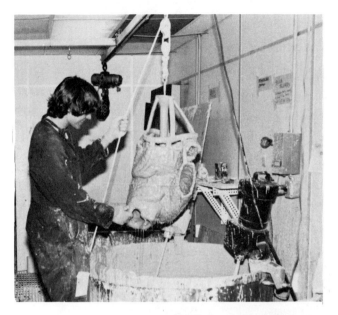

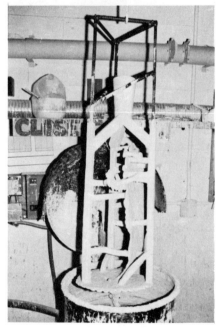

FIGURE 32. SLURRYING LARGER PIECES

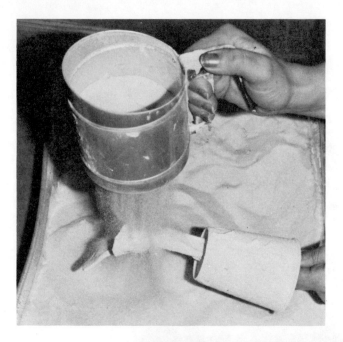

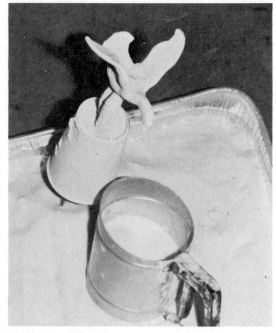

FIGURE 33. HAND STUCCOING

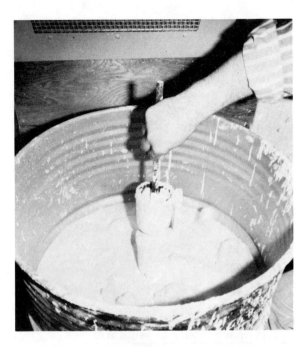

FIGURE 34. STUCCOING WITH FLUIDIZED BED

1. <u>Inspect the wax sculpture.</u>

 Fill any cracks that may have developed be-
 cause of distortion from heat where the wax
 was stored, and make sure the sprue system
 is strong, with well-seamed joints. On small,
 slender wax pieces, a small (1/4-inch) hole
 drilled through the wax lets in the ceramic
 material which then acts as a core pin:

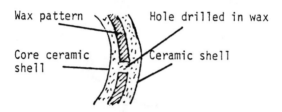

Wax pattern Hole drilled in wax

Core ceramic Ceramic shell
shell

2. <u>Clean and prepare the wax sculpture.</u>

 For pieces of average size and complexity, be
 sure the wax piece, including the spruing, is
 free from dust, then shellac it with a 50/50
 mixture of regular orange shellac and shellac
 thinner. Do not let the shellac form any
 puddles; allow it to dry thoroughly before
 applying the first coat of slurry and stucco.

 For very detailed, small pieces, clean (etch)
 the wax with trichloroethane, then spray it
 with a debubbling agent such as Ultrawet 60L
 (10 percent) in silica binder (40 percent) and
 water (50 percent)--or a jewelry surface tension
 reducer (liquid)--just before the first slurrying.

3. <u>Apply first slurry and No. 1 stucco coat.</u>

 Submerge the model, including the sprues, for
 15 to 25 seconds in the slurry, remove and
 allow it to drip for 10 to 20 seconds, revolving
 it slowly to avoid lapping or sluffing. Break
 any apparent bubbles with a toothpick or other

fine point and, if you have the equipment, give the whole surface a light air blast to remove any other bubbles. (If the model is very intricate, it is better to brush on the first coat of slurry so as to minimize the risk of bubbles.) Sprinkle all over with a refractory stucco of about 80 grain size (what we call No. 1 stucco). For very fine detail, a zircon 100/150 stucco is recommended for this first application.

If the piece is of average complexity, allow it to dry for about 30 minutes, preferably in a place with good air circulation, temperature about 75°F. to 78°F., and humidity between 25 and 75 degrees--30 degrees is ideal. If the piece has very deep indentations where the slurry can gather, allow it to dry for an hour or longer; otherwise the shell may remain damp in these areas and cause imperfections in the metal cast. A squirrel-cage blower may be used to speed the drying.

4. Apply second slurry and No. 1 stucco coat.

After the first drying period (half an hour for the average piece), dip the piece again in the slurry and sprinkle with No. 1 stucco as above. Although some sculptors and manufacturers recommend allowing each slurry/stucco layer to dry completely--for an hour or more--before the next coat is applied, our experience shows that the inner layers seem to bond better together if they are still a little damp at the next application. However, we repeat that a piece with deep indentations should be given a longer drying time.

5. Apply third slurry and No. 1 stucco coat.

Follow the procedure in Step 4 above for the slurrying and stuccoing.

6. Apply liquid colloidal silica binder.

After the third slurry/stucco coat, either (a) brush or spray on the liquid colloidal silica binder until it starts to run off, showing that no more can be absorbed, or (b) submerge the piece in the liquid for 20 to 30 seconds. Allow to dry for only about 1 to 2 minutes before applying the next slurry/stucco coat.

This dipping or spraying with the pure binder laminates and strengthens the first three layers of slurry/stucco and thus helps assure fine detail, and no breaking through of the metal in the casting. Some manufacturers recommend the application of the liquid binder between each slurry/stucco coat but this in an expensive procedure that does not, in our experience, add much to the shell's strength.

7. Apply fourth slurry and No. 2 stucco coat.

Again, do not let the previous slurry/stucco coat dry for more than 30 minutes or so unless it has deep indentations. Then follow the procedure above but with a coarser refractory stucco--about 40 grain (No. 2 stucco, we call it here).

8. Apply more coats of slurry and No. 2 stucco.

To assure strength that will stand up to the molten metal, the ceramic shell for a small casting needs to be at least 1/8-inch thick and for a large casting, at least 1/2 inch thick. You can determine the thickness by filing or scraping down to the edge of the styrofoam or other material used as a pouring cup. Each of these secondary or buildup coats of slurry and stucco should be allowed to dry thoroughly to maximize the shell's strength. Drying may

take from an hour to a day, depending on the size and complexity of the piece and on the air circulation, temperature, and humidity. When thoroughly dry, the shell is an off-white color. It is then ready for the next backup coating of slurry, followed by the stuccoing and another drying period.

9. Seal with liquid colloidal silica binder.

 Completely soak the shell with the liquid binder, as in Step 5 above. Allow it to drain for no more than 3 minutes.

10. Apply last coat of a slurry, do not stucco.

 You finish the actual building of a ceramic shell by dipping it once more in the slurry mixture. Do not stucco it, however, for this stuccoing would not add to the shell's strength and the layer of stucco would risk con- tamination of the molten metal during the pour.

Optional Coating

By micro-venting, you can encourage gases to escape during the pour and also make the shell easier to break away from the metal. However, micro-venting can also weaken the ceramic shell.

Micro-venting is usually done at about the fourth coating of slurry: in places where gases are likely to be trapped during the pour, you pat on with your hand a layer of very small polystryrene beads or small shreds of hemp (just unravel a bit of rope for the hemp). See Figure 35.

Vermiculite is sometimes used for quite another purpose, on the button or cup: it will keep the molten metal hotter for longer during the pour. The vermiculite should be applied over the sixth or seventh coating of slurry.

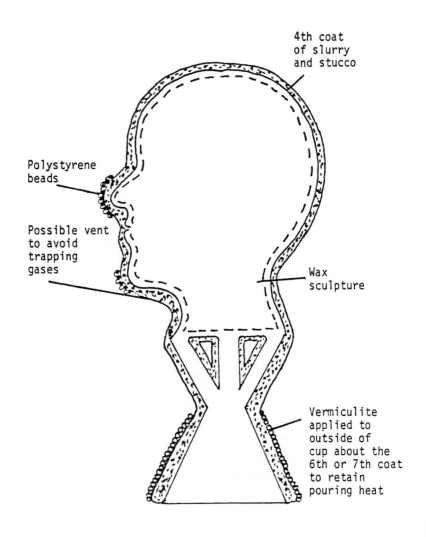

4th coat
of slurry
and stucco

Polystyrene
beads

Possible vent
to avoid
trapping
gases

Wax
sculpture

Vermiculite
applied to
outside of
cup about the
6th or 7th coat
to retain
pouring heat

FIGURE 35. MICRO-VENTING

REINFORCING THE SHELL

On some occasions, a ceramic shell may need reinforcement beyond the strength given by thorough drying of the normal slurry/stucco coatings and the two applications of the liquid colloidal silica binder. (See below for advice on drying.)

Each coating greatly increases the overall strength of the shell so, for large pieces, be sure that you apply enough coats to build up a thickness all over of at least 3/8 to 1/2 inch. If the piece is very large, you may want to wrap stainless steel wire around it, with the strands about 2-inches apart, after the fifth or sixth coat of slurry: see Figure 36.

If the piece has an extensive flat surface or appendages that are liable to crack during the pour, you can add strength by dipping pieces of fiberglass cloth in the slurry and applying them to the areas of stress. Again, such reinforcement is best applied after the fifth or sixth slurry dip.

Also, a very small hole may be drilled in any area that will be subjected to great stress and pressure during dewax. After the dewax, this hole is then filled with a bit of wax and covered with a slurry-like putty mixture before the metal pour. The refilled hole should be allowed to dry at least one hour before refiring (the putty mixture is made with slurry and No. 1 stucco).

Do not forget the final dipping or coating in the liquid colloidal binder to bond the layers, followed immediately (before drying) with a final sealer coat of slurry without stucco. This final slurry coating not only prevents particles of stucco from contaminating the molten metal at the time of pouring but also increases the shell's strength.

Note: If your model is made of styrofoam instead of wax, wrap wire around the shell after the fifth or

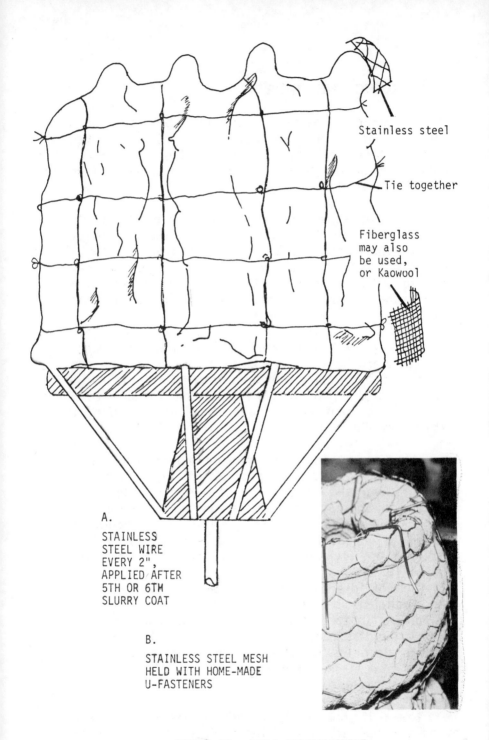

Stainless steel

Tie together

Fiberglass
may also
be used,
or Kaowool

A.
STAINLESS
STEEL WIRE
EVERY 2",
APPLIED AFTER
5TH OR 6TH
SLURRY COAT

B.
STAINLESS STEEL MESH
HELD WITH HOME-MADE
U-FASTENERS

FIGURE 36. SHELL REINFORCEMENT

sixth slurry/stucco coating to help the shell withstand the expansion of the styrofoam when it is flashed out at high temperature.

DRYING THE SHELL

The drying rate of a shell made from liquid colloidal silica is controlled by the temperature, humidity, and the velocity of the air around the shell's surface.

The green strength of the shell--its strength before it has been fired--is highest immediately after the shell buildup is complete, and decreases with drying time. The rate and amount of drying necessary before dewaxing depends on the size and configuration of the shell and the drying technique used. In general, however, the faster the drying rate, the stronger the shell.

An easy way to speed up drying is simply to get the room temperature up to somewhere between $75^{o}F.$ and $78^{o}F.$ However, you shouldn't increase the temperature too much because of the low melting point of the wax and the large difference in expansion coefficients of wax and ceramic shell, which can cause the shell mold to crack.

Very high air velocity may result in a loss of ceramic material from the mold surface. Very low humidity may result in uneven drying between flat areas and curved parts of the shell, casuing it to crack. Thus, there are limits on how hot, dry, and fast-moving the air around the shell should be.

It is helpful to consider that each slurry coat dries in two distinct stages. First there is a period during which there is an even rate of evaporation. The surface is thoroughly saturated and the rate of transfer of moisture by capillary action from within to the surface is at least equal to the rate of evaporation at the surface. However, at a point, the capillary action cannot move the diminishing concentration of moisture to the surface at as fast a rate as evaporation is occurring at

the surface, whereupon the rate of surface evaporation starts to decline.

The disposition of slurry particles at the surface immediately after the dip is illustrated in Figure 37A. The change that takes place in the second stage is shown in Figure 37B: when the loss of moisture to evaporation has drawn the refractory particles closer together, it is more difficult for the internal moisture to come through to the surface. At this point, surface moisture is quite low, while the level of moisture below the surface remains relatively high and the rate of sub-surface drying slows considerably.

With additional coats of slurry and stucco, the drying process slows down. The liquid from fresh slurry applications is partially absorbed by the dryer previous refractory coatings, so that as the newly dipped piece is giving off moisture rapidly through evaporation at the surface, moisture is still moving in the opposite direction towards the wax/mold interface of the ceramic shell.

It is understandable that stresses develop in the ceramic shell mold in the second stage by its uneven cross-sectional drying. These stresses can cause cracking in the shell, particularly where diminished air circulation in recessed areas of the shell causes slower drying of those areas. Where rapid evaporation has cooled and shrunken the shell and wax pattern, upon re-warming the wax expands and can also crack the ceramic shell.

We have found that the best way of safely speeding up the drying process to increase the shell's strength is to use forced air fans, with air temperatures at 75^{o}F. to 78^{o}F. and humidity ideally at 30 degrees but definitely not below 25 degrees or above 75 degrees. For intricate pieces, air hoses can be run into the interior of the shell--see Figure 38.

MATERIALS AND MIXES

If you keep in mind the fact that there are just three ingredients--the binder and powder of the slurry

78

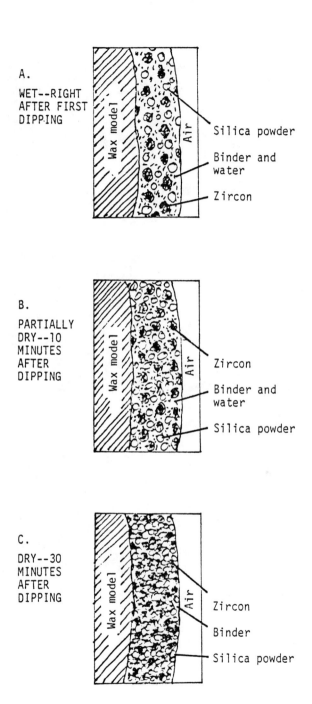

A.

WET--RIGHT
AFTER FIRST
DIPPING

Silica powder

Binder and
water

Zircon

B.

PARTIALLY
DRY--10
MINUTES
AFTER
DIPPING

Zircon

Binder and
water

Silica powder

C.

DRY--30
MINUTES
AFTER
DIPPING

Zircon

Binder

Silica powder

FIGURE 37. PROGRESSION OF SHELL DRYING

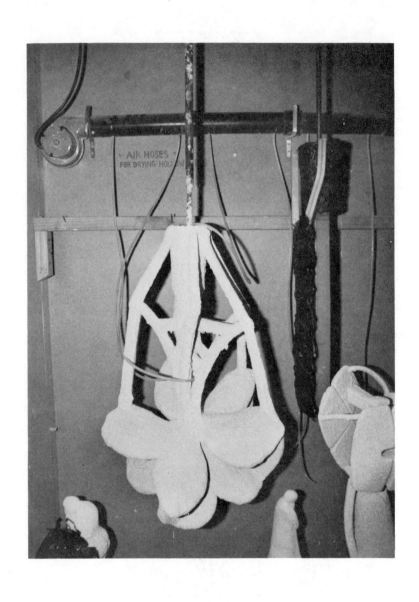

FIGURE 38. DRYING SHELL WITH SQUIRREL-CAGE BLOWER AND AIR HOSES

80

and the stucco sand--needed to make a shell mold, you will be less confused than if you try to remember the physical and chemical properties of each ingredient and how they react to each other.

Liquid Colloidal Silica Versus Ethyl Silica

First of all, the binders for liquid colloidal and ethyl silica are both commercially available, premixed, in either gallon or drum containers. In other words, you need not concern yourself with the chemistry of these special formulas. The solutions may be mixed immediatley with the appropriate slurry powders.

Some companies do produce colloidal and ethyl silicas in concentrated forms (primarily to eliminate excess shipping weight) which must be diluted according to the manufacturer's specifications. However, we do not advise the use of concentrated liquid silicas until you have become thoroughly familiar with the ceramic shell process.

Colloidal silica is a water-based binder and ethyl silicate is an alcohol-based binder. We would definitely recommend that anyone starting off in shell casting use the colloidal binder. It appears to create a stronger shell than ethyl silicate, it has a tank or shelf life of many months, and is much safer to use since it is without toxic vapors and is nonflammable. It is also less expensive than ethyl silicate and is easily obtainable.

Colloidal silica's chief disadvantage is that it takes longer for each layer of shell to dry and cure. Ethyl silicate dries rapidly because of the alcohol evaporation; often a backup coat can be applied within 45 minutes of the previous one when ethyl silicate is used. Ethyl silicate binder is used primarily by large foundries or sophisticated art studios where mass production and time factors are serious concerns.

There is no argument that much time can be saved with the proper use of ethyl silicate. Artist and teacher

Herk Van Tongeren of Johnson Atelier, Technical Institute of Sculpture went from an 8-inch wax sculpture to a bronze casting in 2-1/2 hours with the ethyl method. After working in a foundry for 15 months and using ethyl silicate, he perfected many techniques. Some of the problems and answers in dealing with ethyl silicate that he shared with us are set out below.

Because of its alcohol base, ethyl silicate evaporates quickly and is less stable. In other words, it is more difficult to maintain the proper slurry consistency. An accurate temperature control room is essential. If many pieces are to be dipped throughout a day, alcohol (isoproponol and anhydrous) should be added each morning and evening, and ethyl silicate binder added during the day. In order to keep the slurry stable over a long period of time, the rubber-lined steel holding tanks or large plastic tanks should have a water-cooled coil, either inside or outside, that will keep the slurry at the ideal temperature of 60°F.

The first coat of slurry for ethyl silicate should be rather thick. Using 50 percent zircon flour in the slurry mix, a 12 or 20 second viscosity measured in a #5 Zahn cup viscosometer is ideal for the first dipping. This thicker first coating allows time to break any surface air bubbles before stuccoing. The first stuccoing should be done by hand or rained on by some type of sifter. A wide screen flour sifter works well.

There are two methods of drying the ethyl silicate shell mold. The first and by far the best in relationship to shell strength is to allow it to air dry just as you would a colloidal silica binder. This usually may be accomplished in 30 to 45 minutes with good air circulation. The second method, which many production foundries use, is the rapid gel or ammonia set method. This is done by immediately placing the dipped and stuccoed sculpture in an enclosed chamber and exposing or charging it with ammonia fumes. The chamber is then purged of the fumes by exhaust fans or vacuums and the sculpture removed. The cycle of dipping, stuc-

coing and ammonia fuming is repeated immediately and as often as needed until the shell has reached desired thickness. Although this method is the fastest, the completed shell has a much weaker green strength than with the air setting method. After the desired thickness is obtained, it is best to allow the sculpture to dry overnight before firing to eliminate the wax and harden the shell.

Besides the trickiness of keeping ethyl silicate at the same consistency, there is a very real fire hazard when dealing with alcohol. The slurry tank must be well vented to prevent the accumulation of alcohol vapors and the tank must not be near any open flames. Flameproof motors and electrical switches that are properly grounded should be used.

Because of the many variables and safety requirements in dealing with ethyl silicate binders, it is wise for the beginning metal caster to stay with the more predictable colloidal silica until a good deal of experience has been gained.

Colloidal Silica Slurry Mixes

The basic slurry is a mixture of the colloidal silica liquid binder and a fine refractory powder such as fused silica, zircon, alumina, or clays.

Most companies that make colloidal silica produce it in various grades, referred to as colloidal percentages, that are usually indicated by a code number in the name. For instance, Nalco 1030 has a 30 percent dispersion of colloidal silica and the 1035 has a 35 percent dispersion. Dupont HS-40 has a 40 percent colloidal silica dispersion. Some companies, such as Dupont, also use letters indicating various factors of their particular solutions; for example, HS preceding the colloidal percentage indicates a high sodium stabilization level and LS indicates a low sodium level. These different types of dispersed liquid silicas are made for different casting needs but few if

any exceed the 40 percent available-silica level. The most commonly used is 30 percent.

Appendix A presents some formulas for the slurry. After you decide what type of colloidal silica you will use, you have to measure it and the powdered refractory material accurately, by weight, before mixing them. Then gently sift or sprinkle the refractory powder into the colloidal silica until it is totally absorbed. Avoid dumping large quantities of the powder to prevent it from lumping and sinking to the bottom of the tank. You can mix each new slurry batch by hand with a paddle or by electrical-mechanical means described later. In any case, you want to get the refractory powder suspended in the solution as quickly as possible.

To achieve accuracy of your final casting with a fine reproduction of the original detail, you must make certain that the slurry mixture is proportioned correctly, that is, the correct amount of powder in relation to the particular liquid colloidal silica.

Most manufacturers of colloidal silica as well as foundries that cast in ceramic shell recommend addition of a wetting agent to the slurry mixture. (Ultrawet 60L, which is produced by the Atlantic Richfield Co., is one of the popular wetting agents.) The purpose of a wetting agent is to allow the slurry mixture to coat the entire wax sculpture uniformly when it is dipped into the slurry. It prevents the slurry from pulling away and thus uncovering some of the wax pattern. This wetting agent should be added only after the slurry has been mixed for 15 to 30 minutes. Only a very small portion of wetting agent is needed--about one-third of one percent by volume, or roughly a tablespoonful to a gallon of slurry.

Do not be alarmed if bubbles rise to the surface when the wetting agent first goes into the slurry batch. The bubbles will slowly dissipate or you can hasten their removal by skimming the mixture with a spatula coated with a debubbling agent such as Antifoam B (a product of Dow-Corning). We do **not** recommend adding the

anitfoaming agent directly into the slurry tank since using too much of it could result in an inferior or weakened ceramic shell mold. If there is so much foaming that you do decide to add an antifoaming agent directly to the slurry, follow the manufacturer's suggestions or use only a few drops. Wait at least 15 minutes to see if defoaming occurs before adding any more of the agent.

Once the slurry is properly mixed, you have to keep it in suspension by stirring it about 3 minutes in every 15. As described later, a simple electric stirring motor with automatic timer is the easiest way to assure that the slurry stays in suspension.

A new batch of slurry mixture should not be used for a minimum of 24 hours in order to allow the fine refractory powders to be completely coated by the colloidal silica.

It is extremely important to minimize evaporation by keeping the slurry container covered when not in use. Because there is bound to be a certain amount of evaporation no matter how well the slurry is covered, distilled water should be added along with some of the liquid colloidal silica. We have had good results by adding approximately 8 ounces of distilled water and 4 ounces of colloidal silica per day to a 30 gallon mixture. As measured with a #5 Zahn cup, the viscosity of the slurry should be kept between 26 and 40 seconds, depending on the particular formula. In any case, follow the manufacturer's instructions.

Suitable equipment for mixing and storing slurry is illustrated later.

Stuccoing

The refractory grain stucco is sand-like in appearance and texture. Often it is the same refractory material that, in much finer form, is added to the binder to make the slurry, but it does not have to be the same

material as long as it is compatible with the colloidal material. Some of the common refractory stuccos are silica, fused silica, zircon, alumina, molechite, and calcine clay.

We have obtained some of our best results by using fused silica, zircon, or a combination of the two as stucco materials. However, they are expensive and excellent results can also be obtained if the more economical calcine clays such as Calamo (trademark of Harbison, Walker Refractories) or Ion Calcine (product of Interpace Corp.) are used in the slurry for the backup coatings. Appendix A includes names of available refractory materials and guidelines for their appropriate use.

Once you have decided which stucco material to use, you should obtain it in at least two grain sizes. For the early applications--the No. 1 stucco--a grain size of approximately 80 should be used. The secondary or backup stucco--No. 2--should have a coarser grain size of approximtely 40.

When doing intricate or fine detail sculptures, it may be beneficial to use a finer grain stucco, such as zircon 100/150, on the first one or two applications, followed by a coarser grain stucco for the remaining applications. This will produce accurate detail and satin-smooth finishes.

There are four basic methods of applying the refractory grain stucco to the wax sculpture that has been dipped in the slurry mixture and allowed to drain. The first and simplest method is to hold the dipped sculpture or model over a box and sprinkle the wet sculpture by hand with the stucco coating until it is so completely covered with a thin layer of stucco that it will not accept any more.

The second method is similar but the stucco is applied with a sifter, as illustrated earlier, until the piece is completely coated. A sifter with a No. 30 U.S. screen usually works well for the primary stucco with

a grain size of approximately 80; and a No. 16 U.S. screen size works well for the secondary coats if a grain size of approximately 40 is used.

The third method is to apply the stucco from an overhead rainer that is vibrated by mechanical or manual means to rain the stucco on the slurry-coated sculpture held underneath it.

The fourth method, the "fluidized bed" illustrated later, is used in many commercial foundries, art foundries and colleges, and by professional sculptors. The fluidized bed is basically a steel container, the bottom of which has a finely perforated screen that the stucco sits on. Below this fine screen is a second, closed container with an air hose and an off-on pressure control. When the pressure is turned on, the air flows evenly across the entire surface of the fine screen in an upward motion and the force of this escaping air lifts or floats the fine refractory stucco upwards. The wetted sculpture or model is gently lowered into the "fluidized" stucco and gains a complete and uniform coating as simply as it was coated with slurry.

A Quick-Drying Core Material

Ceramic shell is an excellent casting medium for most hollow core bronzes because you can completely cast both the outer and inner walls of the thin wax model with the same material and at the same time.

There are occasions, however, when it may be advisable to use a complete-fill core material in order to achieve the best casting results. This is especially true if the hollow wax model has an unusually uneven inner surface, with many nooks and crannies that may entrap air or not allow ceramic shell material inside the model to dry completely.

When using the core materials described below, do **not** rinse the ceramic shell with water, for the materials

will absorb that water and not dry out even if the piece is put in a kiln.

We have had excellent success with the following formulas for core materials used in conjunction with ceramic shell casting.

		Percent by Weight
Formula 1:	Satin Cast Investment (Kerr)	50%
	Refractory cement	49
	Chopped fiberglass (1/2 to 1 inch lengths)	1
Formula 2:	Casting Investment 903 (Ransom and Randolph)	50%
	Satin Cast Investment (Kerr)	25
	Refractory cement	23
	Chopped fiberglass (1/2 to 1 inch lengths)	2

Ransom and Randolph also market a complete-fill material (Investment 713) but we have not tested it.

With both our formulas, you mix the listed ingredients together, then make the dry mix into a pourable liquid by mixing it with about 80 percent water (distilled water if possible) and 20 percent liquid colloidal silica. Add the water first to the dry mixture and, noting the volume of water used, stir until it reaches a consistency close to unthinned latex paint. Then add about a quarter as much liquid colloidal silica as water and stir until

well mixed. The material will quickly start to set up to a yogurt-like consistency--but don't be alarmed, for you still have 10 to 15 minutes before it really sets up. Immediately scoop the material into the core and distribute it carefully throughout the core with a vibrator or rod.

Place the wax hollow core model on a support that is cushioned on the bottom--rubber matting or styrofoam beads work well--and carefully insert core pins through the wax (four to six are usually enough). Then insert a wax-coated steel rod into the core opening, supporting it if necessary with wax bars tacked to it and to the sides of the core opening. (The wax-coated bar is used to hold the model during the dippings and stuccoings.) Fill the core to the top with the complete-fill material and allow a drying time of 2 to 3 hours. The pouring cup, gates, and vents may then be attached to the model.

When the shell is dewaxed prior to the bronze pour, as described in the next chapter, the wax coating on the steel rod melts and the rod falls out of the hardened core. After the pour is made and the casting has cooled, the core material is broken away from the casting along with the ceramic shell material.

EQUIPMENT NEEDED FOR CERAMIC SHELL CASTING

Stuccoing Equipment

We have already illustrated a simple box and sifter for stuccoing and while we are on that subject, we describe below how to build a fluidized air bed similar to the one sketched in Figure 39.

1. Cut off a 30 or 55 gallon steel drum 12 inches from the bottom (the cut can be made with a gas cutting torch or an electric jig saw with a steel cutting blade).

2. Using the smaller (bottom) section as a template, place it on a piece of 3/4-inch plywood

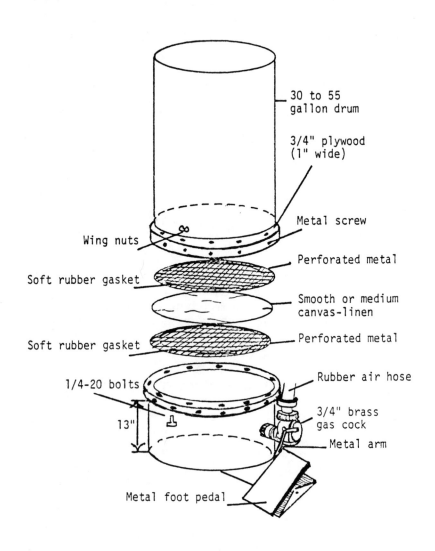

30 to 55
gallon drum

3/4" plywood
(1" wide)

Metal screw

Wing nuts

Perforated metal

Soft rubber gasket

Smooth or medium
canvas-linen

Soft rubber gasket

Perforated metal

1/4-20 bolts

Rubber air hose

3/4" brass
gas cock

13"

Metal arm

Metal foot pedal

FIGURE 39. PARTS FOR A FLUIDIZED BED

and draw a complete circle onto the plywood next to the edge of the outer steel wall. Using a 1-inch spacer as a guide, draw another circle an inch outside the first circle. With a jig saw, cut both the inner and outer lines. You now have a plywood ring or circle 1-inch wide and 3/4-inch thick. Make two of these rings (one will later fit onto the top part and the other onto the bottom of the cut drum).

3. Coat the inside edge of both rings with silicon glue and, with the drum pieces on a flat surface, place the rings over both the cut edges of the drum. Now drill (horizontally) holes about 1/8-inch in size through both the plywood ring and the steel drum. The holes should be placed about 3 inches apart around the entire ring. Screw sheet-metal screws through all the holes, locking the plywood rings to the cut edges of the steel drum.

4. In the lower or smaller drum section, drill a 3/4-inch hole about 2-inches from the bottom and braze or silver-solder a 3/4-inch pipe of 6 inch length, the outside of which has been threaded. This will later be used as the air inlet.

5. You will now need the following items: (a) two sections of perforated 16 to 18 gauge metal--the perforations should be about 3/16 inch in diameter and 1/8 to 1/4 inch apart, (b) one section of strong canvas--the type used for oil painting works well, (c) approximately 8 feet of foam rubber weather stripping 1/4-inch thick and 3/4-inch wide.

6. Cut the two perforated metal sections and the one canvas section the same circumference as the plywood-circles drum section. Place the first section of metal on the bottom half of the cut drum. Now place the foam weather

stripping around the metal, about 1/2 inch from the edge. Place the cut canvas over this weather stripping and then place the second perforated metal plate on top of the canvas. Put the large top half of the cut drum over the top plate. The two plywood sections, perforated metal plates, and canvas should all have a common edge: when they are all lined up, drill 1/4-inch holes about 4 inches apart through all these sections around the entire circumference. Use 1/4-inch lag bolts with washers and wing nuts to hold the two sections of the drum together. (Wing nuts allow the two sections to be tightened or removed easily.)

7. A gas or air off-on release valve should now be attached to the outer threaded end of the 3/4-inch pipe attached to the bottom of the drum. A foot pedal, either commercial or home-made, is attached to the off-on handle of the valve (a return spring makes operation of the valve easier). The air pressure hose is now attached to the valve assembly and the air pressure turned on to test for leaks; be sure to coat all threaded fittings with a pipe sealer such as pipe joint dope compound.

The amount of air pressure needed depends on the size of the drum, but 50 to 100 pounds of pressure is usually adequate. This can be tested by filling the drum 2/3 to 3/4 full of stucco material, then stepping on the foot pedal and seeing how far the stucco material lifts inside the drum. Adjust the air pressure until the stucco rises at least 2 to 3 inches.

If the amount of shell casting warrants it, two fluidized air beds should be made, one for the No. 1 stucco material and one for the No. 2.

Mixing and Storing Slurry

Three types of containers can be used to make

and store the ceramic shell slurry mixture. Each has the essential ability to agitate and keep the slurry mixture in suspension. If this is not done, the powder refractory material that is added to the liquid silica binder will drop to the bottom of the tank, forming a mass that is extremely difficult to return into suspension.

The three types of containers are: a stationary drum with a motor-driven shaft and mixing propeller (see Figure 40), a rotating drum with a stationary paddle mixer--a turntable mixer (see Figure 41), and a rotating closed tumbler (see Figure 42).

A stationary drum is normally 30 or 55 gallons in size, but any size can be chosen to meet individual requirements. No matter what the size, there are some essentials for proper maintenance of the slurry mixture. First, the lining inside the drum must resist corrosion and therefore should be either stainless steel--the stainless steel drum in Figure 41 started life as an Army soup container--heavy plastic, or heavy-duty rubber. The motor-driven shaft with attached propeller must also be corrosion resistant; normally stainless steel is used although new durable materials, such as special hard rubber and shock resistant plastics, have been used with success.

Various sizes of stainless steel mixing propellers, as well as plastic ones, are readily available at hardware or paint stores and at ceramic supply stores. The mixing propeller should be the minimum air entrapment type.

The Lightnin mixer (a trademark of Mixing Equipment Co.), with a reverse pitch propeller for refractory flour suspension, is one of the most popular mixers used for stationary slurry tanks. There are, however, many other good motors available. All mixing motors should be of the enclosed, moisture-proof type and powerful enough to turn the shaft and mixer at the proper RPM. The size of the shaft and propeller should be relative to the volume of slurry it must keep in suspension. Normally a minimum of 1/2 HP should be used, and the motor should be of the high torque, low RPM type.

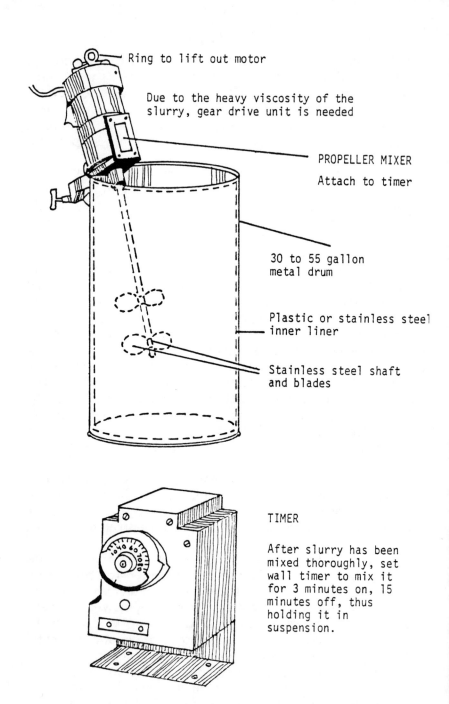

Ring to lift out motor

Due to the heavy viscosity of the slurry, gear drive unit is needed

PROPELLER MIXER

Attach to timer

30 to 55 gallon metal drum

Plastic or stainless steel inner liner

Stainless steel shaft and blades

TIMER

After slurry has been mixed thoroughly, set wall timer to mix it for 3 minutes on, 15 minutes off, thus holding it in suspension.

FIGURE 40. PROPELLER MIXER AND TIMER

B

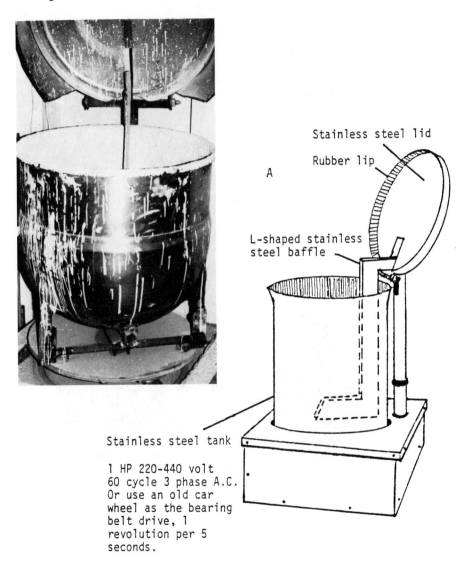

Stainless steel lid

Rubber lip

A

L-shaped stainless
steel baffle

Stainless steel tank

1 HP 220-440 volt
60 cycle 3 phase A.C.
Or use an old car
wheel as the bearing
belt drive, 1
revolution per 5
seconds.

FIGURE 41. TURNTABLE MIXER

A

B

FIGURE 42. TUMBLER MIXER

Since it is imperative that the slurry mixture be kept in proper suspension, the mixer motor must be hooked into a timing device that is pre-set to operate on and off during the required time: this period should be a minimum of 3 minutes on and 15 minutes off.

Being a water-based liquid, the colloidal silica slurry is subject to evaporation, which affects its composition and its ceramic shelling ability. It is therefore necessary to minimize this evaporation by covering the drum with a metal, plastic, or wood lid when the drum is not in use for dipping.

The second type of slurry container tank, the revolving type with a stationary paddle or baffle, is basically the same as the tank with propeller and shaft, except that the entire tank or drum revolves and only the paddle or baffle is stationary.

Many foundries and art academies using ceramic shell prefer the revolving tank, since it is felt that there is less chance of dry slurry buildup on the tank walls. Although this type of tank may be more involved to build than the stationary motor-driven propeller type, the innovative craftsman can fabricate it out of readily available materials such as a slow speed, high torque motor with a belt and pulley. The pre-made drum is usually readily available. The revolving platform that the tank sits on may be made from 3/4 inch plywood cut in a circle that is slightly larger than the diameter of the drum itself.

No matter how the revolving drum is made, it must be equipped with an electrical on-off timing device, as previously mentioned, and it must be covered when not in use to minimize evaporation.

Commercially available rotating drums with stationary paddles are very expensive. Normally they are out of the price range that the home founder can afford although it may be practical to obtain one if the volume of work or size of foundry dictates.

The third type of slurry container and probably the most practical and economical for the home founder is the tumbler type. This can be easily made, or bought at a moderate price. The tumbler container turns slowly until the slurry is thoroughly mixed. When you want to use the slurry, you lift the drum from the tumbler platform and set it on a table or bench. The wax model or pattern is either dipped in it or, if the model is too large, it may be held over the drum and the slurry ladled out onto it or brushed on.

If the tumbler platform is large enough, more than one drum can be used for the slurry. This type of slurry container is easy to make, economical to buy, and takes up little space. Another practical aspect is that there is relatively little or no evaporation from the tightly capped drum. A timer may be needed if the drum is to be used constantly over a long period of time. However, we have been successful in merely turning on the tumbler 8 to 12 hours before using slurry that has been stored in the well-sealed tumbler for some months.

The disadvantage of the tumbler type of slurry container is its limitation in size which poses some problems in coating large or unusually shaped sculpture wax models. However, as already noted, this disadvantage can be overcome by ladling, pouring, or brushing the slurry from the container onto the oversized or irregularly shaped sculpture.

Other Equipment

Air drying can be used for each slurry/stucco layer but if you have no suitable room space with good air circulation, temperature at 75°F. to 78°F., and humidity around 30 degrees, you can build the type of drying cabinet shown in Figure 43 to handle smaller pieces.

No other equipment is essential for making ceramic shell molds but you may want a heater to keep room temperature at the ideal of some 75°F. to 78°F. In

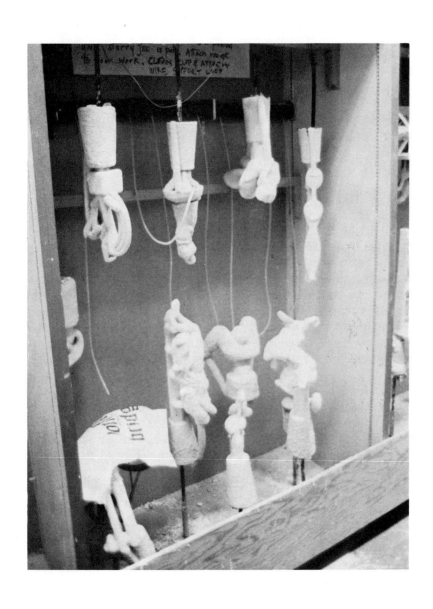

FIGURE 43. DRYING CABINET

some extremely dry areas, you may also need a humidifier to keep within the recommended humidity range of 25 to 75 degrees. A thermometer and hygrometer are obviously useful. So too may be a hydrometer to measure the specific gravity and a #5 Zahn cup to measure the viscosity of the slurry.

PROBLEMS IN CERAMIC SHELL

Although the making of a ceramic shell casting mold is simple and dependable compared with more traditional methods, it shares the sad fact that defects in the mold are often not observable until the metal has been cast and the defects are reflected in the surface. The mold itself cannot really be diagnosed--the symptoms do not show until the metal is poured, cooled, and inspected. Therefore, we recommend that you read the "diagnosing problems" section of our chapter on the melt and pour in order to foresee and avoid some of the possible problems with ceramic shell.

Here we simply repeat for emphasis some of our recommended practices for shell building:

1. Be sure that the wax piece to be shelled is not exposed to extreme temperature or dryness that could cause cracks, for the ceramic shell material will get into the cracks and result in metal breakthrough on the final casting.

2. Be sure the wax sculpture is thoroughly cleaned with trichloroethene, or carefully shellacked and dried, before applying the first coat of slurry. Definitely use shellac to seal any part of the original that is made of porous material such as cloth.

3. Take all possible precautions against the formation of bubbles or thin patches in the first slurry coat, for they will deface the metal's surface. With an intricate piece, it is often worth the extra time to brush on the first coat of slurry rather than dipping the piece.

4. Keep the slurry well mixed in a covered tank and check its viscosity two or three times during any day you are using it. For the first two applications especially, it is important that the slurry be not too thick or too thin. If the first coat is too thin, sharp corners in the original work may come out rounded in the metal casting, or the second coat of slurry may get under the first coat in places, and the lines of demarcation will show as "scabs" on the metal. If the second coat is thicker than the first, bits of the original coat may break away and pit the metal.

5. Let each slurry/stucco layer dry where there is good air circulation, temperature between 75^{o}F. and 78^{o}F., and humidity well within the 25 to 75 degree range--preferably 30 degrees.

6. Handle the shell gently, especially during the early coatings and dryings.

7. When in doubt, give the piece an extra slurry/stucco coat, reinforce stress areas with fiberglass, and, for a very large piece, wrap it with stainless steel wire or mesh.

V

Dewaxing

Dewaxing is one of the most important steps in preparing the shell for casting. The aim is to burn out every bit of wax from within the shell and to avoid any contamination or damage to the shell that might subsequently affect the surface of the bronze casting. Before we discuss actual techniques, we consider below some of the general problems you may experience in dewaxing of ceramic shell and how they can be prevented or corrected.

PROBLEMS IN DEWAXING

Because wax expands as it is heated, the pressure it puts on the inside of the shell can occasionally cause a crack. One easy way of minimizing this risk is to put the shell in a freezer for about an hour before it is dewaxed. The low temperature makes the wax shrink away from the shell; therefore when it is suddenly heated, there is more space for the wax to expand before it starts melting out of the shell. Another antidote to

localized pressures is to drill 1/4-inch holes through the shell.

If your original sculpture is made of styrofoam rather than wax, it must be entirely flashed out in a high temperature kiln: styrofoam expands rapidly with heat and therefore it must be burned out fast--within about 20 minutes at a heat of 1650°F. to 1800°F. Again, small holes made in the shell with a drill and 1/4-inch bit will let the gases from the burning styrofoam escape. These gases are toxic and therefore the flue and chimney system of the kiln must be in good condition to avoid risk. Reminder: styrofoam sculpture should be wrapped with wire after about the fifth or sixth slurry/stucco coating while the shell is being made.

The cracking of a ceramic shell during or after dewaxing is in practice not too important because the shell can easily be patched. If you find a small crack in the shell, you can simply putty over it with a paste made by mixing the slurry and the finer-grain stucco. Let the patch dry for 30 or 40 minutes and then, if you think still more strength is needed, cover the whole shell again with the slurry and allow it to dry. If a piece of shell has actually fallen away, you should cover the hole with sheet wax, then patch the piece back into place with the same paste mixture, then dip a piece of fiberglass cloth into the slurry and wrap it over the patched area for extra strength. Put the shell in a hot place--hanging over a kiln, for instance--to dry the patch, which may take up to three hours. Be very sure the patched area is perfectly dry so that it will not pop out when exposed to high heat.

DEWAXING WITHOUT A KILN

Although the kiln, several types of which we describe later, is the usual equipment for dewaxing ceramic shell, other methods can be used successfully, especially if the sculpture is small and relatively simple.

One of the cheapest and easily obtained pieces of equipment for dewaxing is a propane torch. The type

103

shown in Figure 44A has a rosebud tip. To prepare to use it, you wrap stainless or Nichrome steel wire around the shell and hang the shell cup down with two strands of wire from a wall bracket. Then light the torch and, holding it about 4 inches from the shell, move the flame evenly around the entire surface of the shell, starting at the bottom of the cup so that the wax can run freely from it. To avoid cracking the shell, the flame should not be held for more than a second or so in one place but rather moved steadily along. For most small sculptures, dewaxing with this method should be complete in about 15 to 20 minutes.

The propane torch method can be used in conjunction with a holding tank made of a 30 or 55 gallon drum with a small gas burner and a squirrel cage blower--see Figure 44B. Once the shell has been heated up with the torch, it can be hung for about 30 to 40 minutes in the tank, where the temperature should be about 300° to 450°F. (but no more than 500°F. or the wax will catch fire). Most of the wax can be retrieved in a pan or bucket under the tank.

Another simple way of dewaxing a small piece is in an ordinary household pressure cooker. Put no more than a pint of water in the bottom, set the shell cup down on the bottom rack, put the lid on, let the pressure build to about 10 or 15 pounds on the indicator, and allow about 15 minutes for the dewaxing. This and any other method using steam cannot be applied if there is pattern material other than wax, for such material will absorb the steam and will not dry out.

A more sophisticated machine is the autoclave, which provides steam pressure of 100 pounds or more per square inch. In the autoclave, the combination of pressure, heat, and steam will give complete dewaxing in about 30 minutes.

We have experimented with a microwave oven for dewaxing, first wetting the outside of the shell so that

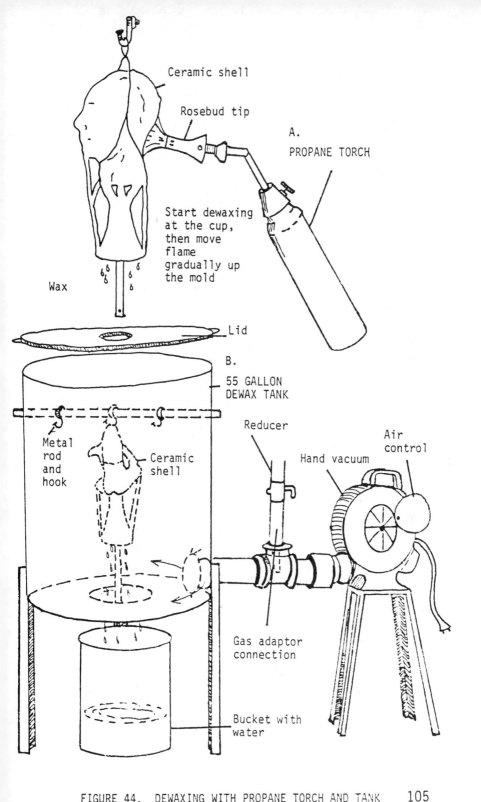

Ceramic shell

Rosebud tip

A.
PROPANE TORCH

Start dewaxing
at the cup,
then move
flame
gradually up
the mold

Wax

Lid

B.
55 GALLON
DEWAX TANK

Metal
rod
and
hook

Ceramic
shell

Reducer

Hand vacuum

Air
control

Gas adaptor
connection

Bucket with
water

FIGURE 44. DEWAXING WITH PROPANE TORCH AND TANK 105

the steam created within the oven would work on the wax. Although this method takes only about 2 or 3 minutes, we are not ready to recommend it.

Returning to more traditional methods, there is the gas/air furnace of the Speedy Melt type shown in Figures 45 and 46. For this you put loops of Nichrome or stainless steel wire around the piece and a hook to hang the piece from the metal holding rod. The piece should be held over the furnace while it is heating, then carefully lowered into the furnace and held there until the flashout is complete--about 10 minutes at a temperature of about 1000^{0}F. As with the propane torch, care has to be taken to prevent any part of the shell from overheating and cracking.

DEWAXING WITH A KILN AND HOLDING TANK

Second only to an autoclave, the best equipment for dewaxing a ceramic shell is a high fire kiln and a holding tank. Before getting into the details of the types of kiln you can buy or build, we summarize below the steps in dewaxing by this method:

1. Make sure the shell is completely dry: allow at least 12, and if possible, 24 hours for drying.

2. Bring the temperature of the kiln up to at least 1650^{0}F. (1800^{0} F. maximum) and the temperature of the holding tank to at least 300^{0}F. (500^{0}F. maximum).

 3. Wrap stainless steel wire around the shell and make a loop at the opposite end from the cup so you can:

4. Hang the shell, pouring cup down, from a hook attached to the end of a long metal pole.

5. Open the door of the kiln just enough to insert the shell.

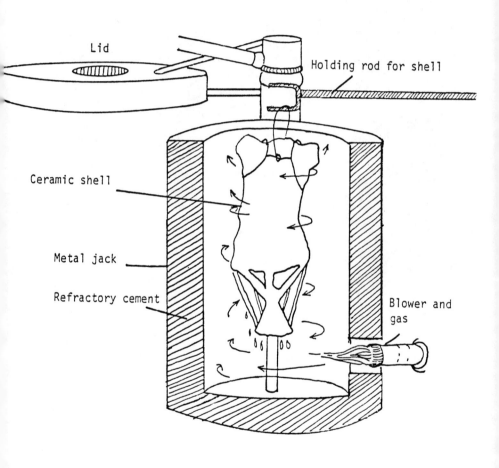

Lid

Holding rod for shell

Ceramic shell

Metal jack

Refractory cement

Blower and gas

FIGURE 45. OPERATION OF COMMERCIAL GAS/AIR FURNACE

107

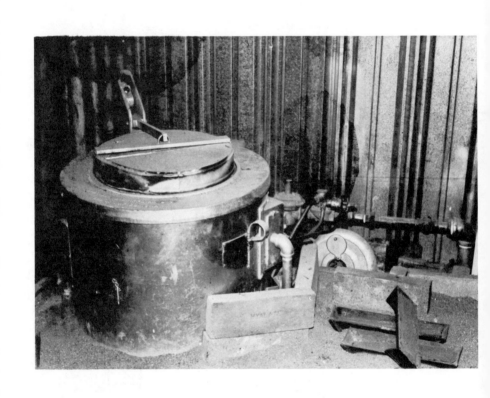

FIGURE 46. A COMMERCIAL GAS/AIR FURNACE THAT CAN BE USED AS A KILN

6. Keep the shell in the kiln for only 20 to 30 seconds, until you see the wax begin to drip from the cup, then:

7. Hang the shell in the holding tank for at least 30 minutes and up to 1-1/2 hours for complicated pieces. (Note: If the shell has a core made of styrofoam or wood or other organic material, it has to be left in the kiln at 1650^{o}F. or more for at least 3 hours to be sure the core material is burned out; do **not** put such shells in the low temperature holding tank.)

8. To be doubly sure that all the wax has melted out, put the shell back into the hot kiln for about 20 minutes.

9. Let the shell cool at room temperature.

10. If necessary, wash the shell out with water.

11. If available, use an airblower (at 50 psi pressure) to remove any sediment that may have been left behind inside the shell if the original slurry/stucco layer did not dry completely, and to remove any wax carbon if the kiln had a reducing rather than oxidizing or neutral atmosphere.

Once a shell has been dewaxed it can wait indefinitely for the pour but it should be wrapped in plastic to make sure that no dust gets inside that would subsequently contaminate the metal surface.

The steps you should follow in preparing the dewaxed shell for the pour are summarized later in this chapter, after the descriptions of different kilns.

CHARACTERISTICS OF KILNS FOR CERAMIC SHELL DEWAXING

A kiln for the ceramic shell process must be built very well because of the amount of thermal shock it is

going to take. The kiln door will often be opened when the atmosphere inside it is 1600°F. or as high as 2000°F., and therefore the stress on the metal, particularly the door and hinges, is very great. Compared with other kilns, a kiln for ceramic shell has to have stronger wall bracings. Many sculptors prefer a gas kiln over an electric kiln because the electric wiring would be constantly exposed to thermal expansion and soon wear out. If you use a gas kiln, there is no wiring to worry about.

You want a kiln that will heat up fairly rapidly and therefore it must be able to produce a good deal of heat quickly and to hold the heat. Remember that the faster you heat up a kiln, the greater is the thermal expansion and therefore the shorter is the kiln's life expectancy unless the kiln, expecially the metal framing, is made much stronger than usual.

Another factor needed for ceramic shell dewaxing is an oxidizing atmosphere (more oxygen than gas) or a neutral atmosphere (equal gas and oxygen), rather than a reducing atmosphere (more gas than oxygen). The sulphur emitted from a reducing atmosphere will sometimes permeate the shell and leave deposits inside it.

The Alpine Company makes a special kiln for ceramic shell work. Dickerson, Burt, Cressy, and other manufacturers also make good kilns that can be adapted to ceramic shell. If you do decide to use an electric kiln, several types are available.

A Raku gas kiln can be used for relatively small pieces. Another type of commercially-available kiln is made of refractory insulating material and fiberglass. It has some advantages such as light weight and few thermal shock problems, but it is costly compared with the home-made kilns described below, inefficient in holding heat, and not as sturdy as a brick kiln.

BUILDING A SMALL KILN

A home kiln can be built along the Speedy Melt principle, as illustrated in Figure 47. It is basically a

steel drum lined with traditional refractory cement or a "space-age" refractory blanket as shown in Figure 48.

We have had good success with a home-built kiln of open-bottom type shown in Figure 49. This kiln is usually square with a door or lid on top. The bottom is open and the entire kiln is raised on steel legs or bricks to a height of about 6 inches off the floor. This type of kiln can be made of fire brick or insulating brick (as in the photograph), or it can be lined with steel and space-age refractory material. The gas/air fuel mixture comes from one or more side burners with a small blower, or it may come from a burner at the bottom of the kiln. A steel tray with water is placed under the hole in the bottom of the kiln to retrieve most of the melted wax.

The ceramic shell is looped with steel wire (either Nichrome or stainless) as previously mentioned, and the kiln is fired to a temperature between 1650° and 1800°F. You then use a steel holding rod to lower the ceramic shell into the kiln--cup down, of course--and rest the bottom of the cup on steel bars or fire bricks. Be sure not to block the opening of the pouring cup. Now replace the lid.

Within a few seconds the intense heat of the kiln will permeate the thin walls of the ceramic shell and start the wax melting before it has a chance to expand and crack the shell. Instead of using a holding tank, you can leave the shell in this kiln until all the wax and carbon residue are burned out--usually 15 to 20 minutes is long enough for a small (12 to 16 inch) shell.

You can also use this sturdy kiln to hold a small mold for the pour (the melt and pour are described in detail in the next chapter). First, you turn off the kiln and, using heavy asbestos gloves, you invert the sculpture and rest it on fire bricks so that the lip of the cup is near the top of the kiln. Replace the pan of water

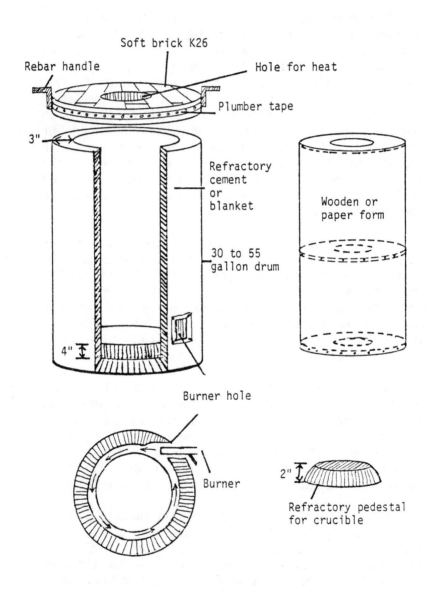

FIGURE 47. OPERATION OF HOME-MADE GAS/AIR FURNACE

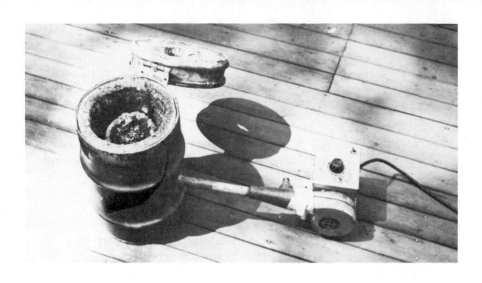

FIGURE 48. HOME-MADE FURNACE LINED WITH "SPACE AGE" REFRACTORY BLANKET

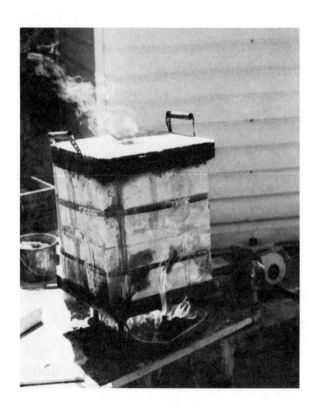

FIGURE 49. SMALL TOP-LOADING, OPEN-BOTTOM KILN--EASY TO MAKE

113

with a pan of dry sand, replace the lid, and refire the kiln until it reaches at least 1650°F. Then turn the heat off, remove the lid, and pour through the open top of the kiln. Any spills will be caught in the sand beneath the kiln. Small sculptures with intricate detail have been very successfully cast using this method because the shell loses little or no heat.

DESIGNING AND BUILDING A LARGER KILN

There are several good books available on how to build a kiln. Two of the best, in our estimation, are Daniel Rhodes' **Kilns: Design, Construction and Operation** (Radnor, PA: Chilton) and Frank A Colson's **Kiln Building with Space-Age Material** (New York, NY: Van Nostrand Reinhold). One of the crucial factors in kilns for ceramic shells is a high rate of heat generation--the Btu's (British thermal units) produced per hour. On this point, Rhodes emphasizes that you should have bigger or more burners rather than smaller or fewer burners. A downdraft kiln doesn't require as many Btu's as an updraft kiln--see Figure 50--but still you should be generous in the number and size of burners.

It is not our purpose here to repeat the good advice available in other books, but rather to highlight some of the important requirements in kilns for ceramic shell work.

Consider first the size of kiln you need. In a school or college situation, where several shells may be dewaxed at once, obviously a bigger kiln is wanted than in a home setting. An in-between size is shown in Figure 51. A large kiln is easier to build in a square shape. It need not be quite as wide as it is tall, yet it should have a good depth from front to back. You want a high ceiling in order to be able to place the shells at the end of their holding rods without risking direct contact with the kiln. Critical dimensions for the different parts of different sizes of kiln are summarized in Table 2. Most of the guidelines that follow assume a relatively large kiln--one with internal dimensions of 5 feet height, 5 feet depth, and 4 feet width.

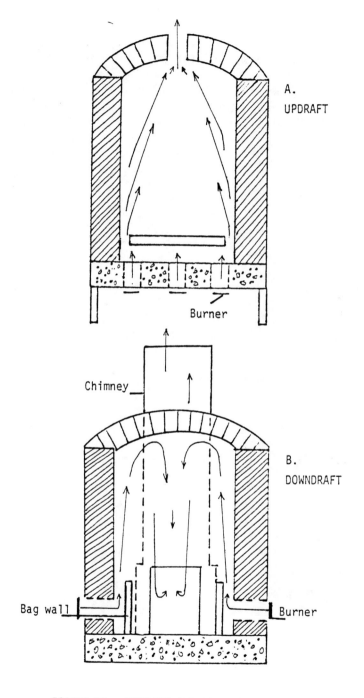

A.
UPDRAFT

Burner

Chimney

B.
DOWNDRAFT

Bag wall

Burner

FIGURE 50. UPDRAFT AND DOWNDRAFT KILNS

115

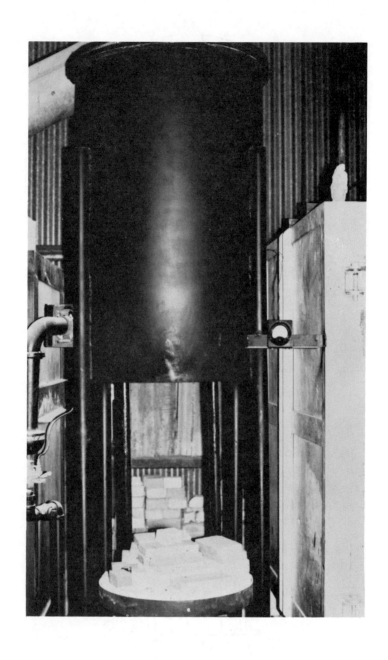

FIGURE 51. AN IN-BETWEEN SIZE KILN

TABLE 2. CRITICAL DIMENSIONS FOR GAS-FIRED KILNS

Size Inside (cu. ft.)	Number of Burners*	Area of Flue Opening (sq. in.)	Cross-Section of Chimney (in. x in.)	Height of Chimney (ft.)
Downdraft				
10	4	45	9 x 9	12
20	6	65	9 x 9	16
30	6	81	9 x 9	20
100	8	220	13½ x 13½	20
Updraft				
10	6	60	(a chimney is not needed but hood and vent are used to allow gases to escape)	
20	8	80		
30	10	120		
100	16	220		

* Each burner assumed to produce 15,000 Btu's. It is always
 better to have more/larger than fewer/smaller burners.

A basic design for a downdraft kiln is sketched in Figure 52. The stages in constructing such a kiln are:

1. Foundation

2. Floor

3. Walls

4. Metal bracing

5. Arch

6. Shelves and burners

7. Door

8. Chimney and damper

In small kilns, it may be better to assemble the metal bracing first and then build the walls within it.

Foundation

The foundation must be absolutely level. It can be made just with concrete or with cinder building blocks. If you use blocks, lay them with the holes up. You can cement the blocks together but this is not essential.

Floor

Hard brick (fire or refractory) is recommended for the floor of the kiln since such brick can withstand temperatures up to 3000°F. Mortar these bricks carefully over the concrete or cinder block foundation to assure a solid and level floor.

Walls

There are three choices of material for the inner walls: hard brick, insulating brick, and thermal blanket. We don't recommend the thermal blanket since it can be damaged easily.

118

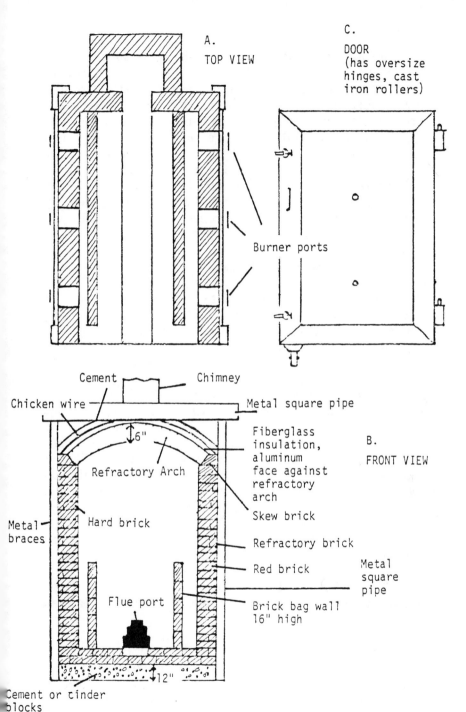

A.
TOP VIEW

C.
DOOR
(has oversize
hinges, cast
iron rollers)

Burner ports

Cement Chimney

Chicken wire Metal square pipe

6"

Fiberglass
insulation,
aluminum
face against
refractory
arch

B.

FRONT VIEW

Refractory Arch

Skew brick

Metal
braces Hard brick

Refractory brick

Red brick Metal
square
pipe

Flue port

Brick bag wall
16" high

12"

Cement or cinder
blocks

FIGURE 52. DIAGRAM FOR LARGE HOME-BUILT KILN

119

Insulating brick such as K26 (it withstands 2600°F.) can be used for smaller kilns but hard brick is recommended for the inner walls of larger kilns. Ordinary red or soft brick can then be used for the outer walls, with or without vermiculite between the two layers. Or the hard brick wall can have an outer insulation of asbestos sheeting or aluminum and fiberglass. These combinations are sketched in Figure 53B. Good insulation is important in a kiln: the bricks must heat up before they can provide the radiant heat required for the dewaxing, and loss of heat through the outer walls will make the process slow and expensive.

Each course of brick should be laid so that a brick covers the seam in the course below. Thus, you should start one course of bricks with a whole brick and the next course with a half brick. With the bricks overlapping or locking in this fashion, there is no risk of the kiln wall breaking straight down through a line of mortar.

After laying the first two courses of brick, apply a layer of mortar around the kiln floor where it joins the wall. In the next couple of courses, allow for the burner ports. Four-inch squares will usually accommodate burners large enough (say, 3500 Btu) for a 4-foot high kiln. (In updraft kilns, the burners are usually set into the floor rather than near the bottom of the walls.) In subsequent courses, leave a small gap between every second or third brick to allow for expansion when the kiln is heated. Use a level constantly to assure proper alignment of the bricks.

When figuring the number of bricks you need for the kiln walls, add about 10 percent to allow for trimming and breakage.

While building the side walls, you may want to mortar in some extra bricks to hold shelves at different heights for different sizes of sculptures, as shown in Figure 54. In a kiln 4 feet high, a large shell can be laid on a ceramic shelf resting right on the floor; for

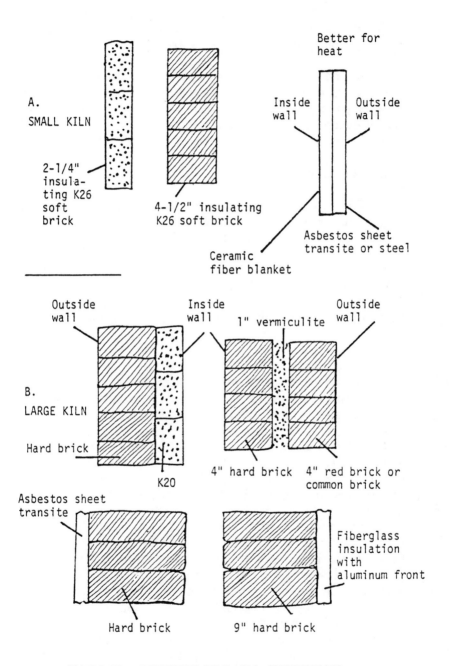

A.
SMALL KILN

2-1/4"
insula-
ting K26
soft
brick

4-1/2" insulating
K26 soft brick

Better for
heat

Inside
wall

Outside
wall

Ceramic
fiber blanket

Asbestos sheet
transite or steel

Outside
wall

Inside
wall

1" vermiculite

Outside
wall

B.
LARGE KILN

Hard brick

K20

4" hard brick

4" red brick or
common brick

Asbestos sheet
transite

Hard brick

9" hard brick

Fiberglass
insulation
with
aluminum front

FIGURE 53. DIFFERENT KILN WALL COMBINATIONS

medium-size pieces, another shelf resting about 16 inches up from the floor is useful; small pieces can be laid on the top shelf, about 36 inches from the floor.

We have found that an appropriate mortar for kiln walls is a mixture of two parts fire clay to one part grog or sand, mixed with water until it is a heavy paste. For greater strength, liquid sodium silica can be added: about 1 quart per 100 pounds of the dry mix.

Metal Bracing

To absorb the thrust of the arch and the expansion of the hot kiln, a strong metal bracing should be built around the walls of larger kilns.

For a kiln 5 x 5 x 4 feet inside, that is, 100 cubic foot capacity, with double-brick walls, we recommend 1/4- to 1/2-inch tie rods of high grade steel. For very large kilns, channel iron braces (buck stays) may be used.

Arch

With either a downdraft kiln or updraft kiln, an arched roof is needed to redirect the heat downward and help disperse it throughout the kiln.

A form of thin plywood or Masonite supported with 2 by 4s has to be built to support the arch during construction. The form should **not** be too strongly joined, for it has to be removed once the arch is complete.

Although the arch can be made of insulating brick, we recommend a high cast refractory cement for the basic material. Brick can be disassembled while the ceramic arch cannot, but brick is a little more expensive and, as can be seen in Figure 55, the skew bricks at the tops of the walls require tedious shaping if they are to fit well. Then at least two courses of brick must be laid, starting at the skew brick and ending when the keystone brick is inserted into the center gap.

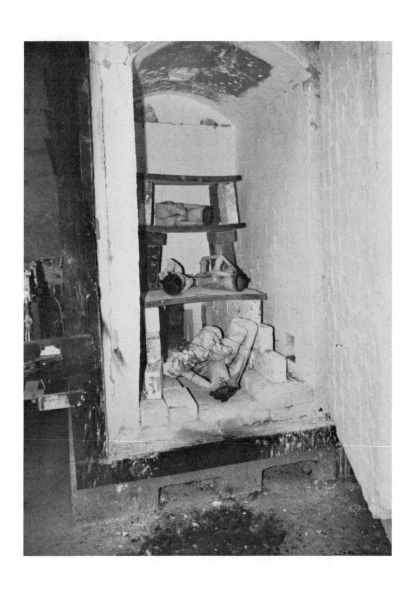

FIGURE 54. SHELVES IN KILN

123

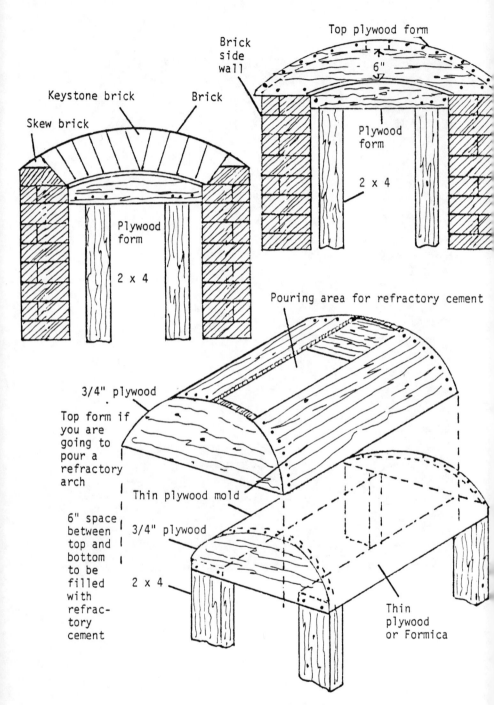

Top plywood form

Brick side wall

Keystone brick

Brick

Skew brick

6"

Plywood form

2 x 4

Plywood form

2 x 4

Pouring area for refractory cement

3/4" plywood

Top form if you are going to pour a refractory arch

Thin plywood mold

3/4" plywood

6" space between top and bottom to be filled with refractory cement

2 x 4

Thin plywood or Formica

FIGURE 55. KILN ARCHES

124

With a refractory cement arch, a plywood "roof" with curvature similar to the form has to be used to hold the cement in. No matter how well a refractory cement arch is made--and it should be at least 6 inches thick--it will tend to crack from the heat of the kiln. You should therefore build in a "crack" to allow for expansion by inserting a piece of mat board at the top of the arch while the cement is still soft.

Once the cement has hardened, the main form and the plywood roof are removed. Insulation can be improved by covering the outside of the arch with a thermal blanket of fiberglass with aluminum, for example. To protect this blanket, a thin layer of cement over chicken wire can be added to finish off the arch.

Shelves and Burners

The shelves for a kiln designed for ceramic shell work should be made of ceramic material such as silica carbide. They can rest on bricks mortared into or stacked firmly against the inside of the kiln walls.

The simplest type of burner, which you can buy commercially or (with care) make for yourself, is the atmospheric or Venturi burner. More efficient is the Alfred burner, and best of all--because of the good control it allows over the gas/air ratio--is a forced air burner. All three types are illustrated in Figure 56. When choosing and placing the burners, remember the basic requirements of a kiln for ceramic shell work: high heat production--a large number of Btu's per hour-- and an oxidizing or neutral atmosphere rather than a reducing atmosphere.

Remember also that the primary function of any kiln is to produce controlled heat. How heat enters the kiln and moves within it determine its success or failure.

Door

Along with strong bracing, the door is the most crucial part of a kiln for a ceramic shell work. For a

125

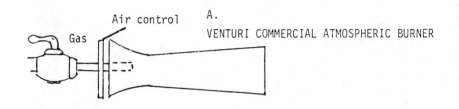

A.
VENTURI COMMERCIAL ATMOSPHERIC BURNER

Air control
Gas

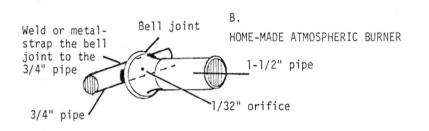

B.
HOME-MADE ATMOSPHERIC BURNER

Weld or metal-strap the bell joint to the 3/4" pipe

Bell joint

1-1/2" pipe

3/4" pipe

1/32" orifice

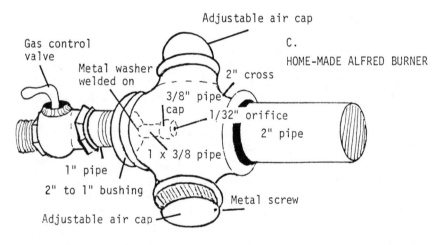

C.
HOME-MADE ALFRED BURNER

Adjustable air cap

Gas control valve

Metal washer welded on

2" cross

3/8" pipe cap

1/32" orifice

2" pipe

1 x 3/8 pipe

1" pipe

2" to 1" bushing

Adjustable air cap

Metal screw

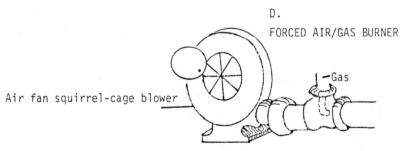

D.
FORCED AIR/GAS BURNER

Gas

Air fan squirrel-cage blower

FIGURE 56. KILN BURNERS

126

kiln 5 feet high by 4 feet wide inside we would use a door that is 5 inches higher and wider on the outside to assure good overlap with the kiln wall. A peep hole can be built into the door so that it does not have to be opened each time you want to see inside the kiln. The best material for the inside of the kiln door is a brick with high insulation properties, such as K26.

We strongly recommend using oversize hinges. Even so, they may warp slightly with the great heat, and the door will then tend to sag. To keep it from jamming, there should be good clearance around the inside of the door; and to relieve the stress on the hinges when the door is open, it should have a cast iron roller on the bottom. Figure 57 illustrates the need for these features on a large kiln door.

Chimney and Damper

The size (internal volume) of the kiln for ceramic shell work directly governs both the size of the flue opening and the chimney size and height. If the flue and/or chimney are not big enough, the kiln will produce a reducing instead of an oxidizing or neutral atmosphere. The appropriate sizes of flue and chimney for given kiln sizes have been shown in Table 2. It is better to be overly generous in the size of flue and chimney, and build a damper into the chimney if necessary. The bottom of the chimney--2-1/2 feet for a kiln 5 feet high--must be built of hard brick because of the intense heat from the burners at the bottom. However, the rest of the chimney can be made of 1/4-inch steel pipe, ceramic drain pipe, or other common materials.

SAFETY AND KILNS

Some safety practices for kilns are obvious: for instance, keep flammable material well away from the kiln and do not get your face too close to the peephole in the door. Not so obvious are the following:

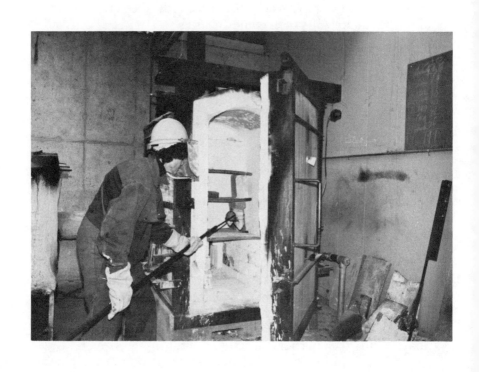

FIGURE 57. KILN DOOR

128

1. Protect the kiln from drafts that could blow out the burner flames, and be sure the kiln room is well-ventilated.

2. Do not use any gas piping that can provide more than 15 cubic feet per hour.

3. Test to see that loss of pressure between the gas regulator and the burners does not exceed 0.5 inches of water column pressure.

4. Test also to see that any automatic gas shut-off will turn off the gas within 20 seconds.

PREPARING THE SHELL FOR THE POUR

Before the actual pouring of the bronze or other metal described in the next chapter, you should:

1. Inspect the ceramic shell closely for cracks with a flashlight, and patch any cracks or reinforce any weak-looking areas.

2. Put the shell back into the kiln at 1650^{o}F. for at least one hour and preferably three hours, which will add to the shell's strength and burn out any impurities.

3. Remember that the heat will be higher at the top of the kiln than near the bottom, so bring the shell to the appropriate heat for the metal it is about to receive:

 -- For bronze and other copper alloys, from 1650^{o} to 1700^{o}F.

 -- For steel, from 1650^{o} to 2000^{o}F.

 -- For aluminum, from 300^{o} to 500^{o}F.

 -- For cast iron, just above room temperature.

VI

The Melt and the Pour

The foundry tasks are the most dangerous work for a sculptor, and indeed, many artists do not attempt the actual casting of their work. This chapter is written for those who want to see the ceramic shell method right through its many stages.

EQUIPMENT NEEDED

A full range of safety clothing is needed by a foundry person. As Figure 58 shows, it includes a safety face shield and helmet, asbestos gloves, a leather coat and apron, asbestos leg guards, and heavy boots--preferably steel-toed safety boots.

Figure 59 illustrates the actual foundry equipment. It includes lifting forks and shafts for handling the hot ceramic shell from the kiln, and tongs for removing the crucible from the furnace, an immersion pyrometer for measuring the temperature of the molten metal, the half-round skimmer for removing slag from the surface

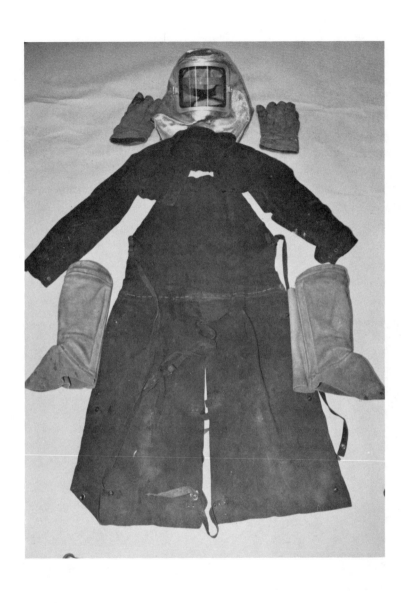

FIGURE 58. SAFETY CLOTHING FOR THE FOUNDRY

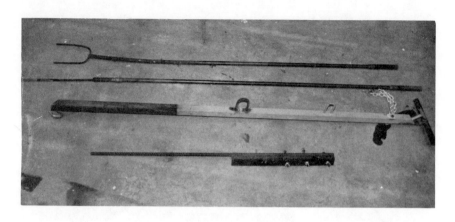

A.

HANDLING CERAMIC SHELLS

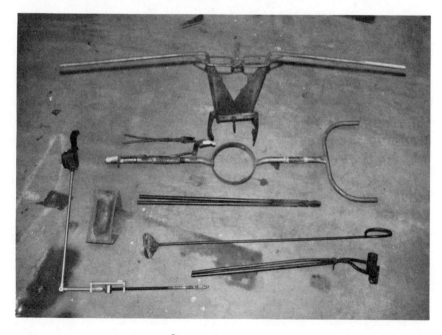

B.

HANDLING CRUCIBLE

FIGURE 59. KILN AND FURNACE EQUIPMENT

of the molten metal (and for scraping out the crucible after the pour), and shanks used to tip the crucible during the pour. For storing leftover metal, an ingot mold is a simple but useful device.

THE FURNACE AND CRUCIBLES

Although some foundries and a few colleges have new (and very expensive) microwave furnaces, more typical is the type of forced air/gas furnace shown in Figure 60. When efficiently operated, this type of furnace is capable of bringing bronze up to as high as 2250°F.--the maximum usually needed--in about half an hour after the first firing. However, when a crucible is new, it must be cured during the first melt by being brought up slowly to the metal's pouring temperature. Crucibles are made of graphite or silicon carbide, and can crack if not cured with a slow first firing. Again to minimize thermal shock, the tongs, immersion pyrometer, and skimmer should be pre-warmed on the furnace top before they are brought in contact with the hot crucible or molten metal. The skimmer should be made of stainless steel so that it will not melt.

BUILDING YOUR OWN FURNACE

There are many books and articles available on designing and building furnaces, but we want to describe here a simple furnace that can be built in a day at little expense, yet is capable of sustaining heat up to 2250°F. for a long period of time and is rugged enough to last through years of bronze melts and pours.

This is a simple gas-fired melting furnace, as illustrated in Figure 61. It can be made with fire bricks, refractory clays that can be rammed in place or--least expensive and simplest--refractory castable cement. It is essential that this furnace be operated only in a very well-ventilated area.

Most of the items needed for the melting furnace are readily available: a steel liner or drum, a blower,

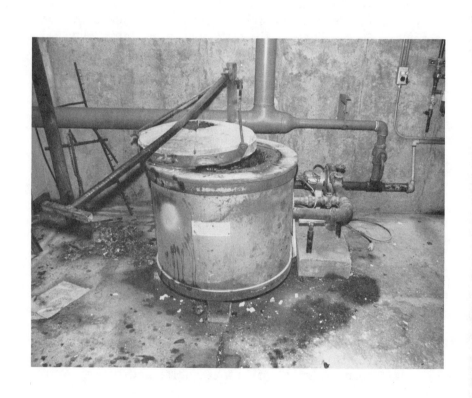

FIGURE 60. COMMERCIAL MELTING FURNACE

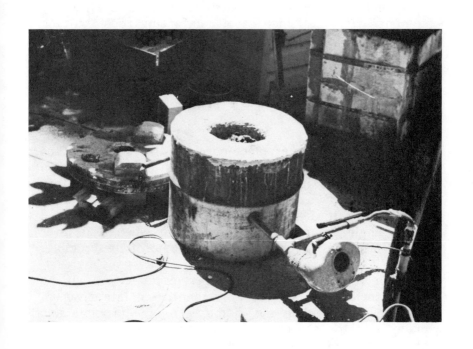

FIGURE 61. HOME-MADE MELTING FURNACE

a burner, and the refractory castable cement. The number of sacks needed depends on the size of the furnace you want to build, of course. Normally, two to three sacks are enough to build a furnace capable of melting 100 pounds of bronze, a sufficient capacity for the average home casting foundry.

Cut off the top of a 30 or 55 gallon empty steel drum with an electric saber saw or a cutting torch and then pour a "floor" of about 4 inches of refractory cement into the bottom of the drum: be sure to follow the manufacturer's mixing instructions for the refractory cement. Put half-inch steel reinforcing rods into the cement (or the rods may be pre-welded across the bottom of the drum before the cement is poured) as the cement sets, placing the rods vertically a couple of inches from the inside of the drum and approximately 4 inches apart. The rods should come to one inch below the top of the drum.

The steel burner pipe, normally 1-1/4 to 2 inches in diameter, should be placed through a hole drilled in the side of the drum two inches above the refractory floor bottom. Wax the outside of the burner pipe before you insert it into the drum. The burner must be placed at an angle to the drum wall so that when it is later fired, its flame will swirl around the base of the crucible.

Decide the size of the largest crucible you will be using, then make a removable round template or drum 4 inches larger than the diameter of the crucible and place it in the center of the pre-poured floor. It must clear the steel drum sides by at least 3 inches. Styrofoam, heavy roofing paper, or rolled formica all work well as a template. Whatever you use, make sure it is held immovable as you pour in refractory cement to make the walls of at least 3-inch thickness. Clay, wax or plaster or paris can first be poured into the bottom of the template to make sure that the refractory cement for the walls does not seep under the template. Cover the reinforcing rods with the cement and let it cure for the time suggested by the manufacturer. When the walls

have set, the burner pipe can be removed by heating it so that the wax coating it melts. The centered template core may be cut out or burned out with a torch. Acetone will melt out a styrofoam core.

A lid or cover for the furnace may be made by pouring refractory cement into the top of the drum that has previously been cut off. This is done much the same way as the floor except the lid needs to be only 2 to 3 inches thick. Use horizontally placed rods or heavy steel mesh for reinforcement. Cut a center hole about 4 inches diameter to allow heat and gases to escape. Fire or high temperature refractory bricks may be used for the cover and held in place with stainless steel bands, but the cement is less expensive. Eye bolts or a swingaway attachment may be later welded to the top of the lid to allow easy removal from the furnace.

When the furnace is completed, a 2-inch thick crucible base block is placed at the bottom of the furnace. The width of the base block should be about the same size as the bottom of the crucible to be used. Ready-made base blocks of durable refractory material last a long time if given proper care, if you cannot obtain one of these manufactured base blocks, you can cut a piece of high-fire brick 2 inches thick. It is easier to remove the crucible from the furnace if, before the firing, a piece of wet cardboard or powdered aluminum hydrate is placed between the base block and the crucible bottom. Remember that the height of the crucible should be such that the flame from the burner will just hit its base when the flame begins to swirl.

The burner pipe should be connected to a blower with a speed control or a rheostat attached to it. Manufactured burner-blower units are available, but one can easily be made from steel pipes attached to an old vacuum-cleaner motor or a squirrel-cage blower. The gas pipe that goes into the side of the burner pipe can be held there by brazing or welding. Be sure to have a gas shut-off on the pipe near the blower as well as a primary shut-off further back on the supply line.

The electric blower motor should have an adjustable baffle plate in order to control air intake.

The burner pipe should be placed through the furnace wall until it is flush with the inner chamber opening. When you are ready to light the furnace (see below), turn the speed control motor to its lowest setting, and open the gas valve slightly. Light the furnace with a small rag attached to a metal rod (charcoal lighter fluid works well).

The crucible, with clean dry metal in it, is placed in the furnace chamber and the lid of the furnace is left off during the first 10 minutes of firing. As the furnace warms up, place the lid on it and slowly increase the gas-air mixture until a rather loud buzzing or roaring sound is heard and a bit of green-tipped flame is seen at the center hole of the furnace cover. To test for an oxidizing atmosphere, hold a piece of zinc or aluminum sheet at the hole in the cover. If it stays bright, the atmosphere is right; if it blackens, more air is needed in the air/gas mixture.

Remember always to warm the furnace and crucible slowly--at least 10 minutes with the lid off--so as to maximize the life of both by minimizing thermal shock.

If any more metal is to be added to the crucible later on, it should be pre-warmed on the furnace cover near the opening. The crucible should be filled no higher than 2 inches from the top.

FIRING THE FURNACE

Safety precautions are essential when firing the furnace, as in later stages of the melt and pour.

A gas-fired furnace can backfire during light-up, so you must wear a face shield, heavy gloves, and leather protective apron. Before lighting the gas, always remove the lid, then check that the crucible and metal are clean

and that the layer of wet asbestos or powdered aluminum hydrate is in place on top of the case block. Make sure the air control is off and turn the gas control on slightly, lighting the gas with a burning rag at the end of a metal rod. Increase the gas slowly, then turn on the air. As already noted, wait for about 10 minutes before putting the lid on the furnace, then gradually increase the gas and air volume until a greenish flame is just visible at the center hole in the lid.

PLACING THE SHELLS

The shells into which the molten metal will be poured should be placed in a bed of sand and supported there by chains attached to a simple metal frame of the kind shown in Figure 62. The sides of the rack can be adjusted to different heights and the top to different angles to accommodate several sizes of shell at one pour. The sand in the bed should be scooped up a couple of inches around the base of the shell to assure steadiness when the chain is loosely looped around the pouring cup.

Ceramic shell should be removed red-hot from the kiln (about 1850°F. for thinner shells or 1650°F. for thicker ones) and racked in the sandbed just before the pour so that the molten metal will not cool below its proper pouring temperature.

JUDGING METALS

Because the different bronzes vary in composition, their pouring and solidification temperatures also differ. Table 3 summarizes these characteristics.

Silicon bronzes all have essentially 4 percent silicon content. The manganese that is added acts as a deoxidizer and enhances the physical properties of the metal. Lead or iron in silicon bronze, even if present in only trace amounts, can cause inclusions on the surface of the casting.

139

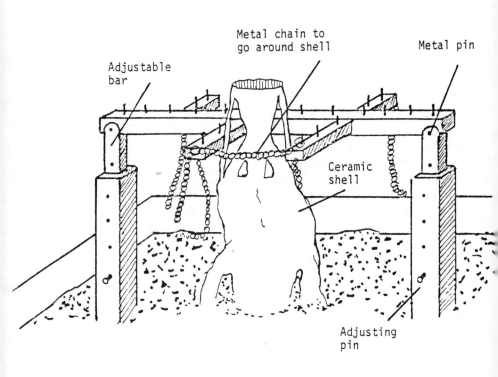

Metal chain to
go around shell

Metal pin

Adjustable
bar

Ceramic
shell

Adjusting
pin

FIGURE 62. RACKING SHELL FOR POURING

TABLE 3. COMPOSITION AND TEMPERATURE CHARACTERISTICS OF COMMON BRONZES

Composition (Percent by Weight)	Silicon Bronze (e.g., Herculoy)	Silicon Bronze (e.g., Everdur)	Silicon Brass, White Bronze (e.g., Tombasil)	Leaded Red Brass	Leaded Tin Bronze	Aluminum Bronze
Copper	92%	95%	82%	81%	87%	89%
Zinc	4	--	14	9	2	--
Manganese	--	1	4	--	--	--
Silicon	4	4	--	--	--	--
Aluminum	--	--	--	--	--	10
Tin	--	--	--	3	10	--
Iron	--	--	--	--	--	1
Lead	--	--	--	7	1	--
Pouring temp. (°F.), thin casting	2050-2250	2075-2150	1900-2100	2100-2300	2100-2300	2050-2250
Pouring temp. (°F.), heavy casting	1900-2050	1900-2050	1750-1900	1950-2150	1920-2100	2000-2100
Solidifaction range (°F.)	1780-1580	1850-1700	1680-1510	1840-1540	1800-1550	1913-1904
Shrinkage (inches per foot)	3/16	3/16	3/16	3/16	3/16	3/16

Although care must be taken not to contaminate the crucible or metal before or during the melt, most of the problems experienced in handling a metal occur after it is melted. With copper alloys, the two main problems are the dissolving of gases and the creation of metal oxides.

The gases can come from a number of sources. At high temperatures, water vapor splits into hydrogen and oxygen. The hydrogen dissolves in the metal, and the oxygen forms oxides with components of the metal. As the casting cools, the hydrogen is forced out, causing porosity on the metal's surface. If electrolytic silicon instead of pure silicon has been used in a silicon bronze, that is another source of hydrogen, which is formed in the process of electrolysis and is contained in the metal.

Once silicon bronze has picked up gas, several careful oxidizing melts may be needed to reclaim the metal. Introducing dry nitrogen through a graphite lance just before the pour will help by mechanically carrying the hydrogen out.

A common way of minimizing the dissolving of hydrogen in a gas furnace is to use a slightly oxidizing atmosphere. However, even a slightly oxidizing atmosphere can build up an excess of metal oxides, especially in tin bronzes, lead bronzes, and red brass. An answer to this oxidizing problem is to add a deoxidizer to the melt after the skimming and just half a minute or so before the pour: about 2 ounces of phosphor copper or simply broken glass per 100 pounds of bronze are needed.

The formation of oxides is not normally a problem with the silicon bronzes, aluminum bronzes or yellow brass, but the best way of avoiding oxides, whatever the metal, is good melting technique: a clean furnace and crucible, a fast melt, and removal of the crucible from the furnace at a temperature as close as possible to the middle of the pouring range of the particular alloy. Holding metal that is overheated is a sure invitation to gas pickup.

142

If a pyrometer is not available, the correct metal temperature for pouring can be judged by dipping a steel rod into the melt and lifting it out again immediately. If the bronze sticks to the rod, the metal is not ready for pouring; if it drips off slowly, the temperature is just about right; if the bronze runs off fast, it is likely to have gone beyond its proper pouring temperature.

THE POUR

As soon as the right temperature has been reached, fast but smooth actions are required: removing the shells from the kiln and racking them in the sand bed; lifting the crucible from the furnace with tongs and placing it in a pouring shank; skimming the slag from the metal's surface; lowering the lip of the crucible as close as possible to the pouring cup of the shell; and filling the pouring cup without splashing or other turbulence, and slowly enough to let air and gases escape past the bronze in the main sprue and cup. See Figure 63. If an extra person is on the scene, he or she can use the skimmer during the pour to help assure that no slag gets into the shell.

For thick pieces, two or more minutes after the pour, when the bronze has solidified at the top of the cup, the piece can be set right side up and the shell surrounding the sculpture sprayed with water so that the bronze in the sculpture will draw more metal from the main sprue and from the cup down through its entire mass. Spraying with water is often not necessary with thin, uncomplicated pieces.

COOLING

Copper alloys divide roughly into two groups according to the range of their solidification temperature. Alloys such as red bronze, tin bronze, and lead tin bronze of the silicon type may show a range of 250°F. between the temperature at which the metal begins to solidify and that at which it is completely solid. The second group, such as silicon bronze, aluminum

143

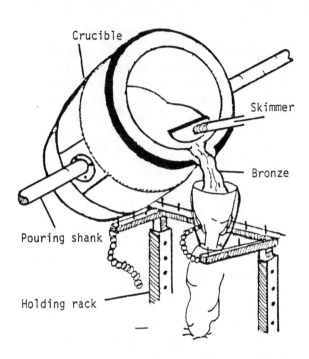

1) At all times the metal should be kept as quiet and free from agitation as possible.

2) The lip of the crucible should be brought as close as possible to the top of the cup, to avoid turbulence or air being drawn into the cup with the metal.

3) Cup should be filled to the top.

4) Use skimmer to stop slag from going into shell

Crucible

Skimmer

Bronze

Pouring shank

Holding rack

Try to pour the bronze slowly enough to allow the air to escape past it.

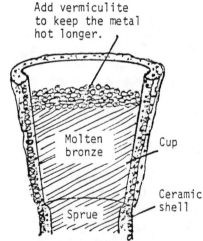

Air

Bronze

Cup

Vent

Sprue

Add vermiculite to keep the metal hot longer.

Molten bronze

Cup

Ceramic shell

Sprue

FIGURE 63. GOOD POURING PRACTICES

bronze, and alloys with particularly high copper content have, like pure metals, a narrower solidification range. The first group needs more sprues to fill the shrinkage voids; the second group needs large sprues but not as many.

Most bronzes should be left in the ceramic shell for at least one hour and preferably overnight. Remember that if you have really deep undercuts, the metal will shrink round the shell the longer you let it cool, and thus the harder the shell will be to get off.

SHELL REMOVAL

After the cast shell has cooled thoroughly, it should be nestled firmly in a sandbag. Then take a hammer and tap the button to remove the shell. Usually more that half the shell will come away and the remaining large pieces can be levered off the casting with a **blunt** chisel. The rest can be removed--sometimes it's tedious--by wire brushing or blasting with sand, then glass beads.

DIAGNOSING PROBLEMS IN SHELL CASTS

As earlier chapters in this book have shown, ceramic shell has many advantages over traditional molds for bronze sculpture. Nevertheless, it is not foolproof and is, in any case, only one step in the many needed to produce a finished bronze casting.

Several types of faults are often seen in bronze casts. As noted in the next chapter, some of these faults can be made good during the chasing process. But with care and practice, most can be avoided in the first place. Below we summarize some of the most common problems and the methods for preventing them in future casts.

A **misrun** is an incomplete casting, that is, the metal has not filled the entire mold cavity--see Figure 64. Misruns can be caused by one or more of the

following factors:

1. Pouring temperature too low.

2. Shell kiln temperature too low.

3. Metal-fluidity not sufficient and fluxing may be needed.

4. Time between shell removal from kiln and metal pouring too long.

5. Shell did not de-gas--venting may be needed, or better shell design.

6. Breakout of shell particles caused by poor handling, incomplete drying of primary coat, or failure to clean shell well before firing.

Gas defects--see Figure 65--normally do not occur with ceramic shell molds because of the relatively high permeability of the shell. However, when carbon has not been completely removed in the dewax and preheat operations, gas can cause such defects as nonfill, porosity, bubbles, and pits in the metal surface. In such instances:

1. Allow more time for burnout and preheat, perhaps 1 to 3 hours.

2. Check wax for contamination.

3. Check burnout and preheat atmosphere and temperature to make sure the atmosphere is an oxiding one.

4. Check that the shell is permeable.

A **shrinkage** or **drawing** in the casting may be caused by inadequate spruing to a heavy or a thin section. Here you should:

1. Assure adequate feeding to heavy section of casting with better sprue design.

2. Pour the metal at a cooler temperature, using a pyrometer when possible to check the temperature.

A metal fin or **flashing** on the surface of the casting--see Figure 66--is caused by a mold failure:

1. Be more careful during dewaxing to minimize shell expansion.

2. Reinforce the mold with fiberglass or stainless steel wire.

3. Improve the wax sprue design.

4. Keep temperature in drying room steady.

Porosity in a casting is usually the result of gases accumulated during the melting of the metal. Here:

1. Check the furnace for the right (oxidizing) flame.

2. Use a de-gassing agent.

3. Avoid turbulence in pouring of the metal.

Gases that the molten metal absorbs during the melt and pour can cause **pin holes.** The solution may be:

1. Bigger sprues.

2. More vents.

3. Oxidizing atmosphere.

Wormy looking tracks on the metal's surface may result from:

FIGURE 64. A MISRUN--METAL FROZE OUT BEFORE THE MOLD WAS FILLED

148

FIGURE 65. GAS DEFECTS, INCLUSIONS IN SHELL

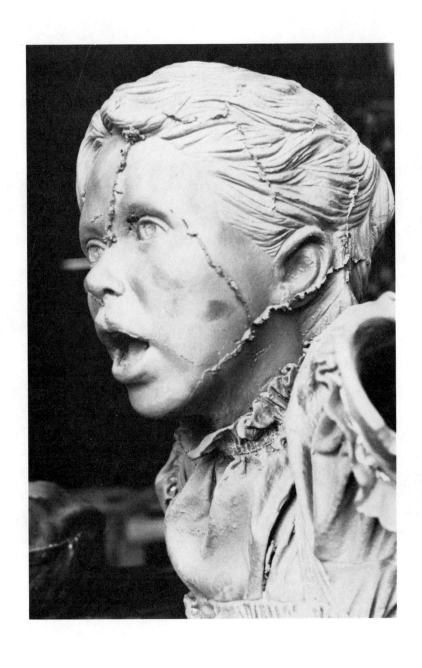

FIGURE 66. FLASHING DEFECTS

FIGURE 67. COLD SHOT--METAL ESCAPED DURING POUR

151

1. Inadequate spruing.

2. Excessive pouring temperature.

Holes in the surface of the metal can be caused by:

1. Metal contamination--use new metal or a different alloy.

2. Crucible contamination--clean the crucible.

3. Gas from the furnace--reduce the gas-to-air ratio.

Cold **chill lines** are often due to:

1. Inadequate number of sprues.

2. Not enough head pressure during the pour.

3. Metal sluggish because it is contaminated.

4. Too much gas.

5. Metal too cold (most common cause).

6. Sprue design (metal coming from different direction).

A **cold shut** is usually observable as hairline crack on the surface of the casting. Figure 67 illustrates a bad case. It usually occurs when the metal is fed into the mold in two or more streams and the two flows do not bond. The basic cause may be:

1. Metal too cold.

2. Mold too cold.

3. Poor wax sprue design.

Internal or external **blow holes** in the casting are caused by trapped gases. Here the precipitating cause may be:

1. Poor wax sprue design in terms of vents.

2. Shell not de-gassing.

3. Core not de-gassing.

Slag oxides or shell particles present in the casting can cause **inclusions** from:

1. Careless handling of the shell.

2. Improper melting of the metal.

3. Failure to remove all slag.

4. Poor shell bonding.

5. Inferior metal.

Hot tears and **cold cracks** are caused as the metal shrinks in the cooling and may be due to:

1. Poor wax sprue design.

2. Metal too hot.

3. Using the same metal too many times or using an inferior alloy.

4. When using a core--bottom and sprues cool before piece.

Uneven cooling of metal and irregular thickness in the wall of the wax or metal mass may cause **warping** during cooling. The solution may be to:

1. Cool the metal more slowly.

2. Improve the wax sprue design.

3. Build the shell thickness as evenly as possible over the whole wax piece.

4. Reinforce the shell with fiberglass or stainless steel wire.

VII

Welding, Chasing, Cleaning

When the ceramic shell has been parted from the cooled bronze casting, sandblasting is the best means to remove the last bits of the investment. For this and most of the other stages in finishing bronze, snugly fitting **safety glasses** must be worn, and a respirator mask is a sensible precaution.

For sandblasting, fine grain sharp sand or glass beads can be used out-of-doors, or a bead-blasting cabinet will accomplish this cleaning. If you are using a hand-held blaster attached to an air compressor, test the best distance to hold it on a scrap of the bronze--too close, and the sand will pit the surface; too far away, and the surface will not be properly cleaned. Use a sufficiently fine sand or glass bead shot, otherwise the operation may actually increase the roughness of the cast surface. For casts with very fine detail--as often occurs in aluminum, gold, or silver pieces--it is sometimes advisable to use grits such as ground walnut shell in the blasting instead of the sand or glass beads.

REMOVING SPRUES AND VENTS

After the sandblasting (and sometimes before) comes the removal of the ceramic shell sprues and vents by chipping, shearing, sawing, or cutting with an abrasive wheel, flame cutting, or with a carbon arc.

The hacksaw is a common hand tool for cutting, and different blades are available for different metals. It is fast and economical for small jobs. Hand shears with steel jaws can also be used but only on metals-- bronze, brass, copper, and soft irons and aluminum--that are softer than the jaw steel.

A bandsaw is useful for sprue and vent removal jobs. It works well on nonferrous metals; blades for cutting mild and low alloy metals are now available. With bandsaws as with hacksaws, it is important to have the right blade--particularly in number of cutting teeth per inch--for the metal being cut, and to keep the blade well oiled. Also, on a bandsaw, the speed is very important, so look at the operation manual.

An abrasive cutting wheel can be used for metals too hard to cut quickly with a hacksaw or bandsaw. It is especially useful to make smooth cuts flush with a flat surface but has to be handled with great care so that it will not damage any elevated part of the sculpture--or injure the user. Gloves as well as eye shields should be worn.

Much more versatile is a cutting torch, once used only on metals that were easily oxidized by the flame but now available for work on many metals. An air arc is a delightfully efficient cutting tool, but much too expensive for most individual sculptors.

WELDING

Ceramic shell sculpture usually has to be cast in more than one piece if the original sculpture is larger

than about 30 inches by 20 inches. In these cases, the pieces have to be welded together with an oxyacetylene torch or a TIG (heliarc) welder. A heliarc is one of the finest (and most expensive) pieces of equipment a sculptor can have because of its versatility and the delicate work it can handle.

Welding is a whole separate skill which we cannot go into fully here. However, we can give a few helpful hints for the person who has had some practice. First, always use a good metal for casting and a 10/10 Everdur rod for welding the bronze; second, burnish the welded area with a wire brush so that you can see clearly whether the weld is complete.

The preparation of a joint for welding is of utmost importance. The surfaces to be joined must be made as clean as possible--by grinding, wire brushing, or wiping with solvents--to prevent any foreign material from weakening the joint. Three different welding methods are summarized below.

Gas Welding

In gas welding, acetylene is burned at the end of a nozzle with oxygen, which make a range of hot flames for different metals--see Figure 68. This flame is washed over the edges of the pieces to be joined until they become cherry red (molten), then a welding rod (of a compatible metal) is introduced into the flame on the metal. The rod melts and combines with the parts of the metal sculpture. A flux may also be introduced into the joint. The flux attracts impurities and keeps them from polluting the weld.

After cooling, the joints are cleaned with solvent and a wire brush, then smoothed with files or a high speed sander/grinder.

An oxyacetylene torch is a very useful piece of equipment in a school or home studio for many jobs,

A.

NEUTRAL

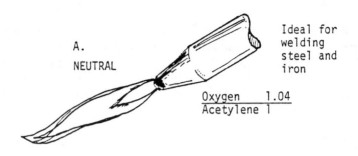

Ideal for
welding
steel and
iron

$$\frac{\text{Oxygen} \quad 1.04}{\text{Acetylene 1}}$$

B.

OXIDIZING

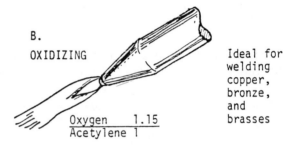

Ideal for
welding
copper,
bronze,
and
brasses

$$\frac{\text{Oxygen} \quad 1.15}{\text{Acetylene 1}}$$

C.

CARBONIZING OR
REDUCING

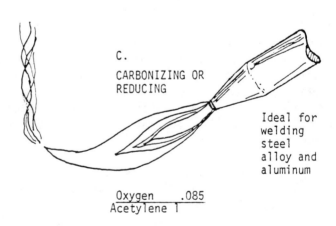

Ideal for
welding
steel
alloy and
aluminum

$$\frac{\text{Oxygen} \quad .085}{\text{Acetylene 1}}$$

FIGURE 68. OXYACETYLENE FLAMES FOR DIFFERENT METALS

not just welding of sculpture pieces. However, it is particularly useful for this chore because the characteristics of the flame and its action on the weld metal can be closely regulated.

TIG Welding

Tungsten-inert gas (TIG) welding is somewhat similar to oxyacetylene welding. A tungsten electrode which is not consumed, is used to form an arc for the heat source, and the metal edges are fused or a filler rod is added to the weld--see Figure 69.

The principal advantage of the TIG process is in welding such metals as stainless steel, copper, bronze, and aluminum. Welding of these metals has always been difficult because of heat dissipation and rapid formation of protective oxides when the metals are exposed to the atmosphere. In TIG welding, a protective wall of inert gas (usually argon or helium) around the arc and the weld zone protects the weld being formed from the atmosphere, thus preventing oxides from forming. The end result is a sound clean weld, without the danger of flux, slag or oxide entrapment that can occur with the oxyacetylene process.

Brazing

Some high-carbon steel, stainless steels, iron, other ferrous metals, and many nonferrous metals are sometimes difficult to weld. Brazing and silver soldering can be used to join these metals or two dissimilar metals. The nonferrous alloy solder melts around or somewhat above $500^{\circ}F.$, below the melting points of the metals to be joined. (Many steels and irons do not melt below $2000^{\circ}F.$, and even aluminum does not melt below about $900^{\circ}F.$) The two pieces to be joined are cleaned and fluxed, then heated to the melting point of the fusing alloy--the brazing rod or silver solder--which then flows between the surfaces and makes a joint.

A.
OXYACETYLENE

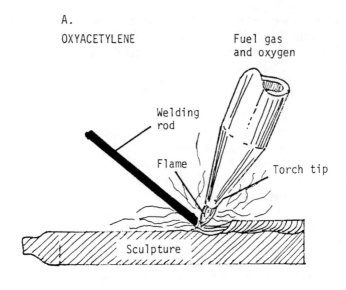

Fuel gas
and oxygen

Welding
rod

Flame

Torch tip

Sculpture

B.
TIG

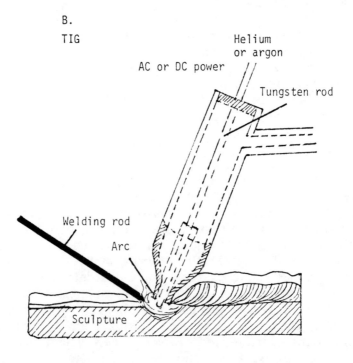

Helium
or argon

AC or DC power

Tungsten rod

Welding rod

Arc

Sculpture

FIGURE 69. TIG VERSUS OXYACETYLENE WELDING

This joint will be weaker than a weld but much stronger than any adhesives. Such a joint can be an ideal way of fastening metal bolts on a sculpture to be mounted on a wooden or stone base.

CHASING

Chasing usually starts with removing the bronze sprues and any flash--fins or little balls (pearling) of unwanted metal that form at cracks or pits in the shell--and ends with texturing the surface of the bronze. Because bronze is difficult to match in color and hardness, you should save some of the vents and scraps for repair work or use bronze 10/10 Everdur rod as taps or fillers for small holes.

The wider the variety of tools you have available, the less tedious and more pleasurable chasing will be to you. Below we describe an array of chasing tools before getting on to the techniques of chasing.

Chasing Tools

Among the power tools, one of the handiest for the sculptor is a small grinder (Figure 70A). A jeweler's grinder, such as Fordem, with a flexible shaft is particularly useful. Dremel and Dumor are other grinders that offer good durability.

At least one electric drill with a powerful motor is needed, preferably two-speed or variable speed and with a 3/8-inch chuck. In two-speed drills, the lower speed (usually about 900 RPM) is good for drilling and the higher speed (2500 to 3000 RPM) for cutting and grinding. Tungsten carbide cutters are recommended over high speed steel cutters for they last much longer and therefore are economical in the end. A swivel-point sanding pad is a useful attachment, for you can glue on different coarsenesses of sandpaper, from 80 or 100 grit right up to 600. It is worth investigating other small electric tools and attachments that are now readily available, and choosing those that are suitable for your individual works.

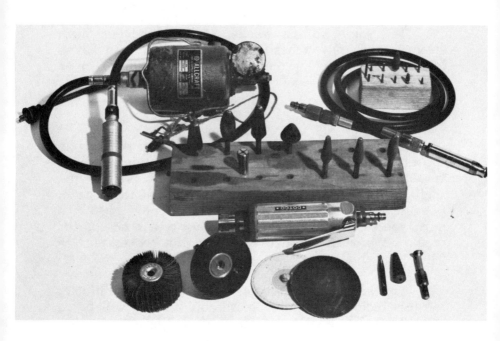

FIGURE 70. SMALL AND LARGE GRINDERS FOR CHASING

There are two simple ways of holding the bronze casting while you work on it. One is a bench vise with a swivel base. The jaws of the vise should be covered with leather, wood, or soft lead so that they do not mar the bronze. The other is even simpler--a sandbag on which you can cradle the piece. It can be made from the leg of an old pair of pants, filled with ordinary sand or cat litter, dried peas or beans, sewn up at both ends. Sandbags are particularly useful for holding small pieces or any piece that may be awkward to place in a vise.

You need a hacksaw, an array of chisels, and--very useful--a ballpein hammer, all shown in Figure 71. The flat side of the ballpein is used to strike the chisel or other chasing tool, and the round side for actually shaping the bronze; the round side of the hammer should therefore be kept very clean and highly polished. A carpet hammer is also a convenient tool for chasing. Chisels are often the most used of all chasing tools, and here it is worth investing in quality and variety; the chisels should be hexagonal in shape, made of highly tempered steels, preferably 3/8 inch or more in diameter, and varying in length from about 6 to 12 inches.

Another assortment you need is files--coarse, medium, and fine; flat, round, and rat-tail. Again it is worth investing in good variety and quality, such as Swedish steel files.

Finally, you need one or more stamping or matting tools that you should make for yourself, as described later, to duplicate the surface texture(s) of the particular piece.

Chasing Techniques

There are perhaps just two basic rules in chasing: when removing sprues and flash, leave a little excess so that it can be worked carefully down to the original plane of the surface; and work from coarse to fine when filing or sandpapering.

FIGURE 71. HAND TOOLS FOR CHASING

Chiseling, Grinding, Filing. Once the vents and sprues have been cut away and welding is completed, you have to work over these exposed areas to bring them down to the casting's surface. Cut and welded surfaces are often very different in color from the casting surface, so it is a good idea first to burnish these areas with a steel brush or steel wool so you can see exactly where chasing is needed. If you have a power grinder, you can go to work with it, as in Figure 72.

If you can chisel or file the rough areas down by hand, chiseling is usually the better technique. As a tool, a chisel has several advantages over a file. It can be kept sharp whereas a file is soon blunted and becomes clogged from the bronze or other soft metals. Handled with care, a chisel is less likely to mar the surrounding surface, whereas it is too easy to get file marks on the surface. However, you will need files for the final leveling and smoothing. A 12-inch flat file or half-round file (one flat and one rounded plane) is useful here. You will also often use cross-cut and rat-tail files and, for delicate work on small bronzes, a needle file.

Filling Holes. The easiest way to fill unwanted holes in the casting is to work the metal over them with a ballpein hammer or flat punch. Larger holes can be filled by welding or by the tap and die method. The latter requires threading tools and is therefore not a common method. You drill out the hole in the casting and thread it. Then you take a piece of Everdur rod that is slightly larger in diameter than the round hole, and cut a matching thread into it. This tap is then screwed into the hole, cut off, and chased into the surrounding surface.

Figure 73 summarizes the methods for filling holes in bronze.

Matting. An area that has been worked over with hammer, chisel, or file will have a different texture from the rest of the surface. To bring all the surface

FIGURE 72. SMALL AND LARGE GRINDERS IN USE

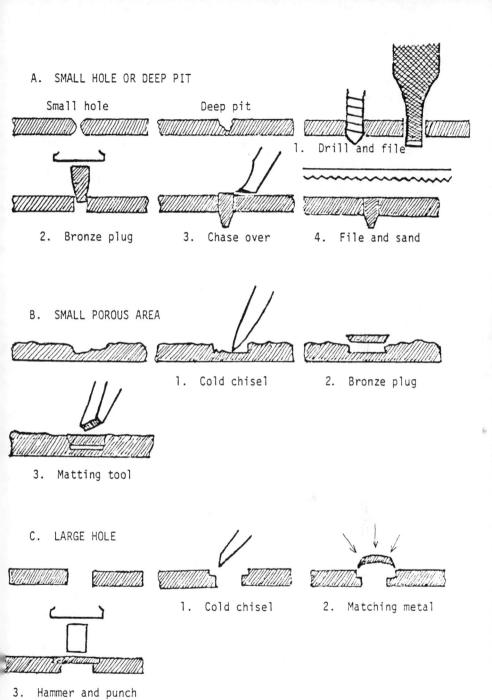

A. SMALL HOLE OR DEEP PIT

Small hole Deep pit

1. Drill and file

2. Bronze plug 3. Chase over 4. File and sand

B. SMALL POROUS AREA

1. Cold chisel 2. Bronze plug

3. Matting tool

C. LARGE HOLE

1. Cold chisel 2. Matching metal

3. Hammer and punch

FIGURE 73. REPAIRING HOLES IN BRONZE CASTINGS

167

to the texture(s) you want, you will need stamping or matting tools.

To make such a tool, use a piece of square or hexagonal shaped high carbon steel or stainless steel that is 4 to 6 inches long and about 1/2 inch in diameter. Heat up one end until it is cherry red (about 1400°F.); put the other end of the steel in a vise, and then with old hacksaw blades, chisels, or files you roughen one end of the softened steel until it resembles the texture of the sculpture. Make the edge of the matting tool round and smooth so that it will not subsequently mar the sculpture's surface. If the tool is still very hot, you can harden it by quenching it immediately in water or, preferably, in oil. If it has cooled, reheat it to cherry red before quenching.

Sometimes the ready-made surface of a file is suitable as a matting tool. If a smoother surface is wanted, a medium-fine emery cloth may make an appropriate imprint.

Many sculptors find it worthwhile to make an assortment of such matting tools. However, if you normally use just one texture on your bronzes, it may be worthwhile having a matting tool specially cast in stainless steel, then welding or brazing it onto a steel handle.

Use the matting tools to bring the surface of your bronze to the textures you want, as in Figure 74. Remember that any surface you leave slightly raised or rounded will catch the light and be obvious. Broken surfaces lose most of the light and therefore are less conspicuous. Even the best bronze casts usually have tiny holes, pearls, or other surface faults. Because they can sometimes add interest to the texture, judge the effects of such areas carefully before deciding to chase and matt them.

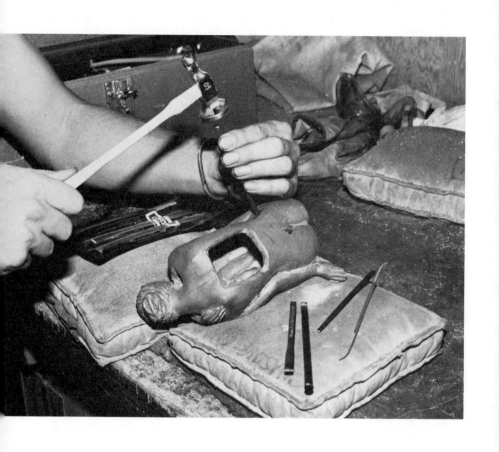

FIGURE 74. CHASING WITH HAND TOOLS (AND HOME-MADE MATTING TOOLS)

Sanding. If the finished sculpture is to have a smooth surface, you can sand it with a belt sander (Figure 75) or by hand using wet and dry sandpaper (Figure 76). Buffing (Figure 77) makes an even smoother finish, as described in the next chapter.

Final Inspection. After chasing and matting or sanding the bronze, spray it with liver of sulphur to blacken it and rub with steel wool. This treatment will show up any unevenness of texture. Bronze becomes work-hardened with chasing and matting, so the second round of chasing or matting, if required, will be more difficult but certainly worth pursuing to get all the surface textures you want.

FINAL SANDBLASTING

You will have handled the bronze a lot by the time you have corrected all its faults and brought the surface to the finish you want. It will need a final sandblasting, either with fine sand or glass beads in a beadblasting cabinet, before you prepare it for the chosen patina.

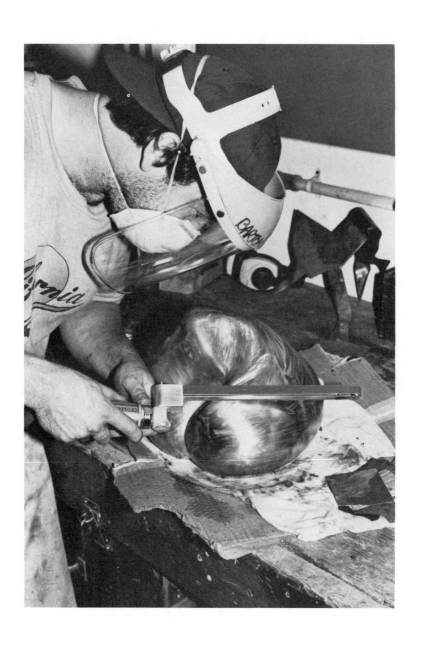

FIGURE 75. USING A BELT SANDER

FIGURE 76. HAND-SANDING WITH WET AND DRY SANDPAPER

172

FIGURE 77. BUFFING WHEEL ON FLEXIBLE SHAFT

VIII

Polishing and Patination

Over the centuries, bronze has been treated in many ways: burnished, gilded, in-laid, enameled, varnished. But no matter how fine the results of some of these treatments, the colors achieved by patination--that is, hues that actually become part of the metal--can be the most rewarding of all.

When newly cast and cooled, bronze has the glow of red-gold but as it ages, the surface of the bronze goes through many transformations, in the end becoming green or dark brown or nearly black. By using chemicals, you can in a few hours duplicate these patinas of nature or create many, many others.

In the United States, very little has been published about the patining of bronze and other metals. Many commercial foundries have good information but they often do not want to share it or they are limited by their own specializations. The main purpose of this chapter is to bring together information gleaned from

174

many sources--artists in other countries, foundry practice and, most important, the personal experimentation of one of the authors, Ronald Young.

Before we enter the rich world of patinas, however, we give below a few guidelines for those who prefer simply to polish their sculpture rather than patine it.

POLISHING AND BUFFING

If the surface is to be polished, different polishing and buffing devices with suitable abrasives are used--the appearance of the final surface depends on the kind of abrasive selected, the grit size, the binder (grease or greaseless), and the buff used. Although polishing and buffing are often thought of as interchangeable, polishing is used here to define the removal of metal, while buffing refers to the final removal of visible scratches to produce a satin or mirrorlike finish. The final surface may be satin, matt, or luster, depending on the metal and on the abrasives used. Polished finishes are produced with abrasive grit sizes from 80 to 220. Buffed surfaces require abrasive grit from 220 to 600, and special compounds for mirrorlike finishes.

For polishing, use a felt or heavily sewed buff; for buffing, use a loose buff. Different buffs are illustrated in Figure 78. Hard metals such as steel can withstand higher buff speeds; soft materials such as plastic require lower speeds.

Buffs are produced in felts, chamois, and a variety of synthetic fabrics. The surface, density, and hardness of the cloth buff depend largely on the manner in which the buff wheel is sewed--close stitching results in a harder buffing wheel; radial and square sewing results in more pockets in the buff to hold compounds. A hard buff is used for polishing harder metal and a buff with fewer stitches and lighter cloth is used on softer metals.

Yellow brass is among the preferred bronzes for high luster finishes. Other bronzes can be polished but will not hold their luster as well.

175

A.
POLISHING FOR BRONZE, ALUMINUM

B.
POLISHING FOR BRONZE,
ALUMINUM, IRON AND STEEL

Loose sewed

Curved tangent sewed

C.
POLISHING FOR BRONZE, ALUMINUM

D.
POLISHING FOR STEEL, IRON

Square sewed

Spiral sewed

E.
FOR BUFFING BRONZE, ALUMINUM

F.
FOR FINAL BUFFING BRONZE, ALUMINUM

Concentric sewed

Sun ray sewed

FIGURE 78. BUFFS FOR POLISHING AND BUFFING

As already noted, there are really two steps in producing a high luster. The first is the cut-down or polishing--the final smoothing of the metal--and the second is the actual buffing with one or more compounds. Table 4 summarizes the appropriate wheels and compounds for the polishing and buffing of bronze and other metals. Buffing wheels, belts, and pads are available as attachments to most electric hand tools, and small wheels can be used with electric drills. For most metals, a speed of at least 3400 RPM is needed (the larger the wheel, the faster its edge is turning.) The speed should be no more than 8000 RPM for the softer metals and often only about 6000 RPM. Carbon and stainless steels, however, can usually be safely buffed at 9000 to 10,000 RPM.

When using a power tool for polishing or buffing, do not press down too hard; if you do, the compound will work into the surface and discolor it. Care also has to be taken when the piece is held in a vise so as not to damage the surface of the sculpture during polishing.

When the cut-down or polishing is complete, the piece should be thoroughly washed with hot water, detergent, and ammonia--about 10 percent ammonia in water--before buffing.

The original red-gold of newly cast bronze can, with effort, be preserved by heating the piece until it is just too hot to touch--around 200°F.--and applying a coat of thin linseed oil. Then you burn off the oil and rub the piece with a soft cloth. Alternatively, you can apply a light coat of paste wax to help retard tarnish. Even so, the gleam will eventually fade unless you occasionally buff the piece with a power rag-wheel and the appropriate rouge.

High luster finishes can be preserved for many years by applying lacquer. We recommend half and half

TABLE 4. POLISHING WHEELS AND COMPOUNDS FOR VARIOUS METALS

Metal	Polishing		Buffing	
	Wheel	Compound	Wheel	Compound
Bronze, brass, copper, aluminum	set-up wheel with abrasives bonded to the surface	stainless* and tripoli rouge	stitch buff, bias finger buff, and open face linen buff	red rouge or chrome rouge
Brass plate and copper plate	cut-buff with a bias finger buff	tripoli rouge	bias finger or open face linen buff	red rouge or chrome rouge
Iron and carbon steel	set-up wheel or belt with emery bonded to the surface	stainless	sisal and bias finger buff	stainless and chrome rouge
Solid gold and silver (unplated)	polishing generally unnecessary	--	flannel or open face linen buff	red rouge or chrome rouge
Plated gold and silver	do not polish with aggressive buffs or emery wheels	--	flannel or open face linen buff	do not buff plated gold; buff silver lightly with chrome rouge
Nickel (plated or in its pure form)	sisal and bias finger buff	stainless and chrome rouge	bias finger buff	chrome rouge
Chromium (plated only)	bias finger buff	chrome rouge	bias finger buff and pocket buff	chrome rouge

* Unfused aluminum oxide.

by weight of clear lacquer and lacquer thinner. Of course, the lacquer has to be removed if you subsequently decide to apply any of the patinas described later.

A number of different surface effects can be made on metals before patination:

1. Burnished surfaces are made by flattening slight obtrusions in the surface with, for example, the convex heel of a spoon.

2. Brushed surfaces are made by mildly scoring the metal with a wire brush or wire wheel.

3. Anodized surfaces create oxides on the surface purposefully to affect the color of the patina.

4. Etched surfaces, made by exposure to acid fumes or solutions, show a dull matt finish as a result of the pitting by the acid.

5. Roughened surfaces can be made by sand-blasting with silica sand or, to get small round craters, with glass bead shot.

Patinas will generally not adhere well to highly polished surfaces although the hot chemical patinas, described later, can be used successfully on smooth surfaces (the cold patinas usually cannot).

PATINA EFFECTS

A patina is, in the broadest sense, the surface appearance or coloring of the metal. There are basically three types of patina: natural, false, and chemical.

A patina forms naturally on any copper, bronze, brass, or other metal surface when the object is exposed to moisture and air over a long period of time. When oil or color is added to the surface of the metal without making a chemical bond with the surface, it can justly be defined as a false patina; colors can be applied in

oil paint, enamel, varnish, colored gesso, acrylic, plastic, or lacquer. Then there are the chemical patinas, intentionally produced by using agents such as sulfides, oxides, or chlorides which bind chemically with the surface and simulate the natural effects of exposure.

The content of the different metal alloys affects the reaction of various chemicals on the surface of the metal. No chemical patina will give exactly the same color on two different alloys, even if the alloys are similar. The color also depends on the way the artist applies the chemicals. You have to learn the characteristics of the particular metal you are using.

The patina on a bronze sculpture, whether natural or applied, is often in fact a number of layers that combine to give different optical effects. For example, in part A of Figure 79, the bronze surface is first polished, then a transparent yellow patina is applied in a very fine mist with a spray gun. After that has dried, a transparent blue is sprayed on. When light goes through the patina layers to the bronze, it bounces back and strikes the eye of the beholder as a subtle green. This will be a very different green from the shade obtained if an opaque black patina is applied to a matt bronze surface, followed by a transparent green patina--see part B of the figure.

Finally, part C of Figure 79 illustrates the subtle changes in optical effects that are possible to obtain when you patine a bronze. In this case, a layer of light-brown opaque patina is applied in varying thickness to polished bronze, followed by an even layer of transparent light-green patina. Different parts of the sculpture will then reflect light varying in hue from yellow-green to yellow-brown.

PREPARING FOR PATINATION

Safety Precautions

Because of the strong chemicals needed both to prepare the sculpture and to apply the patinas that we

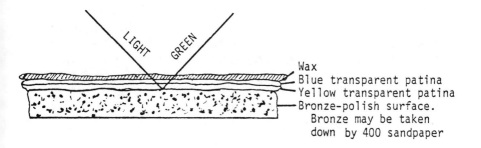

Wax
Blue transparent patina
Yellow transparent patina
Bronze-polish surface.
 Bronze may be taken
 down by 400 sandpaper

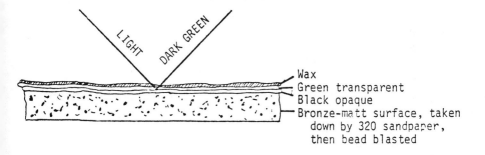

Wax
Green transparent
Black opaque
Bronze-matt surface, taken
 down by 320 sandpaper,
 then bead blasted

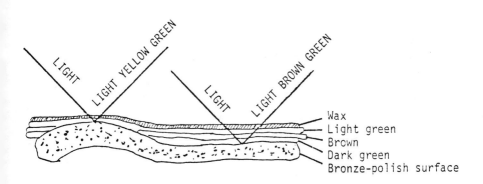

Wax
Light green
Brown
Dark green
Bronze-polish surface

FIGURE 79. OPTICAL EFFECTS OF PATINA LAYERS

181

describe later, **every possible safety precaution must be taken.** Keep acids in labeled glass jars. Wear heavy rubber gloves and safety glasses. Work outdoors or in a well-ventilated place. Most importantly when working with acid, **always pour the acid into the water,** never pour water into acid. Water added to acid will cause a dangerous "boiling" and splattering. Be particularly careful when working with **hydrofluoric acid,** for it is **exceedingly dangerous.**

As you work with the chemicals, wash your hands often in clean water and rub them with equal parts of glycerin and water after you have dried them. To remove stains of copper and ferric compounds, wash your hands with a very dilute solution of ammonia and then with plenty of water. If the stains are old ones, rub them with acetic acid, then wash well.

Tools and Equipment

The following are the tools and equipment most needed for preparation and patination of metals:

1. Rubber gloves and apron

2. Safety glasses

3. Breather mask

4. Glass containers, labeled, for acids

5. Glass or plastic containers, quart or gallon size, for patinas

6. Plastic spray bottles

7. Plastic buckets

8. Vise

9. Natural bristle brushes (1/2 inch) with wood handles

10. Propane or map gas torch

11. Crayons

12. Beeswax

13. Lacquer

14. Asbestos pad

15. Free-standing bench or revolving patina stand (see example in Figure 80)

16. Air compressor with air brush or spray gun

17. Electric fan

18. Oxyacetylene torch

19. Electric oven.

An electric oven is good for applying many patinas because it heats up the sculpture evenly. However, you may want to vary the temperature over the surface of the metal so as to vary the effect of the patina, and then a map gas or gas/air torch is preferred.

Cleaning the Surface

Before coloring metal, you must be sure that it is absolutely clean and free from any trace of dirt, oil, grease, or oxides, any of which will prevent the patina solution from acting evenly. So slight a thing as the moisture from hands is a frequent cause of failure in patination. After it is cleaned, the metal should not be exposed to air for longer than necessary.

The first step in cleaning bronze, brass, silver, copper, or aluminum is to rub it with an abrasive cloth, powdered pumice, 3M Scotchbrite pad, or a wire brush.

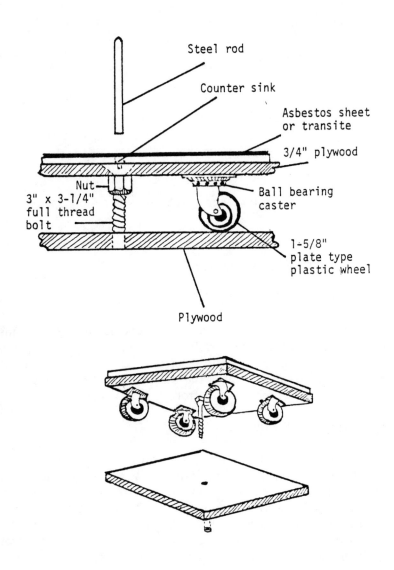

Steel rod

Counter sink

Asbestos sheet
or transite

3/4" plywood

Nut

3" x 3-1/4"
full thread
bolt

Ball bearing
caster

1-5/8"
plate type
plastic wheel

Plywood

FIGURE 80. REVOLVING PATINA STAND

If you have cast in a ceramic shell mold, your bronze should be sandblasted after as well as before the chasing, to assure removal of all shell particles, oils left on the piece by your hands, and metal dust.

An acid bath is then used to prepare a uniformly clean matt surface on the casting. This work is best done outside or in a very well-ventilated place with a good supply of running water. Safety goggles and gloves must be worn, as well as a protective rubber apron. Remember to **pour acid into water,** not vice versa.

Depending on the final surface wanted, acid baths can be classified as:

Pickle solutions--pitted surface

Bright dips--smooth surface

Satin dips--granular surface

Ormolu dips--surface not as smooth as with bright dips but smoother than with pickle solutions.

A few of each type are described below for use with bronze, copper, or brass.

1. **Pickle Solutions**

 a. nitric acid 1 part

 water 10 parts

 This is the most commonly used solution for cleaning bronze. Brush onto the metal with a natural bristle brush (synthetics tend to disintegrate) or dip the piece, leave for 1 to 3 minutes, and rinse thoroughly with cold running water. Do **not** use soap or detergent since it will leave a film that will resist the patina.

A good dipping procedure for small castings is to place the smaller of two plastic buckets, with many holes cut into it so that it acts as a sieve, inside the larger bucket which contains the diluted acid. The smaller bucket with the casting can be lifted in and out of the solution with ease.

If there is much boiling and bubbling when a piece is dipped, either the solution is too strong or there are deposits of some kind remaining on the casting. In either case, remove the bronze from the bath and rinse it thoroughly with cold water before inspecting it to decide whether it needs a longer time in the bath or a more dilute acid solution.

b. sulfuric acid 1 part

 water 10 parts

A good solution for removing oxides. Brush on; or add the acid to the water in a porcelain, cast iron, or Pyrex glass container and immerse the piece for 1/2 to 3 minutes, depending on the temperature of the solution; rinse thoroughly with cold running water.

2. Bright Dips

a. nitric acid 2 parts

 sulfuric acid 1 part

 water 4 parts

Brush on; or add the acid to the water in an earthenware or Pyrex glass container, bring to boil, immerse piece

for only 5 seconds, rinse thoroughly with cold running water.

b. nitric acid 1 part

 sulfuric acid 1 part

 water 1 part

 Caution: This is a very strong solution, so safety goggles and gloves **must** be used. Brush on, or immerse for 5 seconds, and rinse thoroughly in cold running water.

c. nitric acid 3 quarts

 hydrofluoric acid 4 quarts

 common salt 2 tablespoons

 water 5 quarts

 Brush on or immerse for 5 seconds and rinse, as above. Note: hydrofluoric acid will attack glass or pottery; therefore the container used must be coated inside with asphaltum.

3. Satin Dips

 Follow the method for bright dips--that is, brush on or immerse the piece in the solution for 5 seconds, then rinse thoroughly with cold running water. Because of the hydrofluoric acid, use only a container coated inside with asphaltum.

a. hydrofluoric acid 2 pints

 nitric acid 1 pint

muriatic acid	1/2 pint	
water	5 pints	
b.	hydrofluoric acid	1 pint
	nitric acid	1/2 pint
	water	5 pints
c.	hydrofluoric acid	1 pint
	water	3 pints

4. **Ormolu Dips**

a.	sulfuric acid	2 quarts
	water	1/4 pint
	potassium nitrate	3 pounds
	muriatic acid	1/2 pint

Add the sulfuric acid and potassium nitrate to water, then add the muriatic acid slowly. Brush on or immerse for 5 seconds, then rinse thoroughly in cold water.

b.	hydrofluoric acid	2 pints
	nitric acid	2 pints
	zinc scraps	1 pint

Follow method above.

We repeat: after using any of the above formulas, the bronze or copper piece must be rinsed immediately and

thoroughly with cold running water and allowed to dry completely before the patina is applied.

For iron or steel sculptures, solutions with hydrochloric or nitric acids can be used but their effect is immediate, that is, the acids have to be washed off within a second or two. Muriatic acid (one part acid to ten parts water) is preferred because it is not quite so fast acting. Sulfuric acid should not be used on any ferrous metal.

PATINATION METHODS

In Chapter IX we give a large number of "recipes" and precise advice for obtaining different colors and textures of surface on bronze and many other metals. Our discussion of patination methods below is therefore purposefully brief and, except where otherwise noted, assumes that the sculpture is an Everdur bronze casting.

There are five different types of chemical patinas, depending on the method of application. Buried patinas, fume patinas, vat patinas, cold process, and finally, and the most rewarding because of the many effects they can produce, the hot patinas. (Another method, really a subtype of the cold process, is the dry paste method. We found it in a book published in the 1880s and give a few dry paste formulas at the end of Chapter IX.)

Baste and Bury Patinas

In the first method, a chemical solution is basted with a brush over the bronze, which is then buried in sawdust, sand, or clean soil. (Remember that different soils have different minerals, so you are never sure of the resulting color.) Leave the piece buried for anywhere from 3 to 20 days, but usually the latter, and every so often pour new solution over the sawdust, sand, or soil. Then remove the piece.

A good chemical solution for these methods is made of three separate solutions: 4 tablespoons cupric

nitrate in 1 pint water; 4 tablespoons ferric perchlorate in 1 pint water; and 4 tablespoons acetic acid in 1 pint water. Combine the 3 pints of solution and keep in an airtight glass container until you are ready to use. Then heat the combined solution (but do not let it boil) in an enamel pan (never use a metal pan), and it is ready to apply.

Use aluminum foil or wax over any part of the sculpture you don't want to patine, then baste the solution over the rest with a brush. A slight oxidation of the surface will soon show that the solution has bitten into the metal. When you see this evidence on all parts of the sculpture where you want a patina, stop the basting and bury the piece completely in a wooden box containing sand, sawdust, or fine soil.

To keep the chemistry working, any one of a number of liquids should be poured onto the sand or sawdust every day or two to keep it damp. You can use milk (unpasteurized so that it sours quickly), wine vinegar, a solution of 10 percent ammonia and 1 percent cupric nitrate, uric acid, or Purex in water. All will give you beautiful color. The longer the piece is left buried with the chemistry working, the heavier will be the patina on its surface. On bronze, the patina is an antique green hue with reddish spots, or a green-blue if more ammonia is used.

Uric acid is hard to obtain commercially and many sculptors solve the problem with (used) cat litter; the cooperation of a friendly dog or the use of human urine are other possibilities.

When you have reached the color you want, let the piece stand for a day, rinse off any traces of sand or soil with cold water--do **not** use a brush, for it will damage the new patina--and let it dry naturally. After the patina has dried a few days, you may use a soft brush very carefully to remove any traces of sand, sawdust, or soil.

A patina applied with this basting-and-burying method is not very durable, but it will become more durable with age. Once the sculpture is thoroughly dry, you may want to use a beeswax or paste wax to protect it. (The last section of this chapter gives more information about protecting patinas and metals against corrosion.)

Fume Patinas

This process causes a slight crystallization of the metal surface and results in a jewel-like finish on silicon bronze. The method is best for castings that are small enough to fit into an airtight plastic bucket or bag, or plywood box. A fume patina affects the surface less than the hot chemical patinas described later, because the chemical action is gentler. Fume patinas result in some soft color tones not easily achieved any other way, but leave much to chance in terms of the color and uniformity of the patina.

For a fume patina, you need a plastic or plywood container that will not let fumes leak out (see Figure 81) and a large, flat-bottom shallow plastic or glass dish, plus a couple of smaller plastic or glass dishes. Rest the sculpture on a wooden block set in the middle of the shallow dish or suspend it by a stainless steel wire.

Now you can use either of two routines. In the first, you put concentrated acetic acid in one of the smaller dishes and concentrated ammonia in another. Moisten the clean bronze surface by brushing it with fresh or distilled water, place it in the shallow bottom container, then close up the bag or box to prevent the escape of fumes and to keep them concentrated around the bronze. In about 10 to 30 days--it may take longer--a bluish-green patina will have formed on the bronze.

In the other routine, which gives an antique green patina to bronze, you make a solution of one part of nitric or hydrochloric acid to one part water. (Remember **always** to pour acid into water, **never** water into acid.)

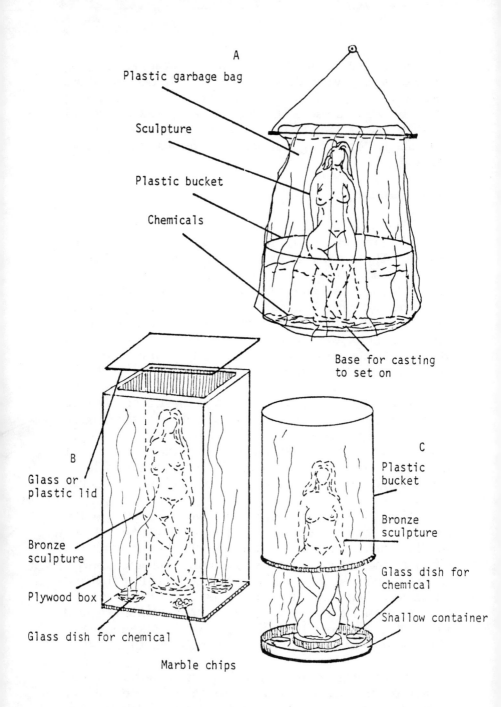

A
Plastic garbage bag
Sculpture
Plastic bucket
Chemicals
Base for casting
to set on

B
Glass or
plastic lid
Bronze
sculpture
Plywood box
Glass dish for chemical
Marble chips

C
Plastic
bucket
Bronze
sculpture
Glass dish for
chemical
Shallow container

FIGURE 81. FUME PATINA SYSTEMS

192

Put the acid solution into a plastic or glass dish and an equal amount of distilled water into another dish. Then put about 4 tablespoons of marble chips or calcium carbonate into the shallow bottom container, moisten the bronze with fresh or distilled water, place the dishes of acid and distilled water in the container, and close it all up. As in the first routine, patining should be complete in 10 to 30 days. (Other formulas for fume patinas are given in Chapter IX.)

Vat Patinas

Vat patinas or dipped patinas are really a subtype of cold process patinas (see below), but they are sometimes heated and also electrified. Studies of old patinas report that Tiffany used vats to do most of his patinas, and he also plated the bronze with copper first to help get some of the beautiful patinas of the Tiffany lamps and sculptures.

With a vat patina, you must be careful if the object is hollow that the chemicals do not get inside, for then the patina may leach out over a long period of time. The sculpture is put into a vat (usually made of porcelain or high fire clay) where the patina is produced by the mixture of chemicals and water. The buildup should be checked from time to time by removing the piece from the vat and rinsing it with cold water. This process may take from 1 hour to 7 days, depending on the color you wish.

Here are three good vat patina (dipped patina) recipes for application at room temperature:

1. **Blue**

 Sodium thiosulfate 60 grams

 Nitric acid 4 grams

 Water 1 quart

The metal should be dipped in the solution for 1 hour.

2. **Yellow-green**

Sodium thiosulfate	1 part by weight
Ferric nitrate	8 parts
Water	124 parts

The metal should be dipped into the solution for 3 minutes. A light green should form on the surface, the color depending on the bronze alloy. Then dip for 6 minutes in a diluted nitric acid solution. Remove the bronze, rinse, and dry.

3. **Brown**

Use the formula above for yellow-green, but leave in the vat longer--until the bronze appears brown.

All patinas applied cold should be rinsed when the desired color is obtained so that the chemical action does not continue.

Cold Process Patinas

It is important for all patinas, but particularly those of the cold process, that the surface of the bronze be very clean and free of any traces of grease, because the cold patinas do not bite well into the metal. Even if you have sandblasted the piece, it is always better to wash the surface with a weak solution of nitric acid (1 part nitric acid to 10 parts water) rubbing well with a brush and rinsing thoroughly afterward. Let the bronze dry naturally if possible. Do not worry at this point if the surface of the metal oxidizes or colors slightly. Begin right on top of the slight oxidation.

For good results with patinas made by the cold process, the chemicals should be very accurately mixed. A few drops of nitric acid may be used to help the patina bite. In this method, some of the recommended chemicals may be heated, but not boiled, to speed up the process. Be careful not to inhale the fumes from the hot chemicals.

One basic cold process is to mix separate solutions--each 3 tablespoons in 1 pint water--of cupric nitrate, ferric perchlorate, and acetic acid. Then mix the three pints together. This solution keeps well, and can be used over again and replenished in the above proportions when it runs out. The bronze sculpture can be put in a basting pan so the solution can be recovered. Pour or brush the solution a dozen or more times over the bronze. After 30 minutes to an hour, it should be evident--by the slight oxidation--that the solution has bitten into the surface of the bronze. After that, the solution is applied cold at intervals of 1 to 12 hours or more over one to several days or longer until you have a good patina. Between applications, let the bronze dry naturally. Between every third or fourth application, rinse the bronze with water and let it dry before reapplying more solution. If it's raining outside, just set the piece in the rain for a while--then let it dry.

Chemical patinas applied to cold metal do not shine when complete and dried. They can be left with their natural matt finish or given a gloss with wax or lacquer.

Hot Chemical Patinas

The hot patinas are so named because the metal to which they are applied is heated to open its pores.

The temperature should not be over 350°F. and usually closer to 200°F. An easy test is to sprinkle a few drops of water onto the metal. If the water sizzles but does not ball up, the metal is about right; if the water balls up, the metal is likely to be too hot.

The chemical solution is brushed on with a long-haired brush (Figure 82A) or stippled on with a shorter-haired brush (Figure 82B), or sprayed on with an ordinary spray bottle or air brush (Figure 82C). Then each coat is dried either in an oven or with the heating torch. The applications are repeated as often as necessary to get the desired patina. To check on progress, after every few applications you can wash the surface with a sponge and cool water, let it dry, and rub it gently with a clean cloth to remove any excess chemical. But washing is not always desirable because it may remove some of the patina.

In addition to knowing what chemicals to use (see below), you must be able to control the heat of the metal with your propane or gas/air torch. Be sure it is in good repair so that you can adjust the volume and strength of the flame and thus can apply more or less heat to any part of the bronze at any stage of the patination.

If you hold the sculpture in a vise while applying hot patinas, you run the risk of scratching it or contaminating the patina with oil or rust. It's safer to lay the sculpture on an asbestos pad. You will also need asbestos or other heavy gloves to handle the hot metal.

The principle chemicals used in hot patinas, and their effects on bronze are:

> Cupric nitrate--light green to blue-green
> Ferric nitrate--light gold to brown
> Ferric perchlorate--brown
> Bichromate of ammonia--light green
> Potassium sulfide--brown to black
> Ammonium sulfide--black to blue-black
> Ferrocyanide of potassium--enriches the color below.

All these chemicals are salt or solid forms with the exception of ammonium sulfide, a liquid. Use a full

A. Painting

B. Stippling

C. Spraying

FIGURE 82. APPLYING PATINA CHEMICALS TO HOT BRONZE

teaspoon dissolved in a pint of water as a good average solution. Store the solution, if you don't use it right away, in an airtight container and it will keep its properties well.

The bichromate of ammonia and the ferrocyanide of potassium are complementing chemicals, modifying or improving color. Bichromate of ammonia pushes green toward yellow-green. Ferrocyanide of potassium pushes green toward purple and violet.

The other chemicals can be used alone or in alternate applications. For example: after one or more coats of cupric nitrate have developed a green color on the bronze, you can add one or more applications of ferric nitrate (or ferric perchlorate or bichromate of ammonia) to give a brown. On top of this, you can apply one or more coats of the cupric nitrate to develop a green tone again.

Another example: having started with cupric nitrate and achieved some green, this time apply two or three coats of ferrocyanide of potassium. After that, try alternate applications of the copper nitrate and ferrocyanide of potassium to develop purple or violet coloring. You can work this to completion of the patina, or you can apply ferric nitrate following the ferrocyanide of potassium, then use a bichromate of ammonia solution.

It is not good practice to apply ferrocyanide of potassium on top of the nitrates or the ferric perchlorate. If you have already applied ferrocyanide of nitrate or ferric perchlorate, it must be "neutralized" with a coat of cupric nitrate before the ferrocyanide of potassium is applied.

Ammonium sulfide and potassium sulfide should also be used carefully. They darken all colors.

An excellent black patina can be obtained by mixing equal amounts of ferric nitrate and potassium sulfide solutions in one container, and equal amounts of ferric

perchlorate and of ammonium sulfide solutions in a separate container. Apply these two combinations alternately until you have the black you want.

A third or even more patinas can be applied over the cupric nitrate or immediately after the first--say, liver of sulphur--patina. One that goes well with cupric nitrate is ferric nitrate, which yields shades of green-gold, browns, blacks, or reds, depending on the strength of the solution and the heat of the metal. However, the effects of ferric nitrate are a little harder to control than some other hot patinas.

A black patina may be made even richer by using a burnout technique as demonstrated in Figure 83. Alcohol is poured over the loose straw in the container and over the patined piece itself. Then the straw is lit and the lid put on the container.

A brass-wire brush (or fine steel wool) can be used for highlighting after each application of patina. If you want to use brushes to apply the patina, they should be made of natural bristles and one should be reserved for each chemical solution to avoid contamination of the colors. Also, the metal neck of the brushes should be protected so that the iron and tin in the metal neck will not get into the patina. You may wish to scrub the patina vigorously. A brush that you clean potatoes with is very good for that. Some foundries in Europe use scrub brushes after every patina.

Well-managed hot patining will result in a natural shine after nothing more than a gentle rub with a soft clean cloth. If you want more shine, brush on a thin coat of lacquer or a coat of paste wax. In one to three hours, the wax will dry and the surface can be rubbed with another soft clean cloth. Do not apply the wax until after the last coat of patina has dried, you have washed the sculpture in clean water, the sculpture has been left in a dry place overnight, and you have checked its surface to be sure that the patina layers have not

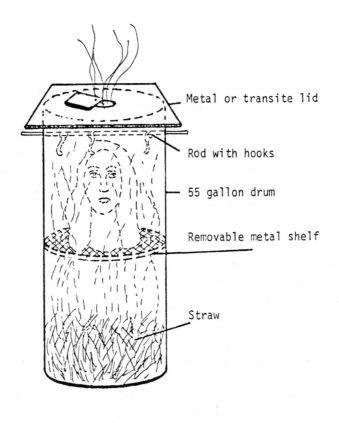

Metal or transite lid

Rod with hooks

55 gallon drum

Removable metal shelf

Straw

FIGURE 83. BURNOUT CONTAINER FOR BLACK PATINAS

reactivated. (Note: Sometimes water can change the patina color slightly.)

Hot Oil Patinas

The most universal of all metal patinas are the oils--linseed, olive, and motor oil. These three oils are easy to get and very inexpensive. They can be used by themselves on almost any metal, whether ferrous or nonferrous, to give a wide range of color from gold to black. Or oils can be used over a patina to add depth or change the color and/or to provide a protective coating, taking the place of wax, lacquer, or varnish. However, lacquer or wax used after the oil will give added protection.

Linseed or olive oil can give a beautiful gold to brown finish to copper, brass, or aluminum. Heat up the metal to around 250^{o} to 300^{o}F. with a torch before applying the oil with a soft brush, then turn the torch on it again. This process will have to be repeated many times to form light gold to a rich chocolate brown. With many coats, the sculpture will need no further protection.

Motor oil can give a gold to black finish to copper alloys. Use new oil for a gold to light brown finish; use old oil from your crank case, which has a lot of carbon and sludge, to get a dark brown to black patina. Again, heat the piece to around 250^{o} to 300^{o}F., and repeat the applications if you want a deep color.

Linseed or motor oil will produce a wide range of color values on ferrous metals, just as they do on nonferrous metals, depending on the amount of heat and oil applied and on the number of applications. Steel can be given brown to black finishes by coating it with linseed oil or motor oil and then burning the oil in with an oxyacetylene torch. To achieve these colors, the metal must be very hot--around 300^{o} to 350^{o}F. or hotter.

VARIABLES AND PROBLEMS IN CHEMICAL PATINAS

Even with care in following the guidelines above and the formulas in the next chapter, any two people may get markedly different results with the same patina formula.

Among the many variables in patining bronze, the biggest is probably the **metal** itself. Each smelter makes bronzes with different ratios of copper, tin, and lead, and most add some zinc. It is therefore well to choose one brand or source of bronze and adjust the patina formulas to suit it. Most of the formulas in Chapter IX are for Everdur, but may be used on other bronzes.

Another variable is the **water.** There is an even greater range of mineral content in water than there are differences in bronzes. It is a good idea to use distilled water in the patina mixtures because of its purity.

Apart from the content of the metal, the **surface** is important. Very shiny surfaces are difficult to patine, but it is nearly as difficult to define the degree to which the shine must be dulled so that the patina will adhere readily and permanently.

Of course, the **chemicals** are a major factor, both in their freshness and, even more important, in learning when to stop their application.

The degree of **heat** is another strong variable. It is difficult to regulate because of the variation in size and shape of sculptures and because of the heat lost during application of a patina. See Figure 84. If you are having trouble with a patina sticking to a part of the bronze because of grease or some other factor, Vari-Temp 3864S by Dupont is very good to clean the area as you are patining. Just brush some on the spot and reheat and continue with the patina.

Honey come

Vegetables

FIGURE 84. COAUTHOR RON YOUNG APPLYING A HOT PATINA FOR GEORGE SEGAL

PROTECTING THE PATINA

When a bronze patina is left unprotected, whether indoors or outside, it will be affected by moisture and chemicals in the air, just as bronze alone is. The carbon and oxides in urban air cause an unprotected piece to turn brown or black: rural air has more nitric oxides, which produce brown hues; and near the ocean, copper salts cause green coloring. A textured surface will tend to oxidize faster than a smooth surface.

Moisture is the main danger to bronze. Water from a patina solution can get trapped in the metal or in pockets of the patina. Thus, it is important to leave a patina for at least 3 hours--or up to 2 days--to stabilize. Putting the piece in an oven at very low temperature for 1 to 3 hours is a good way to be sure that all the water has evaporated. Then any of a number of organic or inorganic protective coatings can be applied. Some sculptors still use beeswax with benzene, the favorite protector used in the 19th century when artificial patinas were first developed. Other waxes also may be used with or without benzene or kerosene. For example, Johnson's Paste Wax and Butcher's Bowling Alley Wax can be used with candle dyes or analine dyes to tint the wax (such tinted waxes can be applied directly to bronze as a finished patina, but may not be as durable as the chemical patinas). Shoe polish can also be used to enrich a patina's color. Kiwi shoe polish is the best because it is natural wax and comes in many colors. First, warm the metal slightly before applying the wax. A hot patina will adhere more strongly to a bronze surface than a cold patina, so that you can rub the metal more vigorously after applying the wax. You must apply the wax more gently to a cold process patina, which does not bite into the metal nearly as well. For a fume patina, which is fragile and easily damaged, a lacquer or acrylic plastic spray should be used instead.

Even the most thorough waxing will not protect a bronze patina forever. After a number of months,

moisture will attack it in a number of ways that are still not entirely understood. For instance, there are at least six sulfates containing copper compounds that can form when copper alloys corrode in the presence of sulfur compounds; and some twenty copper-containing compounds have been identified in natural patinas.

In the presence of moisture, some chemicals work on the bronze and some work on other chemicals Ozone (O_2) in the air contributes to the damage, and the chemicals in the patina further complicate the situation.

The different parts of Figure 85 illustrate different chemical buildups on waxed and unwaxed bronze surfaces. Part A shows how, even when waxed, a bronze surface can corrode and show a "natural" brownish-green patina. An old bronze left unprotected for years (part B of Figure 85) will show a green patina. When moisture penetrates the wax or is trapped in the patina, cupric chloride disease can occur and is evidenced by the formation of pale green powder--see part C of the figure. Another problem, illustrated in Figure 86, can be called "bronze rot." It is evidenced by a white-gray film that forms under the wax when high humidity or a change in temperature causes the bronze to sweat. It can be stopped by putting the sculpture in an oven or kiln at a very low temperture for 1 to 6 hours.

Once you have cured the disease, try to prevent further trouble for as long as possible by rewaxing the bronze carefully. If the patina or bronze itself needs restoration, the information in our Chapter IX will help.

When the patina is complete--when the bronze has the final tone and color you want--and is dry, warm the bronze up and you are ready to put on a thin coating of wax. If you like the patina just as it is, then a clear paste wax will do (Johnson's Paste Wax), but if you wish to enrich the patina, a colored wax may be desirable. Here, Kiwi wax is good. It will greatly enrich the color but will not change it. A wax will go on better if the

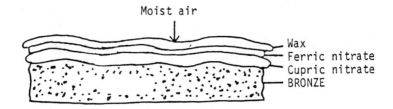

A. Brown-green patina builds up under wax

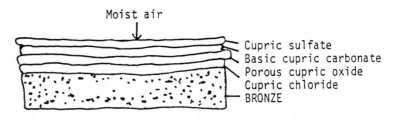

B. Green patina many years old has built up

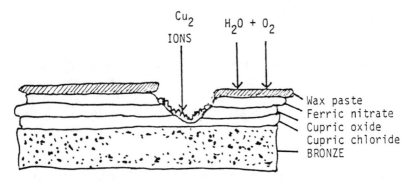

C. Cupric chloride disease

FIGURE 85. MOIST AIR ATTACKS ON BRONZE

Possible Coatings

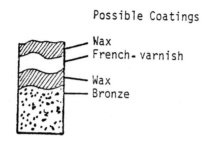

Wax
French-varnish
Wax
Bronze

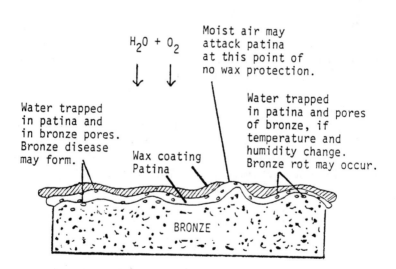

$H_2O + O_2$

Moist air may
attack patina
at this point of
no wax protection.

Water trapped
in patina and
in bronze pores.
Bronze disease
may form.

Wax coating
Patina

Water trapped
in patina and pores
of bronze, if
temperature and
humidity change.
Bronze rot may occur.

BRONZE

FIGURE 86. "BRONZE DISEASE" AND "BRONZE ROT"

207

piece is warm (**not** hot) because the wax will sink into the surface better. Wax may be put on after the piece is cool too, but then you may wish to thin it with benzene. After the wax has been applied, let the bronze piece sit overnight in a dry room if possible. Then if you can scrape the bronze surface with your fingernail and it becomes shiny, the wax is ready to be polished.

More coats of wax may be applied for a deeper shine. If you want a glossier look, use lacquer. French varnish may be used for a more matt look. The lacquer or varnish should be applied on a dry but barely warm bronze. It may take two coats or more.

One of the best coatings for outdoor and indoor bronzes is Incralac 69X-1732 (Stan Chem) an air-drying acrylic resin. In an extensive research program initiated by the International Copper Research Association, Incralac was found to provide the best protection for copper alloys of all air-dry coatings. It contains a corrosion inhibitor, benzothiazole, with an acrylic resin. It gives good protection for 1 to 3 years outdoors and much longer indoors. The best way to apply Incralac is by spraying on two coats--letting each coat dry for half an hour. Then apply a very thin transparent coating of pigmented wax to add richness to the patina and then one more coat of Incralac. Waxes will also help cut down the shine on the bronze.

Linseed oil may be used on bronze. It is applied hot as a coating by itself.

For iron and steel, linseed oil and turpentine in a 50/50 solution is one of the best protections. Apply hot or cold. Many coats may have to be applied for best protection. Masury oil may also be used. It is a varnish that was used by David Smith on steel and iron. He would let his piece weather for a year or so, then scale the rust off, and seal the surface with Masury Oil varnish.

IX

Patinas for Metals

In this chapter we give patina formulas and instructions first, for bronze, followed by patinas for copper and brass, then silver, aluminum, zinc, tin, lead, and finally, steel and iron. The chapter ends with a note of historical interest--some dry paste patinas for bronze, copper, or brass described in a book published about 1890.

Coauthor Ron Young has tried many of these patinas but we cannot guarantee any of the results, since patining is still much more of an art than a science. We do suggest that you try a patina first on a scrap of the same metal as your casting.

BRONZE

The patining of bronze usually starts with chemicals that bring a basic brown or black to the metal, which gives depth to subsequent coats of chemicals producing greens, blues, or other hues.

Browns and Blacks

One of the most common chemical patinas for bronze is:

Liver of sulfur	1 large lump, crushed
Water	1 pint

Using a brush (natural bristle) or spray bottle, cover the surface of the bronze. Heat the metal and continue to apply the patina until it sizzles as it goes on and the bronze turns black all over. Place the bronze in water and when it has cooled, vigorously brush with a wire brush or steel wool, keeping it wet. This will remove a bit of the black or brown, leaving it chiefly in the hollow areas--a nice light and dark contrast.

Do not rub the bronze when it is hot or a leaded look will result, which is difficult to get rid of. For very dark bronzes, leave more of the black on.

Liver of sulfur is a good base patina for almost any other patina. It is even good for large outside bronzes because it is relatively easy to apply and provides an attractive and relatively uniform coloration.

This formula may be used without heat for a light to dark brown, depending upon the amount of liver of sulfur in the water. (Remember, liver of sulfur should set about four hours.)

Another basic and versatile patina that goes well over or under many other patinas is:

Ferric nitrate	1 teaspoon
Water	1 pint

Build it up in thin layers from a golden brown to a deep red-brown. The amount of ferric nitrate may be increased or decreased, depending on the shade of brown

that you want--the more chemical, the darker the brown will be. For a transparent patina, use an air gun. A stippling brush should be used for a more opaque patina.

For redder brown, the following home-made ferric solution works well. Fill a pint jar half full of rusty nails, pour a little water in the bottom of the jar, and leave for about a week while the nails rust further. Then cover the nails with nitric acid: this should be done outdoors, for the resulting fumes are highly toxic. The mixture gets better with age, and it can be used for many months. The proportions are the same as above--1 teaspoon of ferric nitrate to 1 pint water.

Here are some other patinas using ferric nitrate:

Ferric nitrate	1 tablespoon
Ferric perchlorate	1 tablespoon
Water	1 pint

An excellent hot or cold process patina that works well on all bronzes, this gives a semi-opaque or opaque patina. If put on hot, a rust- brown color will appear immediately on the bronze (note: the bronze must be very hot). If applied cold, it will take from two to three hours to work. This patina works well with cupric nitrate, giving an orange-brown. It may be sprayed or stippled on with a brush.

For light to orange-brown and green, try:

Ferric nitrate	1 tablespoon
Cupric nitrate	1 tablespoon
Water	1 pint

This is an excellent hot-process opaque patina. Color appears immediately after application if the bronze is medium hot. This is a good opaque patina when stippled

on with a stippling brush. Many coats may be required. The patina will appear slightly dark yet more transparent if wax is rubbed over it.

Another good hot-process, semi-opaque patina is:

Ferric nitrate	1 teaspoon
Ferric oxide	1 teaspoon
Water	1 pint

Color appears immediately after application. The red iron oxide will have a tendency to go into the recessed areas of the bronze, causing a deeper rust-brown in those areas.

Use this patina at a boiling temperature, applied with a brush:

Golden antimony sulfide	1 tablespoon
Caustic soda (lye)	2 ounces
Water	1 gallon

If the color is not even or dark enough, repeat the brushing process.

A brown patina for the vat (dipping) process is:

Cupric sulfate	4 ounces
Potassium chlorate	2 ounces
Water	1 gallon

Immerse the work in this solution for a minute or so. Then, without rinsing, immerse it in a solution made of 1 ounce liquid sulfur to 1 gallon water. Then rinse the piece in cold water and, if the color is not dark enough,

repeat both the dipping operations. Finally, rinse in hot water, and scratch-brush dry with sawdust.

A solution that produces a red-brown patina when put on hot is:

Cupric sulfide	40 grams
Liver of sulfur	40 grams
Ferric oxide	10 grams
Water	4 liters

If just cupric sulfide and liver of sulfur are used, a blue-black will occur.

A darker red-brown results from:

Cupric sulfide	1 teaspoon
Liver of sulfur	1 teaspoon
Water	1 pint

First heat the bronze and apply the solution. Then, with steel wool, lightly burnish smooth areas, then reheat and spray or brush a solution of ferric nitrate onto the bronze--see above. The metal should be hot enough so that the ferric totally dissipates upon hitting the surface. Stippling on the ferric nitrate solution also produces nice results.

A solution that should be heated to about 140°F. before applying is:

Nickel sulfate	1/2 ounce
Cupric sulfate	1/2 ounce
Potassium chlorate	1/2 ounce

Water	1 gallon

Apply with an intermediate wet scratch brush to even out the color. This patina works better on 85/3/5 bronze than on Everdur. Waxing improves the color considerably.

A patina that does work particularly well on Everdur is:

Sodium thiosulfate	1 part by weight
Ferric nitrate	1 part
Water	128 parts

This is an excellent cold process patina.

Another good solution for Everdur is:

Cupric chloride	3 ounces
Ammonium chloride	1/2 ounce
Water	1 pint

If this patina is put on cold, it will turn green. After it turns green, it will turn an orange-brown if it is put under hot tap water. Also, if this patina is put on very hot over a patina of ammonium sulfide or liver of sulfur first, and cupric nitrate second, the bronze will turn orange to brown.

A transparent, dip or brush type patina that gives a Japanese brown hue is:

Cupric sulfate	5 ounces
Cupric acetate	5 ounces
Cupric carbonate	5 ounces

Water	1 quart

It works well on 85/3/5 but will turn black on silica bronze.

A nice brown patina can result from:

Ammonium carbonate	3 parts
Cupric acetate	1 part
Tartaric acid in vinegar	1 part
Sodium chloride salt	1 part

Make a paste of these ingredients, smooth it over the bronze, leave on for about an hour, then rinse off with hot water.

An excellent hot, semi-opaque brown to black patina is:

Antimony sulfide	2 parts by weight
Caustic soda (lye)	4 parts
Water	256 parts

Like the Japanese brown patina described above, this one works well on 85/3/5 but will turn more black on silica bronze. The color will appear immediately after application. This patina can also be applied cold. A preservative is necessary.

A combination chemical and oil patina starts with a light coat of ferric nitrate (1 teaspoon nitrate to 1 pint water) applied to hot bronze. On top of this put a coat of motor oil, then heat the bronze until you have a very warm chestnut brown. Three coats of oil will give you a very dark brown to black. Cool the bronze in water or air, and apply wax to alleviate any stickiness.

A vat solution for a brown patina is:

Ammonium chloride	4 parts
Potassium oxalate	1 part
Acetic acid	200 parts

Heat the solution, then dip the bronze in it for 4 to 5 minutes. Dry and repeat the dip until the color has the depth that you want.

A solution that will be brown to black on silica bronze but a nice golden yellow to rich orange on 85/3/5 is:

Sodium thiosulfate	1/4 ounce
Ferric nitrate	2 ounces
Water	1 quart

This is a very toxic mixture, so use it only in a well-ventilated place. It can be used either as a dip--in which case, bring the solution to the boiling point--or applied to hot bronze. On a highly polished surface, apply it in several thin layers and then use a preservative.

After you have gotten a brown or black patina with any of the above formulas, you can apply a solution giving green, then apply alternate brown and green.

For example, on silica bronze you can start with the common brown patina:

Liver of sulfur	1 large lump, crushed
Water	1 pint

Next, apply the following cupric nitrate solution for green:

Cupric nitrate	1 tablespoon
Water	1 pint

Then, heat up the bronze until it is very hot and apply:

Cupric chloride	3 ounces
Ammonium chloride	1/2 ounce
Water	1 pint

The result will be an orange-brown patina on silica bronze. A preservative is necessary.

A purple-brown can be obtained by first applying a basic cupric nitrate solution to the hot bronze, then a coat of a saturated solution of potassium ferrocyanide.

There are two cold process patinas that result in very red-browns. We have found that they both work well on 85/3/5 but not on silica bronze. The first of these is applied as a hot solution:

Cupric sulfate	6-1/4 ounces
Cupric acetate	1 ounce
Aluminum potassium sulfate (alum)	2-1/2 ounces
Water	1 gallon
Acetic acid	few drops

The second cold process patina is trickier. If the proportions are wrong, the bronze will end up dark green to blue-green instead of a deep rust-red:

Cupric nitrate	48 grams
Ammonium chloride	48 grams
Calcium chloride	20 grams
Cupric sulfate	10 grams
Oxalic acid	10 grams
Water	1/4 liter

Brush on the solution, then immerse the bronze for 30 minutes in a solution of 1 part nitric acid to 8 parts water. Remove, rinse well in cool water, and allow to dry.

A simple cold solution that works well on all bronze is:

Ammonium sulfide	2 ounces
Water	1 quart

These ingredients will result in a blue to black patina. The solution can be applied hot or cold . A preservative is optional.

Ammonium sulfide will darken all colors and it should therefore be used carefully. It may be used as the last step in this patina:

Ferric nitrate	50 grams
Liver of sulfur	50 grams
Water	1/2 liter

* * * * * * * *

Ferric perchlorate	50 grams
Ammonium sulfide	50 grams
Water	1/2 liter

This black patina can be obtained by mixing equal amounts of the ferric nitrate and liver of sulfur solution together, and in a separate container equal amounts of the ferric perchlorate and ammonium sulfide solution. Apply these two separate solutions alternately until you have a black patina. Now, put the bronze sculpture into a steel container with some straw all around it and pour alcohol over the straw and bronze. Light the straw and cover the container, letting the smoke darken the patina even more. The bronze sculpture may also be held above the straw on a removable tray, so that the straw itself does not get on the patina.

A vat solution for a black patina is:

Cupric carbonate	2 parts
Ammonium carbonate	4 parts
Sodium carbonate	1 part
Water	32 parts

Heat the solution to the boil and immerse the bronze in it. The solution should be stirred every once in a while.

An excellent black patina that can range from semi-transparent to opaque is more complicated. First, apply a light green base with a hot-process cupric nitrate solution. Then apply a light coat of brown with a ferric nitrate solution. Then mix the following two solutions.

Batch A:

Ammonium sulfide	1/2 teaspoon
Ferric nitrate	1/2 teaspoon
Water	1/2 pint

Batch B:

Potassium sulfate	1/2 teaspoon
Ferric nitrate	1/2 teaspoon
Water	1/2 pint

Apply Batch A, then water; apply Batch B, then water; apply Batch A, then water; and so on, until you get the effect you want.

A transparent black patina is a solution of:

Gold trichloride	1 part by volume
Water	200 parts

For immediate results, paint or spray on one coat of this solution.

Renaissance Black

This patina works well on all bronze.

Cover the bronze with cupric nitrate and let it oxidize and dry a bit. Heat surface lightly over a smoking straw fire, until desired color is obtained; keep turning the bronze in the smoke. Clean the surface with ammonium chloride (sal ammoniac). Bury in a flower pot of sand. Pour milk into this to the soaking point every two days. After two weeks, take out the bronze, cover it with a chalk and rebury in sand. Pour milk in every two days for two or three weeks. Take

out and brush off the surface.

The above patina may be stopped after it is smoking in straw for 2 to 3 hours. If the bronze sculpture is on a shelf above the smoke and flame, it will be a metallic black. If put into the straw, it will be a matt black. This formula works well on silica bronze. Black shoe polish may be put on after to enhance the color. Wax is optional.

A black patina that adheres well is:

Liver of sulfur	2 teaspoons
Caustic soda	1/2 teaspoon
Water	1 quart

Heat the casting and apply the solution in a fine spray. This mixture works best when it is fresh, and will lose sticking power as it gets older. It burnishes well with a wire brush, and becomes a warm brown-black when waxed.

For a nice warm black patina, start by mixing 1 teaspoon each of ferric nitrate and cupric nitrate in a pint of water. Apply to hot bronze. The color should be a soft brown-green. Next, apply:

Ammonium sulfide	2 ounces
Water	1 quart

You may continue to alternate the two formulas for a deeper black.

Greens and Blues

The majority of green patinas are achieved by the application of chlorides, particularly solutions of sal ammoniac (ammonium chloride) and hydrochloric acid. You should be particularly careful with the chlorides.

It has been found that thin sheets of copper that had been treated with a thin coating of ammonium chloride and then exposed to a humid atmosphere quickly became pitted. If you are using chlorides, they should be stopped out well (sealed) with wax or other sealer.

Dark green patinas start with a coat of the basic brown-black made from liver of sulfur dissolved in water. This is followed by copper (cupric) nitrate and then, possibly, ferric nitrate. The metal must be very hot when ferric nitrate is applied; too strong a solution will cause a chalky patina. If this happens, rinse off with water and scrub with a stiff brush. The basic brown-black coat is omitted for lighter green hues on bronze.

A basic green patina that works well on all bronzes but is a particularly beautiful blue-green on 85/3/5 is a simple formula:

Cupric nitrate	2 teaspoons
Hot tap water	1/2 pint

A weaker solution gives a lighter green; a stronger solution--or more applicaitons--gives a darker blue-green. The bronze must be hot enough that the solution does not run when it is stippled or sprayed on in thin washes-- the solution should vaporize on contact. Darker blue-green may be obtained by putting cupric acetate over the cupric nitrate.

A more complicated hot patina is made up of two solutions:

Cupric nitrate	2 tsp. to 1 pint of water
Ferric nitrate	1/2 tsp. to 1 pint of water

Build up a layer of cupric nitrate solution. Wash and then apply a thin coat of ferric nitrate solution. The

result is an apple green.

A good basic cold process patina is:

Ammonium chloride	7 parts by weight
Cupric acetate	4 parts
Water	3 parts

After several applications, the result is a heavy, opaque yellow-green to green-blue patina.

A similar patina is:

Ammonium chloride	1 tablespoon
Cupric acetate	1 teaspoon
Nitric acid	10 drops
Water	1 pint

More complicated is another cold process formula that gives a light green:

Ammonium chloride	1 tablespoon
Ammonium hydroxide	1 tablespoon
Sodium chloride	1 tablespoon
Nitric acid	10 drops
Wine vinegar	1 pint

Apply at 12-hour intervals for several days. For a deeper green, 1 tablespoon of copper sulfate can be added to the solution.

A good base green patina over which other patinas can be applied is:

Cupric chloride	3 ounces
Ammonium chloride	1/2 ounce
Water	1 pint

The solution can be applied either cold or heated to a boil; in the latter case, the result is gray-green.

There are several other cold process green patinas, the solutions for some of which can be made from household chemicals. For example:

Vinegar	40% by weight
Household ammonia	40%
Salt	10%
Lemon juice	10%

Or try:

Salt	3 parts by weight
Cream of tartar	3 parts
Ammonium chloride	1 part
Boiling water	12 parts

After dissolving the ingredients in the water, add 8 parts cupric nitrate solution.

Another cold process patina that works well on 85/3/5 but does not bite well on silica bronze is:

Cupric nitrate	40 grams
Ammonium chloride	40 grams

Calcium chloride	40 grams
Water	to make one liter (approx. 4/5 quart)

Apply at 1/2-hour intervals. The color is not usually satisfactory alone but combines well with most brown and black cold process patinas.

The following patina, too, works well on 85/3/5 but not so well on silica bronze:

Ammonium chloride	3 tablespoons
Ammonium hydroxide	1 teaspoon
Sodium chloride	1 teaspoon
Nitric acid	1 teaspoon
Cupric carbonate	1 teaspoon
Wine vinegar	1 pint
Water	1 pint

Yet another cold process patina, this one results in a heavy opaque green:

Sodium chloride	5 parts by weight
Ammonia water	4 parts
Ammonium chloride	5 parts
Acetic acid	4 parts
Water	32 parts

A solution that gives a bluish-green patina on 85/3/5 but turns bluish-black or brown on silica bronze is:

Sodium thiosulfate	1 ounce
Ferric nitrate	8 ounce
Water	1 gallon

In contrast to the above, the following cold process patina remains green on silica but turns brown on 85/3/5:

Barium sulfide	1 ounce
Liver of sulfur	1/4 ounce
Ammonia water	2 fluid ounces
Water	4 quarts

Several similar solutions produce a dark green patina on cold bronze after several applications and a wait of up to 24 hours. Some of these are summarized below--read down the columns--in terms of parts by volume:

Ammonium chloride	10	8	--
Sodium chloride	20	8	20
Cupric carbonate	30	--	--
Cream of tartar	10	--	20
Acetic acid	100	500	100
Ammonium hydroxide	--	15	--
Ammonium carbonate	--	--	60
Cupric acetate	--	--	20

Some solutions produce a good verde green on 85/3/5 but a lighter or grayer green on silica bronze.

226

One of these is as follows:

Cupric nitrate	8 ounces
Ammonium chloride	4 ounces
Acetic acid	4 fluid ounces
Chromic acid	1 fluid ounce
Water	1 gallon

When this coat is dry, apply another if necessary.

For a vat process, opaque verde green, use:

Cupric nitrate	1 part
Ammonium chloride	1 part
Calcium chloride	1 part
Water	32 parts

Immerse the piece for a few minutes, then remove. Repeat the dipping until the color develops, then rinse well in cool water and allow to dry.

Before we leave the shades of green, here is a solution that can bring a beautiful purple-green to bronze:

Cupric nitrate	2 tablespoons
Ammonia water	1 pint

The bronze must be very hot for this formula, which should be applied with a spray gun, if possible. This patina can be used with others but if used alone, it must be preserved immediately or the purple-toned green will turn to turquoise green. Wax, then lacquer, then wax again. This patina works well over a white patina

and is stable.

Turning to shades of blue--one cold process patina is made by combining two solutions:

Ferric chloride	60 oz. per gallon
Potassium ferricyanide	60 oz. per gallon

Combine the two and heat to about $150^{\circ}F$. before applying. This mixture also works well as a vat patina.

Another light green (on Everdur) to blue patina is made from:

Liver of sulfur	15 grams
Ammonium chloride	200 grams
Water	1 liter

Brush this solution on at room temperture.

Three other blue patinas are for the vat (dipping) process. In one you use:

Sodium thiosulfate	150 grams
Lead acetate	25 grams
Cream of tartar	30 grams
Water	1 liter

Immerse the piece for 20 to 30 minutes, then rinse, air dry, and apply a preservative immediately to retain the peacock-blue shade.

A transparent blue patina is:

Sodium thiosulfate	60 grams

Nitric acid	4 grams
Water	1 liter

Again, a preservative is necessary.

For a semi-opaque, blue-black patina, try:

Barium sulfide	1 part by weight
Water	128 parts

Immerse the bronze overnight at room temperature. Rinse, dry, and apply a preservative.

A rich opaque blue on bronze can be obtained simply by saturating sand with ammonia and leaving the bronze buried in it for 7 to 10 days. For a bluish green, use acetic acid or vinegar.

Whites

A simple way of whitening the surface of bronze is to paint it with diluted liquid gesso and buff it down slightly, as desired, with steel wool or a brush. (Powdered colors can be added to the gesso for other surface effects.)

Much more lasting and beautiful is an antique white patina, which is also one of the most difficult to apply to bronze. It is a solution of bismuth nitrate (or bismuth trichloride or carbonate) that is very chalky to apply and needs an undercoat to cling to. It is a beautiful patina either alone or as an under layer that gives a pastel tone to subsequent layers of colored patina. You start by applying the base coat of:

Cupric nitrate	2 tablespoons
Water	1 pint

Or the base coat may be:

Ferric nitrate	1 teaspoon
Water	1 pint

The key to success with the white patina is to have the bronze very hot--around 350°F.--before applying several thin coats of:

Bismuth nitrate	2 teaspoons
Water	1 pint

Follow these coats with:

Bismuth chloride	1/2 teaspoon
Water	1 pint

A more opaque white can be obtained by adding tin oxide or titanium oxide to the bismuth nitrate, which otherwise goes on in very thin, transparent layers.

Another hot patina is:

Sodium chloride	2 tablespoons
Cupric sulfate	1 tablespoon
Water	1 quart

This will turn white almost instantly but is very unstable and so should be waxed or lacquered within a few hours. Equal amounts of the chloride and sulfate in solution turn Everdur bronze a gray color.

For a silver-white patina, apply the following to hot bronze:

Silver nitrate	1/2 teaspoon

| Water | 1 pint |

This can be a good base patina for other colors.

COPPER

Many of the patinas described above for bronze also work well on pure copper. They are repeated here for convenience.

Browns and Blacks

Depending on the number of coats or dips, the following solutions will turn from light browns to near blacks on copper. But first, the basic blacks:

| Liver of sulfur | 1 large lump, crushed |
| Water | 1 pint |

Heat the copper until the solution sizzles as it goes on.

Another basic black is:

Cupric sulfate	1 teaspoon
Liver of sulfur	1 teaspoon
Water	1 pint

Again, heat the copper until the solution sizzles when applied.

Yet another black patina for copper is:

Liver of sulfur **or** Sodium sulfide	1/4 ounce
Household ammonia	1-1/2 ounces
Water	32 ounces

Do **not** heat this solution, for heat would drive off the ammonia. This patina give an "antique," subdued effect on copper.

There are several formuals for brown that can be applied either as vat (dipped) or hot patinas. One is:

Ferric nitrate	1 teaspoon
Water	1 pint

The following vat or hot patina works well without a preservative:

Potassium oxalate	1 ounce
Ammonium chloride	3 ounces
Acetic acid	1-1/2 pints

A dark brown patina is made from:

Cupric sulfate	1 ounce
Sodium thiosulfate	1 ounce
Hydrochloric acid	1/2 pint
Water	1 pint

This vat or hot patina works well with other patinas on copper.

Another brown patina formula is:

Lead oxide	59 parts by weight
Chalk	12 parts
Acetic acid	3 parts

Alcohol	6 parts
Water	20 parts

Heat the solution and apply it to the hot copper either with a spray bottle or stippling brush.

A simple vat solution is:

Liver of sulfur	2 teaspoons
Sodium hydroxide (lye)	3 teaspoons
Water	1 quart

Heat the water to make this solution.

Two cold process, brown patinas follow:

Ferric nitrate	1 tablespoon
Sodium thiosulfate	1 tablespoon
Water	1 quart

This is an excellent, opaque patina that works well without a preservative.

A similar patina is made of:

Potassium chlorate	150 grams
Copper sulfate	150 grams
Water	1-1/2 liters

The following patina is suitable for copper pieces that have a raised design or hammer work:

Sodium chloride	10 ounces
Ammonium chloride	4 ounces

Copper nitrate	10 ounces
Glycerin	1 ounce
Water	1/2 gallon

Heat the solution, apply it by brush, allow it to dry, then highlight the piece by rubbing with a damp cloth. The high spots will be dark brown but the recessed areas that are not rubbed will become dark green.

Reds

With the right patina, copper can gain tones from brownish red to bright red. (The beautiful red colors of Tiffany lamps were obtained this way.)

A vat solution used commercially for a terra cotta hue is:

Copper sulfate	1 pound
Sodium chloride	4 ounces
Nickel sulfate	2 ounces
Water	1/2 gallon

The solution must be hot and the copper piece should be kept moving during the dip, preferably by means of slinging it from copper wire. The patina can be finished with a brass wire brush.

Another red patina formula is:

Red arsenic sulfide	1 ounce
Potassium carbonate	1 ounce
Water	1 pint

Heat the solution and immerse the copper in it until the right red hue is obtained, then rinse in water and allow to dry. Remember that arsenic compounds are **very dangerous,** so handle them with **great care.**

A brilliant royal red on copper is obtained in a more complicated process. The copper is plated with lead, then heated to a cherry red, then allowed to cool at room temperature. The resulting black film is removed by rouge and buffing, exposing the red copper oxide beneath.

Copper can develop a fiery red when dipped in a hot solution of:

Potassium chlorate	75 grams
Nickel carbonate hydroxide	30 grams
Nickel sulfate	75 grams
Water	1 liter

Another red patina for the vat process is:

Cupric sulfate	5 ounces
Potassium permanganate	7 ounces
Water	2 gallons

A more orange-red comes from dipping in the following hot solution:

Cupric acetate	2 tablespoons
Water	1 quart

And a more violet-red comes from dipping copper in a hot solution of:

Antimony chloride oxide	2 tablespoons
Water	1 quart

When this patina has been rinsed and dried, rub it with a cotton cloth to highlight.

A subtle red to blue to lilac hue is given to copper when it is dipped in the following solution:

Yellow arsenic sulfide	75 grams
Sodium carbonate	150 grams
Water	1/2 liter

Blues and Greens

A simple vat solution to turn copper bluish is:

Liver of sulfur	2 ounces
Sodium chlorate	2 ounces
Water	1 quart

A bright blue comes from dipping copper in:

Lead acetate	1/2 ounce
Sodium thiosulfate	1 ounce
Water	32 ounces

Immerse the piece for only about 15 seconds. And be careful: lead acetate is poisonous.

A bluish-green is given to copper by the following cold process solution:

Cupric carbonate	3 parts by weight
Ammonium chloride	1 part
Cupric acetate	1 part
Cream of tartar	1 part
Vinegar (strong)	8 parts

Paint the solution on daily for 3 or 4 days.

Bluish-green can also be obtained on copper first by applying one of the green patinas, followed by dipping the piece in:

Ammonium chloride	2-1/2 ounces
Ammonium carbonate	7 ounces
Water	1/2 gallon

A yellow-green dip for copper is made of:

Ammonium chloride	2 ounces
Potassium oxalate	1/2 ounce
Acetic acid	10 ounces
Water	1/2 gallon

A more complicated solution is applied by brush and results in a Tiffany green:

Cupric sulfate	4 ounces
Ammonium chloride	4 ounces
Sodium chloride	2 ounces
Zinc chloride	1/2 ounce

Glycerin	1/2 ounce
Acetic acid	1 ounce
Water (hot)	1/2 gallon

When the solution has cooled, brush it on and leave it overnight.

A somewhat more corrosive solution that is also brushed cold onto copper is:

Cupric carbonate	12 ounces
Potassium bitartrate	4 ounces
Ammonium chloride	4 ounces
Acetic acid	8 ounces
Water	1/2 gallon

Leave the solution on for 3 or 4 hours or longer if necessary for an antique green patina to develop. Then stop the reaction with a thorough rinsing in water, and air dry.

Gray

Dipping copper in the following solution at boiling point will turn it steel-gray:

Arsenic trichloride	1/2 ounce
Water	1 pint

Be very careful, for this solution is **extremely poisonous.**

BRASS

Brass is very difficult to patine. Best results are

obtained if the casting is soft or medium-hard brass.

Browns and Blacks

One of the brown patinas for brass is:

Potassium chlorate	5-1/2 ounces
Nickel sulfate	2-3/4 ounces
Cupric sulfate	24 ounces
Water	1 gallon

This patina must be applied to hot brass if it is going to adhere.

Another hot patina is:

Ferric nitrate	18 ounces
Sodium thiosulfate	18 ounces
Water	1 quart

This gives an excellent brown opaque patina which appears immediately after application to hot metal. The solution can also be applied cold, in which case a preservative is needed.

Another solution that can be applied cold is:

Potassium chlorate	1 ounce
Nickel sulfate	2 ounces
Water	20 ounces

This patina is dark brown.

For a lighter brown, try the following vat solution:

Barium sulfide	1/2 ounce
Ammonium carbonate	1/4 ounce
Water	1 gallon

The color is made more clear by wet scratch brushing and redipping. The solution must be hot.

Get red-brown shades by briefly dipping the piece in this solution:

Cupric carbonate	1/2 ounce
Household ammonia	7-1/2 ounces
Sodium carbonate (washing soda)	1/4 ounce
Water (near boiling)	48 ounces

Cold-rinse the object and dip for a moment in well-diluted sulfuric acid, then rinse again in cold water.

A standard solution for black on brass is even simpler:

Cupric sulfate	1 tablespoon
Liver of Sulfur	1 tablespoon
Water	1 pint

Apply to hot brass, then preserve with a coating of wax or lacquer.

Another formula for a black patina is even simpler:

| Cupric nitrate | 1 ounce |
| Water | 6 ounces |

On heating the brass, the copper nitrate changes to a permanent dark patina of copper oxide. Casey's "Perma Brass Black" can be rubbed on to darken the color. Alternatively, you can dissolve copper scraps in concentrated nitric acid (caution!) diluted with an equal amount of water in a glass container. Leave the piece immersed until the right depth of black is produced, then rinse well with water.

A vat patina that produces a velvety black is:

Bismuth nitrate	1 teaspoon
Water	1 quart

Gray rather than black results from this vat solution:

Ammonium sulfate	1 part by volume
Water	4 parts

This dip needs a considerable time to produce good depth of color, and is not always consistent in its effects on brass.

Reds and Violets

A cold process patina of red comes from:

Copper sulfate	5 ounces
Potassium permanganate	7 ounces
Water	1 pint

The patina may take 2 to 3 hours to develop.

Another, brighter red patina on brass is:

Potassium chlorate	2 teaspoons

Nickel carbonate hydroxide	1 teaspoon
Nickel sulfate	2 teaspoons
Water	1 pint

This patina, too, should be applied cold.

A vat solution that will eventually produce red is:

Sodium hydroxide	6 ounces
Cupric carbonate	12 ounces
Water	1/2 gallon

First yellow, then orange, then red are produced on brass immersed in this solution.

A two-part patining that gives violet hues starts with:

| Ammonium chloride | 10 ounces |
| Water | 1/2 gallon |

Brush this on after the brass has been heated to where it's difficult to hold by hand. Then brush on the following solution, or immerse the piece into it:

| Antimony chloride | 2 ounces |
| Water | 10 ounces |

Blues and Greens

Another antimony-blue patina is a two-part dip. The first part is:

Antimony chloride	3 ounces
Crystalized brown copper	2 ounces
Cupric sulfate	8 ounces
Water	1/2 gallon

The second dip is:

Ammonium chloride	4 ounces
Water	1 gallon

These dips can be used either hot or cold.

A more definite blue is produced by:

Sodium thiosulfate	4 ounces
Lead acetate	2 ounces
Water	1 quart

Apply the solution hot, on hot brass.

Another blue comes from a hot solution of:

Liver of sulfur	2 ounces
Sodium chlorate	2 ounces
Water	1 pint

Heat the brass for this one, too.

A cold process, blue-green patina formula is:

Cupric carbonate	3 parts by weight
Ammonium chloride	1 part

Cupric acetate	1 part
Cream of tartar	1 part
Vinegar (strong)	8 parts

Brush the solution on daily for 3 or 4 days.

An olive-green is given to brass by:

Nickel sulfate	4 teaspoons
Sodium thiosulfate	4 teaspoons
Water (boiling)	1/2 gallon

You can use this solution as a dip (which may take many hours), or brush it on (when it is boiling hot).

Brass develops a light green patina from:

Ferric nitrate	4 ounces
Sodium thiosulfate	14 ounces
Cupric chloride	4 ounces
Water (boiling)	1/2 gallon

Like the previous solution, this one can be brushed on or used as a dip.

Another dip or brush patina is:

Cream of tartar	3 ounces
Ammonium chloride	1 ounce
Cupric nitrate	7-1/2 ounces

Sodium chloride (salt) 3 ounces

Water (boiling) 13 ounces

This produces an antique-green patina.

Another solution that produces green on brass is:

Potassium bitartrate 1 tablespoon

Salt 2 tablespoons

Ammonium chloride 1/2 teaspoon

Copper nitrate 2 ounces

Water (boiling) 12 ounces

SILVER

The usual finish used for silver is a gunmetal shade known as "French Gray." This is produced by coloring the article black and then highlighting with fine steel wool (or with 3M Scotchbrite pads) and water or other greaseless compound. The dark color is left in the recesses, and the high places have a semi-gloss finish.

The black color may be produced with a weak solution of any polysulfide, such as red ammonium sulfide or liver of sulfur, used hot; ammonia can be added where a darker color is desired--a concentration of 1 or 2 ounces in a gallon of water is satisfactory. It may be applied with a brush instead of by immersion if only a portion of the article is to be "oxidized." In either case, the patina adheres well.

Another antiquing solution often used is made by dissolving 1 ounce of tellurium dioxide in 1/2 pint hydrochloric acid and 1 pint of water. This solution may be used for dipping but is more commonly applied with a brush to fill in designs, such as borders, and thus avoid reaction with areas that are to remain white. Heat the

solution and, if you want to apply it by brush, heat the silver object also.

The sulfide solution cannot be used on silver flatware that has been cleaned electrolytically. In this case, use the tellurium solution.

Brown and Black

To give silver a brown patina, dip in a solution of 1/4 ounce barium sulfide in 1 gallon hot water.

No chemical patina turns silver a deep black, but several applications of Casey's "Perma Brass Black" will darken it considerably.

Other Colors

A golden tone can be created on white silver by dipping it into a solution of 1 ounce of sulfuric acid in 5 ounces of water to which as much iron oxide as possible is added.

A hot saturated solution of copper chloride in water forms a rose-hued patina.

ALUMINUM

All patinas on aluminum should be preserved with wax, oil, or lacquer as soon after application as possible.

An antiqued, reddish tone can be applied with oxides. The process starts with heating the aluminum sculpture in an oven or kiln at about 200°F. for about 30 minutes; then paint the whole surface with a watered down solution of asphaltum. Next, rub the piece with a clean, dry cloth, leaving a light coat of the asphaltum on. This light coat will give the aluminum a light gold color. Now take a red iron oxide or any other oxide, and apply the oxide powder to the piece with a soft brush; then brush off the excess oxide, letting some remain in the cracks and valleys. Put the whole piece

back into the oven at 200°F. to bake the oxide and asphaltum into the aluminum.

Aluminum that is to receive an acid color should be prepared in a bath of hot hydrogen potassium hydroxide, followed by a rinse in hot, then cold water. Suspend the metal in a tank of sulfuric acid, applying high amperage and low voltage for 20 to 30 minutes at 28°F. to 31°F. Rinse the piece. Then dye it by immersion in the acid color solution at 75°F. for 1 to 5 minutes. Seal the color into the aluminum by immersing in a bath of boiling acetic acid.

A lustrous black finish can be given to small pieces of aluminum with a hot oil patina. Coat the piece with olive oil, then, holding the piece with tongs over an even gas flame, burn off the oil slowly. With repetition of this treatment, the color will change from light brown to a shiny black that needs no preservative.

Any of the three following vat solutions, all used warm, will blacken aluminum. First, there is:

Cupric sulfate	8 ounces
Zinc chloride	8 ounces
Hydrochloric acid	1/2 ounce
Water (warm)	1/2 gallon

The second vat solution is:

Ammonium molybdate	2 ounces
Ammonium chloride	4 ounces
Boric acid	1 ounce
Potassium nitrate	1 ounce
Water	1 gallon

The third dip for putting a black patina on aluminum is:

Cupric nitrate	25 grams
Potassium permanganate	10 grams
Nitric acid	4 milliliters
Water	1 liter

Put piece in for 10 minutes.

A blue patina can be applied with the following solution heated to about $150°F$.:

Ferric chloride	60 ounces
Potassium ferricyanide	60 ounces
Water	1 gallon

Aluminum gains a steel-gray patina from an immersion in:

Zinc	8 ounces
Cupric sulfate	1 ounce
Water (boiling)	32 ounces

After the desired tone is obtained, rinse the piece in a 2% solution of lye (caustic soda) in water, then thoroughly rinse it in clear water.

A softly etched, imitation anodized finish may be produced on aluminum by dipping it in a solution of 1 tablespoon or more of lye to a pint of water. Then if you want to color the aluminum, dip it in a solution of

a household cloth dye such as Rita Dye.

ZINC

Two dips can be used to create a black patina on zinc. The first is:

Ammonium molybdate	4 ounces
Ammonia water	6 fluid ounces
Water	1 gallon

For deep black, the solution should be heated. Rinse the piece in cold and then hot water. Do not rub it before the finish has dried and hardened.

The other vat solution is:

Cupric sulfate	6 ounces
Potassium chloride	6 ounces
Water	1 gallon

Use this solution cold.

TIN

An antique finish can be produced on pewter with:

Cupric sulfate	1/3 ounce
Nitric acid	1/2 pint
Water	1 gallon

Immerse the pewter until its surface darkens.

Black can also be produced on tin by two other solutions, both for dipping. One is:

Arsenous oxide	20 ounces
Cupric sulfate	10 ounces
Ammonium chloride	2 ounce
Muriatic acid	1 gallon

The other vat solution, which should be used at about 150°F., is:

Sodium phosphate	100 grams
Phosphoric acid	20 milliliters
Water	1 liter

LEAD

To give lead a black patina, immerse it in a solution of:

Hydrochloric acid	4 parts by weight
Water	1 part

STAINLESS STEEL

Propietary baths are available for blackening stainless steel. Here are three do-it-yourself vat solutions. The first is:

Sodium dichromate	1 part by weight
Potassium dichromate	1 part
Water	1 gallon

Immersion in a 10% oxalic acid solution, followed by a rinse in water, wiping dry, then a rinse in 1% sodium sulfide solution will also give stainless steel a black patina.

The third solution (use at about 210°F.) is:

Sulfuric acid	180 parts
Potassium dichromate	50 parts
Water	200 parts

A bluer black can be put on stainless steel by immersing it in a 5% solution (hot) of sodium thiosulfate and water. Or try dipping in:

Nitric acid	15 parts by volume
Cupric sulfate	8 parts
Alcohol	20 parts
Water	125 parts

Three of several possible solutions for developing a blue instead of black patina on stainless steel are:

Ferric chloride	2 ounces
Mercuric nitrate	2 ounces
Hydrochloric acid	2 ounces
Alcohol	8 ounces
Water (room temperature)	8 ounces

Immerse the piece for 20 minutes, remove, and allow to stand in air for 12 hours. Repeat this procedure, then boil in water for one hour. Dry, scratch brush, and oil.

A simpler solution is:

Sodium acetate	8 ounces
Lead acetate	2 ounces
Water (boiling)	1 gallon

The third formula for a blue patina on stainless steel is:

Mercuric chloride	4 parts
Potassium chlorate	3 parts
Alcohol	8 parts
Water (room temperature)	85 parts

OTHER STEELS AND IRON

Non-stainless steels and iron are very subject to corrosion even when heavily patined, and therefore linseed or other oil, wax, or lacquer should be applied as soon as any of the following patinas are dry.

Browns and Blacks

One method for giving a brown patina to iron and steel starts by wetting the metal with a solution of:

Ferric perchlorate	1 tablespoon
Cupric sulfate	2 tablespoons
Nitric acid	1 ounce
Water	1 gallon

Dry the metal at $80°$ to $90°$F., then steam over boiling water for 30 minutes, and dry again. Brush with a wire brush. Repeat the treatment until the proper color is achieved.

Also brown is the result of dipping in the following solution:

Nitric acid	1 part by volume
Tincture ethyl nitrate	1 part
Cupric sulfate	4 parts
Tincture muriatic	2 parts
Water	60 parts

The following is an old formula for coloring the outside of gunbarrels:

Cupric sulfate	3/4 ounce
Mercuric chloride	1 ounce
Concentrated nitric acid	1/2 ounce
Denatured alcohol	1 ounce
Tincture ferric chloride	1 ounce
Tincture ethyl nitrate	1 ounce
Water	25 ounces

Dissolve the copper sulfate and the mercuric chloride in the water, then stir in the other ingredients in the order named. Apply this solution uniformly with a pad of glass wool and expose to the air for 24 hours. Then rinse well in hot water and dry in air.

The following method for browning steel gun parts

will give a durable finish:

Cupric sulfate	20 grams
Mercuric chloride	5 grams
Ferric chloride	30 grams
Nitric acid	150 grams
Denatured alcohol	1 liter

Dip, brush, or sponge on the solution. Place in a steam box for 30 minutes at 175°F., shut off the steam, and allow to stand in the box until a uniform film of red rust forms. Then immerse in boiling water until the red rust is converted to a black oxide. Dry and scratch brush with a steel wire brush. Repeat the previous operations three times, if necessary.

The following two solutions can be used for blackening a wide range of low carbon and low alloy steels. The finishes are known as "caustic black"; similar proprietary formulations are available. Both solutions are used at boiling point. The first is:

Caustic soda	8 pounds
Sodium nitrate	1-1/2 ounces
Sodium dichromate	1-1/2 ounces
Water	1 gallon

The other formula for caustic black is:

Caustic soda	80 ounces
Potassium nitrate	30 ounces
Water	1 gallon

In the two following hot solutions, the steel or iron piece should be moved rapidly in the bath as the patina develops through lighter shades to black. That may take only a matter of seconds. One formula is:

Ammonium molybdate	2 ounces
Potassium nitric	1 ounce
Boric acid	1 ounce
Water	1 gallon

The other fast-acting solution is:

Cupric sulfate	2-1/2 ounces
Potassium chlorate	3 ounces
Sodium chloride	3 ounces
Water	1 gallon

This formula is also good for a black patina:

Cupric sulfate	2 ounces
Concentrated nitric acid	4 ounces
Denatured alcohol	10 ounces

Dissolve the copper sulfate completely in the water. Then stir in the nitric acid and alcohol. Apply this solution uniformly to the metal and allow to air dry. If not black enough, apply again.

A quick method for a blue-black patina is to immerse the iron or steel in a strong photographic fixer solution, then swab it with an "instant" gun-bluing solution or paste according to the instructions for the product.

The following dip solution also produces blue-black:

Nitric acid	15 parts by volume
Cupric sulfate	8 parts
Alcohol	20 parts
Water	125 parts

Other Colors

A more blue, less black patina can be obtained on iron and steel by a number of dip formulas used at or just above room temperature. One such is:

Ferric chloride	2 ounces
Mercuric nitrate	2 ounces
Hydrochloric acid	2 ounces
Alcohol	8 ounces
Water	8 ounces

Immerse the parts for 20 minutes, remove, and allow to stand in air for 12 hours. Repeat this, then boil in water for one hour. Dry and scratch brush.

A similar effect is obtained with:

Mercuric chloride	4 parts by volume
Potassium chlorate	3 parts
Alcohol	8 parts
Water	85 parts

Before we leave the blues, here is one made by

two solutions. Dissolve 14 parts sodium thiosulfate in 100 parts of water. Dissolve 35 parts lead acetate in 100 parts of water. Then mix the two solutions, boil, and immerse the iron or steel.

Iron or steel can be given a gray patina by boiling the piece for about one-half hour in a weak solution of iron sulfate. Keep adding chemical at intervals if necessary until the metal turns gray. You can etch the gray with 1 part sulfuric acid and 3 parts water.

A final patina for iron or steel--a green one--is:

Cupric chloride 3 ounces

Ammonium chloride 1/2 ounce

Water 1 pint

Bring the solution to a boil before brushing onto the metal surface. This must be followed with a hot linseed oil patina.

OLD DRY PASTE FORMULAS

We have not tested any of the following suggestions found in **Metal Colouration** by Arthur H. Hiorns, published in the last century. Many weeks would probably be needed before these leisurely processes might prove themselves.

1. **Dark Brown, dry high-luster.**

Bronze must be highly polished. Rub piece with soft leather and very finely powdered red iron oxide. A high-luster dark brown patina will occur due to the chemical action between the iron oxide and copper.

5 parts red iron oxide

8 parts graphite

2. **English Brown (dark)**

Red iron oxide is made into a paste with water to the consistency of cream. This is painted over the sculpture with an ordinary paint brush. It is then heated in an oven until the paste is thoroughly dry. Let it set for about seven days. After allowing to cool, remove the powder with a soft brush.

3. **Chinese Brown (light)**

2 parts copper acetate

2 parts cinnebar

5 parts ammonium chloride

5 parts aluminum

Mix the above into a paste with water or vinegar and apply as in **English brown.**

4. Add **copper sulfate** for a darker brown.

5. Add **borax** to make it more yellow-brown.

The above processes may be repeated until the desired color is obtained.

6. For a **lighter brown,** apply same as above and add:

1 part copper sulfate

1 part zinc chloride

1 part water or vinegar.

X

Conserving and Preserving Bronze Patinas

You may be lucky enough to own a fine bronze sculpture whose patina may look damaged or diseased. You may want just to clean it up or to remove the patina entirely. However, before even contemplating a repair, you should be sure that you have an accurate idea of the age and value of the bronze. If you think it is valuable, it may be advisable to take it to a professional restorer. Bronze restoration is still in its infancy as a craft, but conservators, chemists, artists, and art historians are beginning to develop a body of knowledge that should help slow the devastating effects of moisture and air on bronze sculpture. We strongly recommend that you consult a restoration expert, especially if you think the bronze piece may be valuable or if you value it personally.

If you decide to go ahead with the repair yourself, proceed with caution and care, watching for any sign that a chemical change is taking place. Sometimes it is possible by the exercise of ingenuity to arrest corrosion or disease without sacrificing the patina, and there are

many cases where this is desirable. The nature and condition of the corrosion will determine the choice of actions and the degree to which stability can be regained with the minimum of work.

CLEANING A PATINA

A note of warning: before you even contemplate cleaning any bronze or other metal object, remember that more irreparable damage can be done to a metal sculpture in a few seconds than to any other work of art--damage both to the esthetic appeal of the object and to its value. Before you clean any metal object, even if you suspect it is not old, have it looked at by an expert to establish exactly what the metal is, its age, value, whether it is permissible to clean it at all, and if so, whether professional service is called for. There are certain objects that may be very old that should not be cleaned, patined, or repatined under any circumstance, no matter how dirty or old they look. So, if you think you have found an archaeological object, take it to a local museum for an examination and opinion before attempting any cleaning whatever. The rule is: if you don't know what the object is or what metal it is made of, if you are in any doubt, don't clean it.

If the object can be cleaned, the process starts by removing any wax over the patina with a suitable solvent such as naptha, turpentine, or Vari-Temp by Dupont.

Copper and its alloys are very vulnerable to oxidation. While the oxidized layer protects the bronze, chloride from the immediate environment can sometimes become trapped on the bronze surface; the resulting encrustation of cupric chloride has a corrosive action on the metal and is potentially unstable. Pale green to dark green powdery spots on the surface of the object are symptoms of bronze disease. But the problems caused by chloride and dampness are not always confined to the surface; sometimes they will develop underneath compacted layers of patina, and corrosion will continue until in time it will eat through to the surface.

STABILIZING BRONZE DISEASE

To check the corrosion, all traces of chloride must be removed from the surface. Because cupric chloride is unsoluble, washing with water alone is not the answer.

Sodium Sesquicarbonate

The safest way to arrest the diseased area is to soak the bronze in a 5 percent solution of sodium sesquicarbonate made with distilled water. Make only enough solution to last three to four days, but you may have to apply the solution daily for several weeks until the corrosion is arrested. Each time you apply the solution, rub the bronze gently with a soft brush or cloth. Small areas of corrosion that remain can be removed mechanically with a needle. When the treatment is completed, dry the piece completely, if possible in an oven, then wax the bronze.

Silver Oxide

The aim of this method is to expose the cupric chloride and to form over it a stable seal of silver chloride. To achieve this, first remove all the spots of bronze disease by using a needle or small chisel, taking care to ensure that the loose green powder that is removed does not lodge in some other area. Then make a paste of pure reagent-grade silver oxide moistened with industrial methylated spirit, and rub the paste with a cotton swab into the exposed layer of cupric chloride and into the edges of the excavated areas. The treated object is then deliberately exposed to an atmosphere having high relative humidity. This may be done by placing it in a plastic container in which there is a bowl containing a slurry of crystalline sodium thiosulfate; under these conditions the cupric chloride will react with the silver oxide, forming cupric oxide and silver chloride, both of which are inactive salts. Repeat the treatment until the sculpture shows no sign of active corrosion.

Benzothiazole

The treatment starts with thorough cleaning of the object by the mechanical means described earlier. Pay particular attention to areas of corrosion. Then remove any previously applied lacquer or wax by soaking the object overnight in a mixture of equal parts of acetone and toluene. After that, the object is ready to be immersed for 24 hours in a 3 percent solution of benzothiazole in methylated spirit. The sculpture is then removed, dried, and wiped with a swab of cotton wool that has been moistened with industrial methyl alcohol, to remove any benzothiazole remaining on the surface. Examine the piece closely every few days to see if any spots of corrosion recur. If spots return, repeat the treatment until no further corrosion is evidenced.

This technique can be used in combination with the sodium sesquicarbonate and silver oxide methods described earlier.

Other Methods

For a small curved bronze object, a good method is to wet an appropriate quantity of tin filings, imbed the piece in the fillings, cover the whole with a glass or plastic container, and leave it for 24 hours. As the tin corrodes, the resulting stannic acid will remove some of the corrosion products of copper. The tin filings can be rinsed in water and used again, but even several repetitions of this method may not be adequate to remove the signs of bronze disease.

An easy way to clean larger pieces starts with 1 part agar-agar, 80 parts water, and 6 parts glycerin. Bring the mixture to the boil and while it is still very hot, apply it over the entire sculpture with a brush, then wrap the piece completely with aluminum foil. Put a dessicator such as Dri-Flow moisture absorbing powder in the bottom of a shallow container, add a little water,

set the wrapped sculpture into the container, and set over it a glass or plastic container--see Figure 87. After two to four days in this damp atmosphere, the sculpture can be immersed in hot water to remove the foil and coating.

If you want to treat just small, local areas of a large bronze, make a paste as follows: 200 parts of powered tin or zinc, or 150 parts of powered aluminum, mixed with 8 parts animal glue, then dissolved in 10 parts hot water and 4 parts glycerin. Apply the mixture with a brush, leave it on for a day, then wash off gently with hot water and a soft brush or rag.

REMOVING A PATINA

If you want to remove all of a patina or feel you have to sacrifice it in order to save the bronze underneath from deteriorating further, you have a choice of methods.

Electrolysis

When the bronze sculpture is heavily corroded and unstable, the most efficient way of removing encrustation and reducing the products of corrosion is electrolytic reduction. The equipment required can be very expensive but here is how you can do it. (Remember that electrolysis is very fast in removing a patina, so be very careful about the amount of electrical power that is applied and watch the removal closely.)

You need a heavy-duty battery or other source of direct current for the electrolysis method. In a plastic or glass tank large enough to hold the sculpture, two steel plates are suspended from metal rods and wired to the positive terminal--see Figure 88. The sculpture is suspended between them from another rod, which is wired to the negative terminal, and the tank is filled to a half-inch above the sculpture with a 2 percent solution of caustic soda. The current is switched on until the patina disappears. After the current is switched

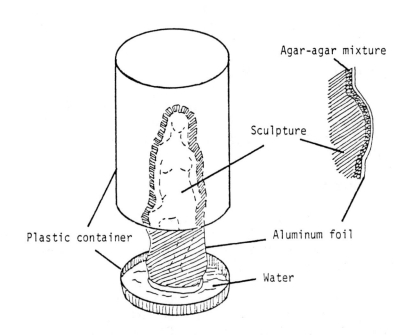

Agar-agar mixture

Sculpture

Plastic container

Aluminum foil

Water

FIGURE 87. CLEANING PATINA WITH AGAR-AGAR MIXTURE AND ALUMINUM FOIL

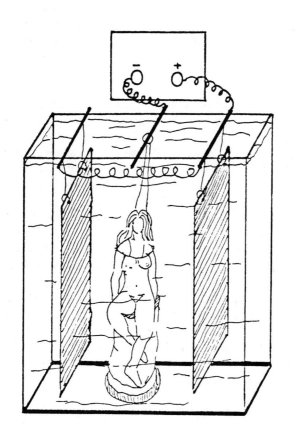

FIGURE 88. CLEANING PATINA BY ELECTROLYSIS

off, the sculpture should be removed quickly and soaked well with distilled water while it is gently brushed to remove all traces of the electrolyte.

Glass Bead Peening

Talk to a conservationist before trying this method. If you decide to try it, work very cautiously. It should be used only when the metal itself is in sound condition. This technique totally removes a patina and the products of corrosion. It is like sandblasting but uses glass beads instead of sand, at a low blasting pressure--about 40 to 60 psi (pounds per square inch).

The glass spheres flake off the encrustation and, because they have no cutting edge, they remove very little metal from the sculpture--less than a micron. Glass spheres of 75 to 100 micron diameter are often used but peening with a larger bead size--say, 140 microns--seems to increase corrosion resistance.

Glass bead peening leaves a satin finish, so is not suitable if you want to retain a highly polished surface. You can polish the surface with stainless steel or bronze wool, or apply a new patina (see the previous chapter). After proper rinsing and thorough drying, apply Incralac, an acrylic resin containing a corrosion inhibitor, benzothiazole, available from StanChem, Inc. (East Berlin, CT 06023). Incralac was formulated as the result of a research project conducted by the International Copper Research Association, and is based on the resin Acryloid B-44 (Rohm and Haas).

Apply two coats of Incralac by spray to the dried, patined bronze. Then apply a very thin transparent or pigmented wax to add richness to the patina. The final coating can be a spray-applied mixture of Incralac and polyethylene dispersion (StanChem, 71X-202) to reduce excessive glossiness of the Incralac.

PRESERVATION

It is often a lot of hard work to clean or remove a bronze patina, whether the patina results from natural weathering or prepared chemicals. Don't waste all that time and effort by then leaving the sculpture unprotected or by forgetting to reapply its protective coating periodically. And do remember to have the bronze or its patina as clean and dry as possible before applying the wax or lacquer or other protector. Otherwise, moisture or air trapped under the protective coat will soon begin to attack the patina or the bonze itself.

Appendix A

SLURRIES and STUCCOS for CERAMIC SHELL CASTING

TABLE A-1. COLLOIDAL SILICA SLURRIES (All Should Be Mixed and Stored at 78°F.)

Single Slurries	Materials	Weight (pounds)	Viscosity (Zahn cup, seconds)	Notes
Formula 1	Nalco 1030*	40	No. 5: 25-40	Zircon may give a better shell surface and a little more strength.
	Nalco P-1W *or*			
	Zircon milled (325 mesh)	30		
	Ultrawet 60	0.05		
Formula 2	Nalco 1030	50	No. 5: 30-50	Start with little water because less than 4 qt. may be needed. Sea Spen (suspension agent) can be used but may weaken the shell.
	Nalco P-1W *or*	100		
	Zircon milled (325 mesh)			
	Ultrawet 60	50		
	Ione Grain 516	0.05		
	Distilled water	50		
		4 quarts		
Formula 3	Nalco 1030	8.7	No. 5: 40-60	Good formula for a small amount-- about 5 gal.
	Nalco P-1W	21.3		
	Ultrawet 60	12 drops		
	Sea Spen A-6	1 percent		
Formula 4	Nalco 1030	85	No. 4: 32-35	Good formula for iron and steel. More zircon may be needed to increase viscosity.
	Zircon milled (325 mesh)	105		
	Nalco P-1W	105		
	Ultrawet 60	15-20 drops		

* The liquid binder is the first material listed for each slurry.

TABLE A-1 (Concluded)

Two-Slurry Systems	Materials	Weight (pounds)	Viscosity (Zahn cup, seconds)	Notes
Formula 5				
(a) Primary coats	Nalco 1030 Nalco P-1W Ultrawet 60	30 70 0.05	No. 5: 40-60 No. 4: 60-90	More Nalco 1030 may be needed to reduce viscosity.
(b) Backup coats	Nalco 1030 Nalco P-1W	38 62	No. 5: 8-13 No. 4: 60-90	Be sure to check viscosity at least once a day.
Formula 6				
(a) Primary coats	Ransom & Randolph Silica Sol Ranco-Sil 4 Victawet	11 24 0.05	No. 4: 60-70	
(b) Backup coats	Ransom & Randolph Silica Sol Ranco-Sil 2	14 20	No. 4: 15	
Formula 7†				
(a) Primary coats	Ludox SM Zircon (325 mesh) Silica (325 mesh) Victawet Distilled water	85 100 100 0.5% 2 gal.	No. 4: 30-35	
(b) Backup coats	Ludox SM Silica (325 mesh) Silica (200 mesh) Distilled water	90 100 100 2 gal.	No. 4: 10-15	

† Used at the Johnson Atelier Technical Institute of Sculpture.

TABLE A-2. COMPATIBLE STUCCOS FOR COLLOIDAL SILICA SLURRIES

No. 1 stuccos (use with primary slurry coats)

 Zircon fine

 Nalco S1

 Calamo

 Rancosil AG

 Ione 514

No. 2 stuccos (use with backup slurry coats)

 Nalco S2

 Ione 511

 (Note: For the last few backup coats, a heavier
 grain stucco can be used to reach the
 desired thickness of shell faster.)

TABLE A-3. ETHYL SILICATE SLURRIES (Used by HERK VAN TONGEREN)

	Materials	Weight (pounds)	Viscosity (Zahn cup, seconds)	General Notes
Primary slurry	Shellvest 50 (Marketeers) or zircon milled (325 mesh) Prehydrolized H6 binder (Stauffer Chemical Co.) Cellosolue solvent	100 26 11	No. 4: 12-20	Maintaining ethyl silicate is very exacting. Adjustment can be critical and you have to work with a slurry daily to develop a feel for what it is doing. There is really no set formula because the behavior of the slurry depends on how hard you work the tanks. Unless the temperature can be kept at 60°F., you have to keep adjusting the slurry if it is to remain usable.
Backup slurry	Shellvest 31-60 Prehydrolized H4 binder Phosphoric acid	200 125 10 cc.	No. 5: 5-8	To compensate for evaporation, we add from 1/2 to 3/4 of a small bucket of isopropanol alcohol each morning and at the end of the day. We also add about 1/3 bucket of the binder at midday, especially if we are using the tanks a lot.
Alternate backup slurry	Zircon milled (325 mesh) Silica fused (325 mesh) or Marketeers 50-27 H4 binder Phosphoric acid	150 100 112 10 cc.	No. 5: 5-8	Making the first coat quite thick gives time to brush or blow out all the bubbles on a very detailed piece. Then we hand-stucco with zircon sand, let the piece air dry for at least 30 minutes, and then place it in an old refrigerator modified to gell the shell with ammonia gas.

Appendix B
FURTHER READING

WAX-WORKING AND MODELING

Averbach, Arnold, Modelled Sculpture and Plaster Casting.
 New York: Yoseloff, 1962.

Eliscu, Frank, Direct Wax Sculpture. Radnor, PA:
 Chilton, 1969.

Hoffman, Malvina, Sculpture, Inside and Out. New York:
 Bonanza, 1939.

Lanteri, Edouard, Modelling and Sculpture. New York:
 Dover, 1965.

Miller, Richard McDermott, Figure Sculpture in Wax and
 Plaster. New York: Watson-Guptill, 1971.

Newman, Thelma, Wax Modelling. So. Brunswick, NJ:
 Yoseloff, 1966.

Rich, Jack C., The Materials and Methods of Sculpture.
 New York: Oxford University Press, 1973.

KILN MAKING

Colson, Frank A., Kiln Building With Space-Age Material.
 New York: Van Nostrand Reinhold, 1975.

Rhodes, Daniel, Kilns: Design, Construction and Operation.
 Radnor, PA: Chilton, 1968.

METAL CASTING

Berman, Harold, Bronzes: Sculptors & Founders 1800-1930.
 Chicago: Abage, 1974.

Choate, Sharr, Creative Casting. New York: Crown, 1966.

Davies, G. J., Solidification & Casting. Halsted, 1973.

Doeringer, Suzannah, ed., Art and Technology: A Symposium on Classical Bronzes. Cambridge, MA: Fogg Art Museum, Harvard University, 1970.

Flinn, Richard A., Fundamentals of Metal Casting. Reading, MA: Addison-Wesley, 1963.

Foundryman's Handbook, 8th ed. Foundry Services Ltd. Elmsford, NY: Pergamon, 1976.

Gulaev, B. B., ed., Gases in Cast Metals. Plenum, 1965.

Investment Casting, Malco Chemical Co. Chicago: Malco, 1973.

Kowal, Dennis, Jr., and Meilach, Dona Z., Sculpture Casting. New York: Crown, 1972.

Metals Handbook: Melting and Casting. Metals Park, OH: American Society for Metals, 1977.

Mills, John W., The Technique of Casting for Sculpture. New York: Reinhold, 1967.

Murris, John D., Creative Metal Sculpture. New York: Bruce, 1971.

Rich, Jack C., The Materials & Methods of Sculpture. New York: Oxford University Press, 1973.

Slobodkin, Louis, Sculpture: Principles & Practice. New York: Dover, 1978.

Strauss, K., Applied Science in the Casting of Metals. Pergamon, 1970.

Tefft, Elden C., Sculpture Casting in Mexico, 2nd ed. Lawrence, KA: University of Kansas, 1968.

Verhelst, Wilbert, Sculpture: Tools, Materials & Techniques. Englewood Cliffs, NJ: Prentice-Hall, 1973.

Wittkower, Rudolf, Sculpture: Process & Principles. New York: Harper & Row, 1978.

WELDING AND CHASING

Hale, Nathan Cabot, Welded Sculpture. New York: Watson-Guptill.

Jackson, Harry, Lost Wax Bronze Casting. New York: Van Nostrand Reinhold, 1979.

Kronquist, Emil F., Metalwork for Craftsmen. New York: Dover, 1978.

The Oxyacetylene Handbook. Union Carbide Corp., New York.

Tubby, Pamela, Working with Metal. New York: Crowell, 1979.

PROTECTION

Byrzostoski, John, "Patinas." New York: Craft Horizons Magazine, 1965.

Fishlock, D., Metal Colouring. Teddington, England: Robert Draper, 1962.

Plenderlieth, H. J., and Werner, A. E., The Conservation of Antiquities and Works of Art: Treatment, Repair, and Restoration. London: Oxford University Press, 1971

Tiner, Nathan A., Coating Materials for Corrosion and Wear Prevention. Long Beach, CA: California State University, 1972.

OTHER

Burnham, Jack, Beyond Modern Sculpture. New York: George Brazillier, 1968.

Coleman, Ronald L., Sculpture: A Basic Handbook For Students. Dubuque, IA: Wm C. Brown.

Savage, George, A Concise History of Bronzes. New York: Frederick A. Praeger, 1969.

Untracht, Oppi, Metal Techniques For The Craftsman. New York: Doubleday, 1968.

276

Appendix C
SUPPLIERS

CERAMIC SHELL

Avnet-Shaw
91 Commercial St.
Plainview, NY 11803

Buntrock Industries
2438 N. Clark St.
Chicago, IL 60614

Casting Supply House
62 West 47th St.
New York, NY 10036

Combustion Engineering
900 Long Ridge Rd.
Stamford, CT 06902 _or_

2 Gateway Center
Pittsburg, PA 15222

Dupont
Wilmington, DE 19898

Harbison Walker Refractories
2 Gateway Center
Pittsburg, PA 15222 _or_

222 Cedar Lane
Teaneck, NJ 07666 _or_

P. O. Box 12548
Calhoun, GA 30701

Interpace
3502 Breakwater Court
Hayward, CA 94545

Kay-Fries
200 Summit Ave.
Montvale, NJ 07645

Leco Corp., Fusion Div.
832 Winer Industrial Way
Lawrenceville, GA 30245

Marketeers
19101 Villaview Rd.
Cleveland, OH 44119

M. & T. Chemicals
1 Woodbridge Center
Woodbridge, NJ 07095

Nalco Chemical
9165 S. Harbor Ave.
Chicago, IL 60617

Ransom & Randolph
P. O. Box 905
Toledo, OH 42691 _or_

2337 S. Yates Ave.
Los Angeles, CA 90040

Remet
Bleachery Place, P. O. Box 278
Chadwicks, NY 13319 _or_

14640 W. Greenfield Ave.
Brookfield, WI 53005

Sherwood Refractories
16601 Euclid Ave.
Cleveland, OH 44112

Stauffer Chemical
Nyala Farm
Westport, CT 06880

TAM Ceramics
Box C, Bridge Station
Niagara Falls, NY 14305

OTHER MOLD MATERIALS

Buntrock Industries
2438 N. Clark St.
Chicago, IL 60614

Crystal Soap & Chemical
Lansdale, PA

Douglas & Sturgess
730 Bryant St.
San Francisco, CA 94107

Dow Corning
Midland, MI 48641

Samuel H. French
Cresson St.
Philadelphia, PA

General Electric-Silicone
 Rubber
Waterford, NY 12188

B. F. Goodrich Industrial
 Products
500 S. Main St.
Akron, OH 44318

Dexter Corp.,
Hysol Div.
Olean, NY

International Latex
 Chemical
Dover, DE

Perma-Flex Mold
1919 East Livingston Ave.
Columbus, OH 43209

Ransom & Randolph
P. O. Box 905
Toledo, OH 42691 _or_

2337 S. Yates Ave.
Los Angeles, CA 90040

Schlicter Products
E. Middle Ave.
Hanover, PA 17331

Sculpture Associates
114 E. 25th St.
New York, NY 10010

Sculpture House
Campmeeting Rd.
Skillman, NJ _or_

38 E. 30th St.
New York, NY

Sculptor's Supplies
99 E. 19th St.
New York, NY 10003

Shell Chemical,
Synthetic Rubber Div.
19253 S. Vermont
Gardena, CA

Smooth-On
1000 Valley Rd.
Gillette, NJ 07933

Tattersalls
309 N. Willow St.
Trenton, NJ

Thermoset Plastics
5101 East 65th St.
Indianapolis, IN 46220

Union Carbide
Silicones Div.
270 Park Ave.
New York, NY 10017

U.S. Gypsum
101 S. Wacker Dr.
Chicago, IL 60606

Will & Baumer Candle
Park St. North
Syracuse, NY 13201

Gary Zeller of
 Plastics Factory
18 East 12th St.
New York, NY

Wm. Zinsser
39 Belmont Dr.
Somerset, NJ 08873

REFRACTORY PRODUCTS

Babcock and Wilcox
Old Savannah Road
Augusta, GA 30903

Buntrock Industries
2438 N. Clark St.
Chicago, IL 60614

Denver Fire Clay
3033 Blake St.
Denver, CO 80205

A.P. Green Refractories
Mexico, MO

Harbison Walker Refractories
2 Gateway Center
Pittsburgh, PA 15222

Industrial & Foundry Supply
2401 Poplar St.
Oakland, CA 94607

Johns-Manville
22 East 40th St.
New York, NY 10016

Kaiser Refractories
Room 1084, Kaiser Center
Oakland, CA 94604

N. L. Industries Inc.,
TAM Div.
Box C, Bridge Station
Niagara Falls, NY 14305

Norton
Troy, NY 12181

Ransom and Randolph
P. O. Box 905
Toledo, OH 42691 _or_

2337 S. Yates Ave.
Los Angeles, CA 90040

Refractory Products
500 W. Central Road
Mt. Prospect, IL 60056

Sherwatt Wire Cloth
Rte. 130
Roebling, NJ 08554

Thermo Engineering
5105 Buffalo Ave.
P. O. Box 3935
Jacksonville, FL 32206

Union Carbide
P. O. Box 324
Tuxedo, NY 10987

FOUNDRY EQUIPMENT

A. D. Alpine
3051 Fujita St.
Torrance, CA 90505

A.L.C. Company
P. O. Box 506
Medina, OH 44256

American Refractories and
 Crucible
New Haven, CT 06473

Buntrock Industries
2438 N. Clark St.
Chicago, IL 60614

Burnham,
Industrial Burner Div.
Lancaster, PA 17604

Carborundum
P. O. Box 808
Niagara Falls, NY 14302

Cleveland Flux
1026-40 Maine Ave., N.W.
Cleveland, OH 44113

Joseph Dixon Crucible
167 Wayne St.
Jersey City, NJ 07303

Eclipse Fuel Engineering
Rockford, IL 61101

Electro-Ferro
661 Willet Road
Buffalo, NY 14218

Electro-Nite
Caroline Rd.
Philadelphia, PA 19154

Foseco
P. O. Box 8728
Cleveland, OH

Foundries Material
5 Preston Ave.
Coldwater, MI 49036

Gas Appliance
20909 Brant Ave. South,
Long Beach, CA 90810

W. W. Grainger
100 Lincoln St.
Boston, MA 02135

A. P. Green Refractories
Green Blvd.
Mexico, MO 65265

Gulton West Instrument Div.
3860 North River Rd.
Schiller Park, IL 60176

W.L. Hemingway
43 Lawrence Ave.
Holland, PA 18966

Inductotherm
10 Indel Ave.
Rancocas, NJ 08073

Industrial and Foundry Supply
2401 Poplar St.
Oakland, CA 94607

Industrial Equipment
Minster, OH 45865

Industrial Products
21 Cabot Ave.
Langhorne, PA 19047

Johnson Gas Appliance
Cedar Rapids, IA 52405

Johnston Manufacturing
2825 East Hennepin Ave.
Minneapolis, MN 55413

Penn Foundry Supply
6801 State Rd.
Philadelphia, PA 19135

Pyrometer Instrument
234 Industrial Pkwy.
Northvale, NJ 07647

Remet
Bleachery Place, P. O. Box 278
Chadwicks, NY 13319 _or_

14640 W. Greenfield Ave.
Brookfield, WI 53005

Ross-Tacony
State Rd. & Milnor St.
Philadelphia, PA 19135

Saunders Equipment
P. O. Box 265, Route 301
Cold Spring, NY 10516

Simpson National Engineering
20 N. Wacker Dr.
Chicago, IL 60606

Westwood Ceramic Supply
14400 Lomitas Ave.
City of Industry, CA 91744

Wolverine Foundry Supply
14325 Wyoming Ave.
Detroit, MI 48238

CHASING AND FINISHING
TOOLS, SUPPLIES

Abrasive Specialists
660 - 2nd St. Pike
South Hampton, PA 18966

Allcraft Tool & Supply
215 Park Ave.
Hicksville, NY 11801

Montoya Arts Studios
4110 Georgia Ave.
West Palm Beach, FL 33405

South Hampton Abrasive
199 Schan Dr.
Churchville, PA 18966

3M, Industrial Abrasive Div.
6023 S. Garfield Ave.
Los Angeles, CA 90040 _or_

320 Shaw Rd.
S. San Francisco, CA 94080

Wallace Murray Corp.
Altrax Div.
Box 2367
Tuscaloosa, AL 35403

WAXES, POLISHES

M. Argueso
441 Waverly Ave.
Mamaroneck, NY 10543

Bareco Div.
6910 East 14th St.
P. O. Drawer K
Tulsa, OK 74115

Competition Chemicals
Iowa Falls, IA 50126

Du Pont Polishing Compounds
Wilmington, DE

Dick Ellis
908 Venice Blvd.
Los Angeles, CA 90015

Freeman Mfg.
1246 West 70th St.
Cleveland, OH 44102

Remet
P. O. Box 278
Chadwicks, NY 13319

Roger Reed
Reading, MA 01867

Saunders Equipment
Route 301
Cold Spring, NY 10516

Stan Chem
East Berlin, CN 06023

Taylor's Wax Processing
Box 106, California Rd.
New Troy, MI 49119

Wax Company of America
5016 West Jefferson Blvd.
Los Angeles, CA 90016

Yates Mfg.
1615 W. 15th St.
Chicago, IL 60608

POWDERS, RESINS

Adhesive Products
1660 Boone Ave.
Bronx, NY 10460

Alcan Corp.,
Metal Powders Div.
Elizabeth, NJ

Berton Plastics
170 Wesley St.
P. O. Box 1906
So. Hackensack, NJ

Cabot
125 High St.
Boston, MA 02110

Frekote
140 N. Federal Hwy.
Boca Raton, FL 33432

Price - Driscoll
75 Milbar Blvd.
Farmingdale, NY

Reichold Chemicals
525 N. Broadway
White Plains, NY 10602

Remet
Bleachery Place, P. O. Box 278
Chadwicks, NY 13319 *or*

14640 W. Greenfield Ave.
Brookfield, WI 53005

United States Bronze
Powders
Flemington, NJ 08822

SAFETY EQUIPMENT, CONTROLS

General Controls ITT
801 Allen Ave.
Glendale, CA 91201

Industrial Products
21 Cabot Ave.
Langhorne, PA 19047

Personal Environment
 Systems
P. O. Box 800
Glendale, CA 91209

Wilson Products Div.
ESB Incorporated
P. O. Box 622
Reading, PA 19603

Appendix D
GLOSSARY OF TERMS

ACCELERATORS: Chemicals that speed up but never start a reaction. Also called promoters.

ACETONE: A volatile, flammable liquid compound used chiefly as a solvent.

ACID BATH (Pickling): Strongly acidic liquid used to remove burnt sand, scale, or specific impurities from the surface of the metal.

ACRYLIC: A synthetic resin prepared from acrylic acid or from a derivative of acrylic. Lucite and Plexiglass are among the many trade names of solid acrylic products; many acrylic paints are also trademarked.

ALKALI: Any mineral salt that can neutralize acids. A soluble salt or mixture of soluble salts present in some soils of some arid regions.

ALLOY: A substance in which one or more metals or nonmetallic materials are intimately united. They are usually fused by melting one into the other and do not separate into distinct layers upon solidifying.

ALUM: A sulphate used in sculpture to harden the surface of gelatin molds.

ALUMINUM: A silver-white metal that is very lightweight and resistant to corrosion.

ANNEAL: The controlled heating and cooling of metal to alleviate internal stress that causes fracturing.

ARCH: To form or bend into an arch.

ARC WELDING: Welding with electricity rather than gases.

ARMATURE: Internal support system.

ASBESTOS: In cloth form, an insulating fabric made from
 woven asbestos fiber, which is fire resistant.

ATMOSPHERIC: Relating to the atmosphere. An atmospheric
 burner uses the air around it.

AUTOCLAVE: A chamber with steam at 100 psi (pounds per
 square inch), used to dewax ceramic shell.

BALLPEIN HAMMER: A hammer with a round top and flat bottom
 used for shaping metal.

BINDER: A material used to bond aggregate particles to form
 a strong solid, as in plaster, cement, or resin.

BRASS: An alloy consisting essentially of copper and zinc in
 varying proportions, depending on what, it is to be
 used for. Other elements are sometimes added.

BRAZING: Joining two metals with an alloy of brass and zinc.

BRONZE: An alloy consisting of copper and tin in varying
 proportions, depending on what it is to be used for.
 Sometimes small amounts of magnesium, silica, lead,
 phosphorous, or other elements are also added.

BRONZE ROD: A welding rod made essentially of copper and
 silica, with other elements like magnesium and
 phosphorous added. The composition varies for
 different purposes and for use with different metals.

BURNER: A device that mixes fuel with air intimately to
 provide good combustion when the mixture is burned.

BURNOUT: Baking the ceramic shell to burn out the wax;
 also called dewaxing.

CALCINING: The preparatory heat treatment given raw
 refractory material to remove volatile substances and
 moisture, as in an investment mold or in shell casting.

CAPILLARY: The action by which the surface of a liquid is
 raised or lowered where it is in contact with a solid.

CARBURIZING: A flame that contains an excess of acetylene
 and imparts carbon to the surface of the metal.

284

CASE: The form devised to hold the sections of a flexible mold or a piece mold in place; also called mother mold.

CASINE: A paint manufactured by allowing skim milk to sour, separating the curd from the whey, washing and drying it, then adding a binder and color.

CAST: A work that has been produced by molding; the positive image.

CAVITY: The mold or space to be filled by the casting media.

CENTIGRADE: A scale for measuring temperature on which there are 100 degrees between the freezing (0°) and the boiling point (100°) of water. $C = 5/9 (F - 32)$.

CHASING: To finish the surface of metals by using various metal tools.

CHIMNEY: In a kiln, the tube that carries the air and gas out.

CHISEL: A metal carving tool made from steel with a hard cutting edge.

CLAY WALL: The method by which sections of mold can be made and separated.

COLLOIDAL SILICA: The binder that holds the ceramic shell material together.

COMPOUND: To form by combining parts, elements or ingredients.

CONTAMINATION: To stain, soil, or infect by contact. To retard the patina on the surface of metals.

COPPER: A reddish-brown, nonferrous element that resists rust.

CORE: The inner mold.

CORE PIN: The bronze pin that holds the core in place.

CORROSION: In metal, oxidation that may eventually destroy the metal.

CRAZING: Small cracks through the thickness of a material caused by uneven shrinkage and expansion.

CRUCIBLE: The vessel of refractory material in which metals are made molten.

DEGASING: Removing gas from the molten metal before pouring.

DEOXIDATION: Removal of excess oxygen from molten metal by adding materials with a high affinity for oxygen.

DEWAXING: See Burnout.

DIE: The tool used to cut a thread on a rod (the male).

DIRECT METAL: Building or shaping metal to create a finished form as opposed to casting from one material into metal.

DRAFT: The way the plaster mold comes off the original.

DROSS: Slag metal oxide and other scum on the surface of molten metal.

DUCTILE: Malleable, flexible, not brittle.

ELECTRODE: A conductor used to establish electrical contact.

EPOXY RESIN: Resin used for making patterns. A mixture of resin and hardeners.

EVAPORATE: To change into vapor, to pass off or away.

FAHRENHEIT: A scale for measuring temperature on which there are 180 degrees between the freezing (32°) and the boiling point (212°) of water. $F = 9/5C + 32$.

FEMALE MOLD: Negative form.

FERROUS: A word used to describe compounds that contain iron, it is derived from *ferrum*, the Latin word for iron.

FIBERGLASS: Very slender fibers made from glass; fabrics or sheeting made from such fibers.

FILE: An abrading tool made of metal.

FILLER: The metal from a rod which is added to the base metal when welded or fused.

FIREBRICK: Brick made from refractory clays used in lining furnaces.

FIRE SCALE: A metal oxide surface scale resulting from hot pour.

FIRING: Heating a kiln.

FISSURE: A narrow opening or crack that sometimes develops in a bronze casting because of pouring of the metal at the wrong temperature.

FLASH: A thin section of excess material formed on the object inside a mold along the parting line; mold cracks.

FLASHBACK: An occurrence when the flame disappears from the end of the torch tip and burns back into the mixer with a shrill, hissing sound. Both valves should be closed immediately to prevent damage to the equipment.

FLEXIBLE MOLDS: Molds made from gelatin, PVC, latex or silicone rubber.

FLUIDIZING: Floating solid particles on air.

FLUX: A substance mixed with metal for welding or brazing that promotes fusion and free run of the molten metal.

FORGE: To shape metal by preheating and then hammering, twisting, and bending.

FOUNDING: Melting and fusing metals to make castings.

FOUNDRY: The place where metal castings are made.

FRACTURE: When metal is broken rather than cut or melted. Some metals are more brittle than others. Cast metal is often fractured easily.

FREEZING: Metal chilling or cooling to form the solid.

FURNACE: The structure that contains the crucible to heat the metal.

FUSION: Complete intermingling between the two edges to be joined or between the base metal and the welding rod.

GALVANIZED WIRE: Wire coated with zinc to prevent rusting.

GATE: The sprue in a shell casting where molten metal enters the casting.

GATING SYSTEM: See Sprue System.

GELATIN: Jelly made from stewed bone matrix, used to make flexible molds.

GYPSUM: Hydrated calcium sulfate (plaster of paris).

HACKSAW: A saw for cutting metal.

HARD SOLDER: Term used interchangeably with silver solder. Distinct from soft or lead solder, which melts at lower temperatures than silver.

HUMIDITY: The amount of moisture in the air.

IGNITER: The sparker used to light the flame on a torch.

INGOT: A mass of metal cast to a convenient size and shape for remelting or hot working.

INVESTMENT: A refractory material used in making of molds for the casting of metals. Usually a mixture of sand, clay, and plaster.

INVESTMENT CAST: In lost wax casting, the refractory material around the wax object.

IRON: A common and useful metallic element which is gray in color, turns dull red upon oxidizing.

JIG: Mechanical device for holding pieces of metal in position.

KEY: The method of making perfect registration; the exact locating of one piece to another, as in molds and roman joints.

KILN: A furnace or oven for baking clay materials.

LEAD: A heavy, easily melted metallic element, bluish-gray in color.

LOST WAX: Cire perdue, the method of making a metal casting via a wax pattern.

MALLEABLE: The capability of metal to be worked by hammering or rolling.

MATTING TOOL: A chasing tool used to texture or mat a metal surface.

MELTING POINT: That degree of temperature when a metal turns into a liquid state.

MICROSCOPIC: Able to be seen only through a microscope; very small.

MICROWAVE: Electric waves.

MOLD: The form made of sand, metal, ceramic shell, or other material that contains the cavity into which molten metal is poured to produce a casting.

MOLDING: Making the mold.

MOLTEN: Metal that is liquid.

NICHROME WIRE: Wire used for the heating element of a kiln.

NONFERROUS: Any metal or alloy that does not contain iron.

NOXIOUS: Harmful or poisonous; fumes that sometimes occur when working with certain metals or acids.

OXIDATION (Corrosion): The chemical combination of a metal (ferrous or nonferrous) with oxygen, forming a coat on the surface of the metal.

OXIDE: The substance that forms when oxygen combines chemically with a metal or other elements. When the combination occurs, the metal is said to oxidize and if the oxidation is rapid, the metal or other substance will burn.

OXYACETYLENE: A mixture of oxygen and acetylene used to create high heat for welding. It may also be used for some soldering and brazing techniques.

PARTING AGENT: Material painted on surfaces of pieces that are to be parted (or released).

PATINA: The color of the surface of metal caused by weathering or chemical application of acids or impurities.

PERMEABLE: Having pores or openings that permit liquids or gases to pass through.

PICKLING: Placing metal in an acid bath to remove burnt sand, scale, or specific impurities from the metal's surface.

PINS: Nails made of the same metal placed through the wax into the core area to retain the space between the two when the wax melts out.

PLANISH: To even out the surface of metal that has been hammered into a shape.

PLASTER: A white cement that is very cheap to buy and drys very fast.

PLASTICINE: A wax-oil clay that never dries.

PLUNGER: The metal rod used to plunge a degasing agent into the molten metal.

POLISHING: To make smooth and glossy by buffing with a cloth pad and powdered compounds.

POROSITY: The quality or state of being porous, full of pores.

POUR: The pour, the action of filling the prepared mold with molten metal.

POURING GATE: The system of risers and runners.

PUDDLE: The pool of molten metal formed during welding.

290

PURE METAL: An element that has not been mixed with other metals or substances.

PVA: Polyvinyl acetate; polyvinyl alcohol.

PVC: Polyvinyl chloride.

PYROMETER: An instrument for measuring intense heat such as in a kiln or furnace.

QUENCHING: Cooling a heated metal suddenly, frequently by dipping in oil or water. This action usually makes the metal more brittle.

RASP: A coarse metal file with sharp, pyramidal teeth.

REFRACTORY: Nonmetallic, heat resistant material used for furnace linings.

REGULATOR: An adjustable mechanical device that raises or lowers the high pressure of gas in the cylinder to a working pressure in the torch.

RELIEF: A design made on or into a flat surface.

REPOUSSÉ: Shaping metal by hammering from front and back with hammers of different shapes.

RIFFLER: A fine-toothed file, usually curved, used to help finish a surface.

ROD: A wire, stick, or rod of metal of special composition used in welding and brazing as a filler metal.

RUNNER CUP: The funnel at the top of the sprue system into which the metal is poured.

RUNNERS: The sprues or channels through which the metal runs to fill the mold.

RUST: The reddish-brown coat that forms on ferrous metals when exposed to weather or water.

SANDBLASTING: Sand projected by an air stream at high pressure; used for engraving, cutting or cleaning glass, stone, or metal.

SCABBING: Scabs of bronze on a cast bronze surface.

SCREEN: The sieve used for sifting and grading refractory
 aggregate.

SHANK AND RING: The tool used to grip the crucible to
 facilitate accurate pouring.

SHELLAC: A varnish made from lac, the resinous secretion of
 an insect.

SHIM: The metal fencing used to make divisions of a waste
 mold.

SILICA: Silicone dioxide, the prime ingredient of sharp
 sand and acid refractories.

SILICA CARBIDE: A very hard refractory material.

SKIMMER: The tool used to skim slag from the molten metal
 before pouring.

SLAG: Foreign substances that separate from the pure metal
 when molten.

SLURRY: A thin watery mixture of a clay-like dispersion,
 such as mud, cement, or mortar.

SOLDERING: A relatively low-temperature form of fusing
 metals. Hard soldering employs a solder that melts
 between 1200° and 1300°F., while soft solder melts
 below 700°F. Both solders melt below the temperature
 required to melt the base metal.

SPATULA: Flat modeling tool usually of boxwood or
 tempered steel.

SPRUE SYSTEM: The complete assembly of sprues, runners,
 gates, and individual casting cavities in the mold.

STEEL: An alloy consisting essentially of iron and carbon.

STEEL WOOL: An abrasive material composed of long, fine
 steel shavings, used especially for scouring and
 burnishing.

STUCCO: A different-grained sand used to coat a ceramic shell.

STYROFOAM: A soft polystyrene.

TAPDRILL: To make a threaded hole in metal.

TEMPERING: Hardening metal by alternately heating and cooling it.

TEXTURING: To make the surface of a metal casting look like the surface in the original wax sculpture.

THERMAL SHOCK: A shock caused by a quick and large change in temperature.

THERMOCOUPLE: A thermoelectric couple used to measure temperature differences.

THE WAX: The positive form in wax.

TINNING: Coating a base metal with another metal for protection or appearance.

TONGS: Used to grip hot items during casting.

TORCH: An instrument for bringing together and properly mixing oxygen and acetylene gases so that, when ignited, the heat of the resulting flame is controlled.

TUNGSTEN CARBIDE: A gray-white, heavy ductile metal that is used for metal parts. It has a high tensile strength.

TURBULENCE: Characterized by up and down currents.

UNDERCUT: The underside of a deep recess.

VAPOR: Fine particles of matter floating in the air.

VARIATION: Divergence in a quality from that typical or usual to a group.

VELOCITY: Quickness of motion; speed.

VENT: A small opening or passage in a mold or core to facilitate escape of gases during pouring.

VIBRATION: Vibrating a mold encourages the escape of any
air that may be trapped in the material.

VISCOSITY: The thickness of a liquid.

VORTEX: The cavity toward which liquid having a whirling
motion tends to move.

WARPING: When a flat sheet of metal bows.

WAX: A yellowish plastic substance secreted from bees, or
various other substances resembling beeswax in
physical or chemical properties. Especially a solid
mixture of higher hydrocarbon.

WAXLITE: A plastic substance with a low melting point.
Used mostly in sculpture studios today.

WELDING: The joining together of two metals causing the
edges to become molten by electrical or oxyacetylene
apparatus.

ART CENTER COLLEGE OF DESIGN LIBRARY
1700 LIDA STREET
PASADENA, CALIFORNIA 91103

7 2051